THE ACCIDENTAL COLLECTOR

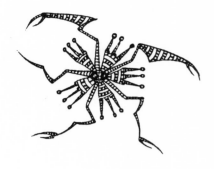

BY WESLEY WEHR

The Eighth Lively Art

Conversations with Painters, Poets, Musicians,

& the Wicked Witch of the West

SEATTLE & LONDON

THE
ACCIDENTAL
COLLECTOR

ART, FOSSILS,
& FRIENDSHIPS

WESLEY
WEHR

UNIVERSITY OF WASHINGTON PRESS

University of Washington Press / PO Box 50096, Seattle, WA 98145
www.washington.edu/uwpress

Library of Congress Cataloging-in-Publication Data
Wehr, Wesley, 1929–
The accidental collector : art, fossils & friendships / Wesley Wehr.
 p. cm.
Includes index.
ISBN 0-295-98382-5 (alk. paper)
 1. Arts, American—20th cengury. 2. Artists, American.
3. Wehr, Wesley, 1929—Friends and associates. I. Title.
NX504.W447 2003
709',73'0904—dc22 2003065762

Frontispiece: Ancient Bird, 1978 by Wes Wehr

FOR OLIVER SACKS

CONTENTS

PREFACE

FRENCH WRITER ANDRE GIDE CLAIMED that artists are for the most part poor judges of their contemporaries: they elevate their friends beyond any credibility and condemn their rivals to the lower aesthetic depths. Artists are often, said Gide, either too close to or too remote from their contemporaries to have perspective. Indeed, who am I to claim otherwise? Personal loyalties obviously play a large role in how I portray the artists who appear in this book. I hesitate to suggest that the profiles, stories, and anecdotes that follow are necessarily characteristic and all-encompassing reflections of the people about whom I write. They are better described as my observations and accounts of what these intensely creative people brought out in each other and in me, and of how they inspired, influenced, challenged, and sometimes infuriated one another.

This book is a mosaic of voices, episodes, images, and places that remain vivid and enduring in my memory. What do these writers, artists, and musicians in the stories that follow have in common? For one thing, many of them

shared a mistrust of theorizing about their own work, and while they were frequently disorganized about their so-called careers, they were remarkably resourceful at living by their wits.

This story is merely one of an infinite number of possible versions of "what really happened," told through the lens of my own selective memory. If I had written this account at the time when these various events took place, I would surely have told some of the stories differently. Events that once seemed so important to me often appear inconsequential now. With time, the accent shifts. The small details that almost escaped my notice will sometimes turn out to be unexpectedly significant later. A chance meeting, a casual remark made in passing—I could hardly have anticipated the pivotal roles such things could play in years to come.

The autobiographical stories and profiles that follow are intented to be read as a continuation of those in my previous book, *The Eighth Lively Art: Conversations with Painters, Poets, Musicians & the Wicked Witch of the West.*

ACKNOWLEDGMENTS

For invaluable suggestions and encouragement, I especially thank Deloris Tarzan Ament, Guy Anderson, Helen Ballard, Lisa Barksdale, Matthias Barmann, Dorothee and Mitchell Taylor Bowie, Ree Brown, Rebecca Brown, Lisa Corrin, Roxanne Cumming, Paul Dahlquist, Donald Ellegood, Gary Fountain, Gordon Grant, Rob Hause, Randy James, Kirk Johnson, Ray Kass, Martha Kingsbury, Leonard and Nancy Langer, Gary Lundell, Beatrice Roethke Lushington, Joanne MacDonald, Audrey Meyer, Elaine Monsen, Mary O'Hara O'Toole, Kathleen Pigg, Mary Randlett, Mark Reeves, Kim Ricketts, Ned Rorem, Oliver Sacks, Leroy Soper, Matthew Stadler, Dale Stenning, Judi Sterling, Jeffree Stewart, Gretchen Van Meter, Karyl Winn, and Robert Yarber.

Earlier versions of some of the material used in this book have appeared in my essay "Mark Tobey: The Dialogue Between Painting and Music," in *Sounds of the Inner Eye* (Munich: Bremen Kunsthalle; Schirmer/Mostel; Seattle and Tacoma: The University of Washington Press with the Museum of Glass, 2002), and in *The Clear Cut*

Future anthology, edited by Matthew Stadler with Richard Jensen (Astoria, Oregon: Clear Cut Press, 2002). For permission to reprint photographs, I thank Mary Randlett, Karl-Heinz Bast, Leonard Langer, Marita Holdaway, Josef Scaylea, Randy James, and Paul Dahlquist. For permission to reprint his drawing, *The Mystics,* I thank Michael Dougan. I also thank Norman Sasowsky, my traveling companion in Paris, London, Holland in 1956, for permission to reproduce his etching.

I also thank the staff of the Manuscripts, Special Collections, University Archives Division, University of Washington Libraries for their generous help and expertise in the preparation of this book.

These acknowledgments would not be complete without a very special tribute to Donald Ellegood, Director Emeritus of the University of Washington Press and my dear friend for some forty years. His death on January 7, 2003, is a profound loss for all of us who knew him. I had the extraordinary privilege of working with him as my sponsoring editor during the publication process of this book and my prior book. I had wanted to dedicate my first book and, in part, this book to him. He would not hear of it. So, my eventual next book in this planned trilogy will be dedicated gratefully and lovingly to him.

THE ACCIDENTAL COLLECTOR

Growing Pains

WHEN I WAS IN MY TEENS, I WAS attracted to three kinds of girls: those who played the piano, those who could play the violin, and, above all, those who sang, especially if they also happened to be blond and slightly plump. And so it came to pass that I met Eleanor Orr, the first of my prepubescent musical crushes. She had only one of these attributes; she could play the piano. She played it, however, with a savage fervor that could make her seem at times vaguely attractive, even though she herself was gangly, angular, and gushy.

My Aunt Edna and Uncle Clarence lived in East Moreland, a residential area of Portland just a few blocks from the Reed College campus. Uncle Clarence worked for the local telephone company in Portland. He and my aunt lived very comfortably in a large new house. He must have had a well-paying job because they never seemed to be concerned about money, even during those lean years in the national economy. Having no children of their own, they invited me to stay with them several summers during the 1940s. The summer of 1945 was particularly significant for

me. That was when I first met Eleanor. Her parents must have concluded that I was not a serious threat to their daughter's virtue; they invited me to stay with them that summer. My sleeping arrangement was in the attic and consisted of a small bed nestled under the eaves. Eleanor's room was on the first floor, next to her parents' bedroom. Any late night assignation with her would have been impossible under the circumstances, even had it occurred to me to attempt one.

Eleanor studied piano with Ariel Rubstein at the Portland Conservatory of Music. I was too inept a piano student to play duets with her. Instead, we played interminable games of two-person *Monopoly* in her parents' basement during the scorching hot afternoons. Our dates consisted of taking the bus downtown to visit the Portland Art Museum, then having an ice cream soda at a local fountain or going to a local movie, chaperoned by Eli's ever watchful parents. Despite her musical charms (she also played the clarinet in her high school band) and her talent for doing portrait sketches, I soon found Eleanor to be as unexciting as she obviously found me. She had her roving eye on the blond-haired boy down the street. He wouldn't give her the time of day. He was a street-smart little thug who ran with a gang of kids who constantly worried the parents in their neighborhood. Eleanor's mother kept urging her to forget about this guy and start going steady with me. After all, she pointed out, nobody knew anything about him or his family, whereas I had an aunt and uncle down the street who personified respectability and solvency.

A turning point came when I attended a piano recital by Rubstein's students one evening in downtown Portland.

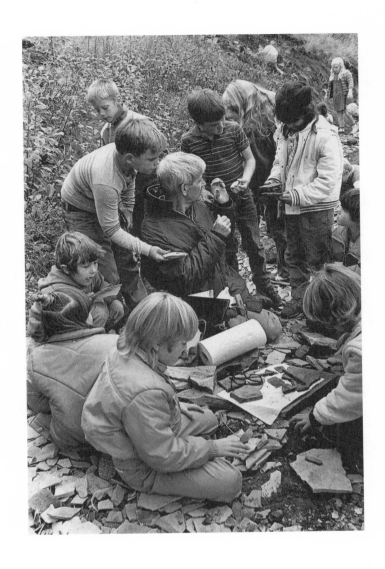

Collecting 50 million-year-old fossil flowers, fish, leaves, and insects with a grade school class at Republic, Washington, October 1986. Photograph © Mary Randlett.

Eleanor was the final performer. She entered the stage quite matter-of-factly, sat down on the piano bench, arranged her skirt, and launched into an unexpectedly passionate performance of *Malagueña*, by composer Ernesto Lecuona. I was shaken. Demure Eleanor, once seated at the piano, turned into a young tigress. She flung her head back triumphantly and smiled wickedly. Cascades of musical notes flew in all directions. Nothing about her before that evening had given me even a clue as to how possessed a creature she could become, given the right piece of music and the right instrument upon which to perform it. Eleanor brought down the house. She accepted the burst of applause calmly and walked off the stage. Some of the young boys who performed on the same program that evening suddenly became very interested in her. Eleanor usually had a vaguely lusty look in her eye, though not for anyone in particular. That look was just there, unfocused, waiting to be kindled and activated. I lay awake in my attic bed that night, wondering if I should bolt the door. Eleanor's appraising glances could be scary. But there was hardly any need for me to do such a thing. Whatever it was that the piano brought out in Eleanor, I could never strike in her such a passionate chord.

When I returned to Portland the following summer, I phoned Eleanor's house. Her mother told me Eleanor had eloped, and no one had any idea where she was. A neighborhood buddy of mine told me a quite different story. Eleanor, it seems, had fallen passionately in love with a young sailor, but she apparently was much more than that seaman could handle. He took off. And then she took off, looking for him. Or so rumor had it.

I didn't have much of a social life in Portland that sum-

mer. Instead of playing *Monopoly* with Eleanor, I tagged along with Aunt Edna and her lady friend, Judy Dalin, while they foraged at endless estate sales buying antique glassware. I quickly learned the names for dozens of kinds of brightly colored antique glass: cranberry glass, milk glass, amberina vaseline glass, ruby glass, thousand-eye, and hobnail. Just name it.

When I returned to Seattle, I was surprised by how easily I had forgotten all about Eleanor. But really it wasn't surprising. Suddenly I was hearing, seeing, encountering famous pianists, violinists, and singers, many of them glamorously beautiful. I had become an usher at the Moore Theatre, near the Public Market in downtown Seattle. Cecelia Schultz, a tall, imperious woman of indeterminate age, was both owner and manager of the theatre. Her concert series was remarkable. The world's greatest performers appeared on her stage: pianists Sergei Rachmaninoff, Artur Rubinstein, Vladimir Horowitz, José Iturbi, and Claudio Arrau; violinists Yehudi Menuhin and Jascha Heifetz; singers Grace Moore, Rose Bampton, Miliza Korjus, and Maggie Teyte. Cecelia Schultz brought them all to Seattle.

A high school friend of mine was an usher at the Moore Theatre. He told me that if I wanted to attend concerts without having to buy a ticket I should become an usher and work for Mrs. Schultz. He introduced me to her. At first she seemed formidable and very businesslike. I'm sure she could be a tough old bird when she needed to be. But she also had a disarmingly friendly side. All in all, I really liked and respected her. She asked me a lot of questions, wanting to know how much I knew about music and musicians. She seemed satisfied with my answers and hired me.

As an usher I was paid $1.25 for each concert. After the audience was seated, Mrs. Schultz let me sit in an empty seat during the performance. Sometimes she had me deliver messages to her backstage crew. If she was especially fond of the concert artist who was performing that evening, Mrs. Schultz even had me deliver flowers to the performer's dressing room.

A poster announced that Viennese operetta star Miliza Korjus would appear in concert at the Moore Theatre. She was blond. She was plump. And she sang! The evening that I was to usher for her concert, I armed myself with a bouquet of flowers from my parents' backyard on Magnolia Bluff, slipped backstage to her dressing room, and tapped on her door.

"Come in," chirped a cheery voice, unmistakably Viennese.

"Miss Korjus," I said haltingly. "I wanted to bring you some flowers before you sing tonight, because I'm sure a lot of people will be bringing you flowers after you have sung!"

"Oh, how very sweet of you," she exclaimed, kissing me lightly on the cheek.

Miss Korjus was world-famous for her high notes, those stratospheric musical moments that always brought down the house. The evening's concert was charming enough as she sang one after another aria to enthusiastic applause. But it was the high notes we were all waiting for, *her* famous high notes. Miss Korjus knew how to keep us in great suspense. Not until well into the concert did she finally sing "Voices of Spring" by Johann Strauss, the song that had made her reputation. The entire audience leaned forward, intense, eager, expectant. But when she reached for her

champagne glass–shattering high notes, something went wrong. There was a gasp from the audience. Miss Korjus had momentarily lost her voice just as she reached for her musical climax. With unperturbed grace she looked at the audience, grinned, shrugged her shoulders, and nodded to the pianist to play the passage once more, starting at the beginning.

The perilous moment came again. This time Miss Korjus not only hit the high note dead center. She caught her breath and hit it twice! The audience went wild. They applauded her. They cheered her. They rose to their feet. She smiled mischievously and pranced off stage, coming back for many curtain calls. Miss Korjus had turned a near disaster into a musical triumph. I knew then and there that I had a lot to learn from people such as she.

I soon figured out a way to skip class during the afternoons. I signed up for a class in journalism and asked our journalism adviser, Carolyn Barclay, if I could do interviews for our Queen Anne High School weekly newspaper, *The Kuay*. Armed with a note from Miss Barclay, I was allowed to go downtown during the afternoons, attend matinee performances, and interview visiting performers. They were often more receptive before a performance than they were in their dressing rooms after a long concert.

I began to work as an usher at both the Moore Theatre and the downtown Metropolitan Theatre, which was in the space now occupied by a drive-through parking lot for the Four Seasons Olympic Hotel. I interviewed the original Count Dracula—Hungarian actor Bela Lugosi—backstage at the Metropolitan Theatre. In his dressing room, taking off his makeup as I interviewed him, his deep, almost menacingly resonant voice was still that of Count

Dracula. He himself, however, did not seem at all fright-
ening as he patiently answered my insipid questions. I was
fascinated by the ability of these performers, who often
seemed so colorless off stage, to hold an entire audience
spellbound as they assumed another identity.

The following year, I interviewed the starring cast of
Shakespeare's *Othello*—Paul Robeson, Jose Ferrer, and Uta
Hagen—while they were in the midst of a heated argu-
ment in the tiny dressing room they shared backstage. Each
of them patiently answered my questions as I interviewed
them in turn. Then each of them would go back to what-
ever it was they were arguing about. This was all very
strange for me. After all, I had just watched the three of
them on stage, speaking the King's English with such elo-
quent diction and style. But the language Mr. Ferrer and
Miss Hagen were using with each other was not at all ele-
gant. Mr. Robeson kept his dignity while petulant tempers
flared around him.

Some weeks later I interviewed Brazilian soprano Bidú
Sayão at the Metropolitan Theatre. Sitting quietly in the
corner of her dressing room was another woman. She was
knitting. I assumed she might be Miss Sayão's traveling
maid. But it was Miss Sayão herself who bewitched me.
I thought she was the most beautiful woman I had ever
seen in my life. She spoke very softly. There was a gentle,
almost affectionate, quality to her voice. She did not in
any way seem to be an "opera star," let alone a tempera-
mental prima donna. She didn't seem hurried or dis-
tracted. So many other opera stars I interviewed during
the following years were very kind to me, but most of them
usually seemed stressed out.

Miss Sayão asked me if I were a music student. When

I told her that I wrote pieces for the piano, she was delighted. "Another composer, my dear friend Mr. Villa-Lobos, has just written the loveliest music for me to sing." She began to sing a few of the opening bars of Villa-Lobos's *Bachianas brasileiras No.* 5 for soprano and cello ensemble. It is one of the most rapturous vocal works in all of twentieth-century music. For a star-struck teenager—for anyone—to hear it sung thus, by a singer as beautiful as Bidú Sayão, was an experience beyond imagining.

"Perhaps *you* will compose something for me to sing someday," said Miss Sayão, shaking hands with me. As I started to leave, she added, "If you do write a piece of music for me to sing, why don't you come visit me in Brazil and we will go over it together!" I stumbled out of her dressing room, silently knowing that whether I ever saw her again or not, I would surely love Miss Sayão forever. My parents were parked outside the Metropolitan Theatre, waiting to take me back to our house on Magnolia Bluff. It was clear to them in a glance that I was hopelessly stagestruck.

Actress Diana Barrymore was the daughter of actor John Barrymore and the niece of actors Lionel and Ethel Barrymore. Her family was the reigning family of the American stage. She had just embarked upon a career of her own when she starred in a nondescript play at the Metropolitan Theatre. The play never went anywhere, and her performance was surprisingly wooden. I attended a performance mostly to find out what sort of actress she might be, considering her family background. Interviewing her was not easy. She was feisty and distracted. Even though she was only then in her early thirties, I asked her, "Miss Barrymore, have you written your autobiography?" This

question took her by surprise, and it annoyed her. "My autobiography? Just how *old* do you think I *am*, kid?" she responded. But she thought about it for a moment. "I was too quick to snap at you that way. Come to think of it, you just might have something there." She gave me a sharp, hard look. "God knows I've already been through a lot in my life, and it's quite a story, let me tell you!" Several years later, her autobiography appeared at the local bookstores. It was entitled *Too Much Too Soon*. She died a few years later.

I interviewed Spanish dancers Antonio and Rosario. On stage their flamenco dancing was fiercely confrontational, like two cobras about to strike each other. But in their dressing room backstage they were more like two beautiful young lovers, laughing and playful. Antonio even suggested I visit them in Madrid in a few years, when I was a bit older. These transformations that took place when performers left the stage and became more like everyday people never ceased to amaze me. At times it almost seemed that, in order to be a great performer, one might have to suppress one's daily personality, confining one's theatricality to the stage.

German pianist Walter Gieseking gave a concert at the Civic Auditorium at the later-to-be Seattle Center. When he played Debussy I became oblivious to the large and drafty auditorium and the bleakness of the winter night outside. The impressionistic colors of Debussy's music suffused the auditorium and audience. He also played several very familiar works by Brahms and Beethoven that evening. Under his hands, however, these works had prismatic colors I had never heard in them before. Was Gieseking a pianist? He seemed at times more like one of

the great French Impressionist artists, painting in pure sound.

Virtuoso pianist Vladimir Horowitz also performed at the Civic Auditorium. He was famous for his piano transcription of John Phillip Sousa's *Stars and Stripes Forever*. This demonically difficult piece was a piece of cake for him, one that he polished off almost gleefully. After the concert I joined the crowd of people backstage. He was in a small dressing room, meeting fans queued up for his autograph. Standing next to me at the edge of the crowd was a dignified, handsome man, wearing a heavy topcoat. I turned to him and asked, "Do you collect autographs, too?"

"As a matter of fact, I do own a number of autographs," he answered with a bemused smile.

At that moment Horowitz glanced past the crowd of people now surrounding him and spotted the man standing next to me.

"Szigeti! *You* are here!" he said, quickly making his way through the crowd to embrace this man beside me. This unassuming man turned out to be Joseph Szigeti, one of the greatest violinists of our time.

MY SO-CALLED JOURNALISTIC career as a newspaper interviewer nearly came to an end when I interviewed Yvette Dare at the Palomar Theatre in downtown Seattle. This was no concert hall. This was Seattle's only vaudeville theatre. Miss Dare advertised herself as a "specialty artist." My high school pals called her "one classy stripper."

Miss Dare had a daringly original vaudeville act. She had trained her pet parrot, Pierre, to swoop down from the stage wing just as she was finishing one of her tantalizing

song and dance routines. Perched on Miss Dare's shoulder, Pierre would pick and peck at the shoulder-strap knots on her ornate gown until it began to slip to the stage floor. Meanwhile, a solo musician in the orchestra pit, an unlit cigarette in his mouth, performed a quickening, muffled drum roll. At the exact moment when Miss Dare's gown fell to the floor, the stage lights went dim, leaving the rest to my gawking, overactive imagination. Miss Dare, my high school pals and I agreed, really had "class."

After the performance I made my way to Miss Dare's dressing room, while the stagehands winked knowingly at each other.

"Miss Dare's dressing room is right down that hallway. Good luck, sonny!" said one of the stage men.

Backstage, in her dressing room, I discovered a very different woman than I had imagined. The off-stage Miss Dare was not only "stacked" (as my school pals described her); she was well read, well traveled, and she was great fun to talk with.

She shook hands with me very properly and offered me a cup of tea. I began to interview her. She told me she was attending a university in southern California and that her performances were a way of putting herself through college. I duly wrote up my interview with Miss Dare. The student newspaper staff published it in the *Kuay*. Our journalism advisor, Miss Carolyn Barclay, was ill with a cold that week and not present to supervise the newspaper's contents.

The interview caused a stir around school, especially among the boys. Had I really met her? What was she like "up close?" For a day or so I was something of a celebrity.

I was summoned to the office of principal Otto Luther.

He was an elderly man (or so he seemed to me at the time) with white hair, horn-rimmed glasses, and a kindly but authoritative nature. He took me sternly to task, telling me to be more selective about which celebrities I interviewed in the future. When he saw me to the door and saw how scared I was, Mr. Luther patted me benignly on the shoulder.

"By the way," he said. "Your story made pretty good reading. But don't you ever tell anyone I told you that!"

Rites of Passage

URING THE 1950S, THE KENNEDY
Building on University Way was a crossroads for
artists, writers, and musicians. Portrait painter Jan
Thompson had an apartment there, where such painter
friends of hers as Morris Graves, Richard Gilkey, and Ward
Corley often came to see her. Painters Guy Anderson,
Helmi Juvonen, and Jack Stangl appeared at the Kennedy
Building regularly. Painter Virginia Banks and her husband
had an apartment and studio there. They were good
friends of Mark Tobey, who came to see them frequently.
Such poets as Richard Selig, James Wright, Theodore
Roethke, Richard Hugo, and Kenneth O. Hanson often
showed. Pianists could be heard practicing down the hall.
Finally, there was "The Swami," a tall, mysterious African
American gentleman who wore a turban, had a painted-
on moustache, and rarely spoke to anyone.

Mark Tobey's companion, Pehr Hallsten, had a small
room on the second floor, facing University Way. He read
there during the day, so that Tobey could have some pri-
vacy while he painted in the house he and Pehr shared up

the street. Helmi Juvonen regularly dropped by to see Pehr. She even encouraged him to try his hand at painting. His first painting depicted the rooftops he saw across University Way from his window. His next paintings began to draw from the world he had known as a child among the Laplanders in northern Sweden. They were filled with trolls, reindeer, sorcerers, and many-colored Nordic sunsets.

The Kennedy Building was ideally located in the very heart of the University District. It was only a block from campus. It was next to the post office. And just down the street was the Coffee Corral, an all-night restaurant. There were also a few drawbacks to living at the Kennedy Building. For one thing, there was only one bathroom on each floor, unless you were able to afford an apartment. And there was only one public telephone. It was just across the hall from my room. Late at night I would have to answer the phone's relentless ringing. One night it was an urgent male voice saying he had to talk to "the Doc"—in room 209—"fast!"

Weaver Jack Lenor Larsen had a room on the second floor. His visible possessions seemed to consist mostly of a bed and a loom. When I first visited him he was weaving place mats and selling them for $1.25 each. During October 1950 he moved to New York, soon to become a leading figure in textile design. Upon his departure I moved into his former room.

One cold and foggy October evening I heard a knock on my door. When I peered into the dimly lit hallway, I saw a nice-looking young man, perhaps a student, standing there. He was dressed like an Englishman, duffle coat with horn toggles and a visored cap. He looked startled.

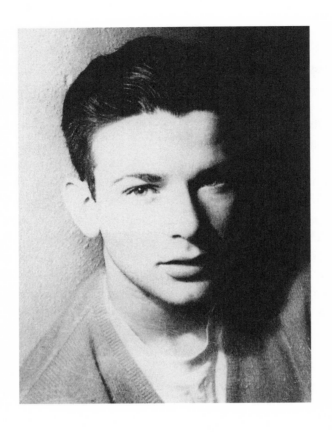

In La Jolla, California, with painter Robert West, April 1951,
en route to Ensenada, Mexico. Photograph by Robert West;
collection of the author.

"Who are *you*?" he asked.

"And who are *you*?' I responded.

"I'm Bob West. I'm a friend of Jack Larsen. I came to pick up the bed I stored with him. Do *you* have it?"

The only bed I had now was my own pull-down one. I had no idea where this stranger's bed might be.

When this young man noticed the upright piano in my room, I explained that I was a music student, a composer. I invited him in. He told me he was a painter, studying architecture at the University of Washington, and that he'd recently moved to Seattle from Tacoma, where he'd done a year of college. We talked for a little while. Neither of us had yet had dinner, so we walked up University Way to a Chinese restaurant. It was called Lun Ting's, but we students called it "The Tin Lung." It was at that time the only so-called exotic food to be had on University Way. Otherwise, one went to the International District in downtown Seattle.

This is wonderful, I thought to myself over dinner. He's a painter, I'm a composer. He's nineteen, and I'm twenty one. I've finally met someone my own age, and a fellow artist! The other painters I knew—Mark Tobey, Morris Graves, Guy Anderson, Pehr Hallsten, and Helmi Juvonen—were considerably older than I, by twenty to forty years. Lockrem Johnson was the only composer I saw much of, and he was all of five years older than I. When one is as young as I was then, a difference of only a few years can seem considerable.

Bob West and I took an immediate fancy to each other and became good friends. Bob lived on a houseboat at the time we met. We later shared a small apartment a few blocks away from the Kennedy Building. Our painter, poet,

and musician friends dropped by regularly. My life had become classically Bohemian. Things happen fast when one is young.

I had never had a roommate before. As luck would have it, he was bright, good-natured, and could cook a bit. What he considered to be a typical meal was gourmet cooking in my eyes. He knew how to cook three dishes: chili, pea soup, and cheese souffle. My ability to cook was limited to a quickly heated can of pork and beans, or a few scrambled eggs and a stack of heavily buttered toast with gobs of peanut butter and jam. I was an only child and a bit of a loner, so living with Bob was my introduction to how pleasant it could be to live with someone, especially when each of us already knew exactly our mission in life. He was a painter, and I was a composer. We didn't have to waste time on identity problems. Too many of my other young friends were squandering their lives trying to decide what they should be or become.

To pay our bills we took weekday jobs. Bob worked as a psychiatric aide at the Pinel Foundation, where poet Theodore Roethke was occasionally hospitalized. I worked as a dishwasher and busboy at Manning's cafeteria on University Way. A full-course dinner cost 95 cents there. Our apartment rent was $37 a month. That doesn't seem like much now, but even then we had to be frugal. After all, a Mark Tobey drawing of a Seattle Public Market figure cost about $20. One of his abstract paintings cost a few hundred dollars at the prestigious Willard Gallery in New York, where painters Morris Graves, Loren MacIver, and Lyonel Feininger, and sculptors David Smith and Philip McCracken also exhibited their works.

We settled into a comfortable daily routine. I composed

music on a rented upright piano that filled most of our kitchen. I had not realized until then that I had a dormant domestic streak. It was unexpectedly enjoyable to do ordinary household things with someone, or with this young painter at least—to shop together, cook dinner, do the dishes, and do laundry. In the evenings, if we weren't too wiped out from our jobs, we sometimes went to a movie at the Varsity Theatre, or went to a concert or lecture on the campus. Otherwise, we stayed home, he painting, I composing, or we listened to classical music.

Philosopher Susanne K. Langer would phone me in the morning, inviting me to go beachcombing at Golden Gardens with her, or to the Woodland Park Zoo for a picnic. Fellow poets Richard Selig, James Wright, Lloyd Parks, and Albert Herzing dropped by to try out their latest poems. I sat in on Roethke's poetry classes now and then. After class I'd go out for coffee with Richard Selig, Carolyn Kizer, or James Wright. A violinist would come by to try out a new piece of music I was composing. Or composer Lockrem Johnson, who was briefly in town from New York, would go through something I was working on and make suggestions on how to improve it.

Our luxuries included an evening pastry and coffee at the Bon Ton pastry shop on University Way. One evening, while Bob and I were having dessert there with him, Morris Graves took a carpenter's pencil from his coat pocket. He began covering the Formica tabletop with elegant groups of bird drawings, until the entire table became a Gravesian aviary. Mr. Hannis, the proprietor, was incensed. He told us to sit at a different table while he wiped our tabletop clean with Dutch Cleanser. Even though he wouldn't put up with such antics by us local artists, he realized we were

among his steadiest customers. Morris seemed amused by this brusque rejection of his artistic abilities.

Tobey dropped by now and then, sometimes while Bob was working on a new painting. Tobey arrived one evening, and stood watching Bob paint. Covering part of Bob's painting with his hand, Tobey said, "*Here's* your painting. Just trim off this side of it and it comes together quite nicely!" I had already observed Tobey do this with his own work. In his studio I'd seen works of his on which he written in faint pencil line, "Trim here." Tobey himself had no set way of working, or of ending up with a "Tobey" painting.

In a 1976 *Northwest Arts* article, Johanna Eckstein, Tobey's good friend and art patron, related a typical story about him: "One day I arrived at his Brooklyn Avenue house and found him on his knees by a wastepaper basket. When I inquired what he was doing, he explained that he had become so dissatisfied with a LARGE painting that had not gone well that he tore it up. At that moment he arose triumphantly with the fragments in his hands and said, 'Look! Four beautiful *small* paintings!'"

One evening, Bob suggested he give me a few drawing lessons. I had never drawn from the model before. After the dinner dishes were washed and put away, we sketched each other, using dark red conte crayon. Bob's figure drawings were elegant, and mine were predictably inept. But over several drawing sessions I improved a little.

Being an opportunist, I took a portfolio of our studies of each other to Tobey for criticism. While he was going through them, Pehr came into the room from the kitchen and started examining them very carefully. "Mark, these two boys have nice-looking bodies! Why don't you hire them to pose for you? I'm sure they could use the money.

You could even do some quite sexy drawings of them together." Mark glanced sharply at Pehr and changed the subject. He was by now almost resigned to this side of Pehr.

Tobey liked Bob's figure drawings, but my own looked as if the figures had no bones or any underlying skeletal anatomy. The limbs were vaguely drawn. The drawings had no vitality at all. I had not been drawing enough from the model. That was only one of many things that were wrong with my drawings. Tobey studied them for a while, and began to point out their other weaknesses to me. "Look at how you've drawn the elbows and knees," he said. "You ignore them, as if they don't exist. You should accentuate them. They're what give the body its interesting angularities. Elbows and kneecaps are like musical accents. They give a figure drawing its sharpness and vitality."

Tobey sometimes used a musical analogy when he discussed a painting or drawing with me. For instance, one of his technical problems in painting was that he "not let the accent detach itself from the picture plane."

"You're a musician," he explained. "You would understand this. When you use musical accents, they can't be too sharp. And they can't be too soft. If they're too harsh they destroy the musical texture. If they're too soft they don't lend the necessary energy to the music.

"When you accent *anything*, you have to know *exactly* how strong that accent can be without its standing out too much. It's the same with accents in music. They have to have *just* the right musical weight. I like playing the piano in the morning before I go to my studio to work, trying to control the legato in a piano piece. But, mind you, you should develop your technique expressively."

When I recall those few years now, I realize they were

happy, pleasant and productive years. They were what Theodore Roethke called "the salad days" of being young.

GERTRUDE PECK, my paternal grandmother, who had a succession of husbands, moved from her farm at Lake Stevens, Washington, back to Los Angeles during the late 1940s. She often sent me checks to help with my tuition and rent. In 1951, she invited me to visit her. I wrote back that I didn't want to make such a long trip alone, that it would be nicer if my roommate accompanied me. A check for several hundred dollars arrived the next week. The non-stop bus trip from Seattle to Los Angeles was an awful experience. Our rest and meal stops were frantically brief. We had barely enough time to place an order for food to go, then jump back on the bus with it, spilling our food and coffee along the way.

Only one vivid image remains for me from that long, tedious bus ride. We stopped late one night, perhaps around midnight, at a roadside cafe in Weed, California, where Bob had lived as a child. We stumbled off the bus, half asleep. Behind the cafe, towering above us in the moonlight, was Mount Shasta, a slumbering volcano at what had once been the ocean's edge some forty million years ago. Its luminosity was like one of Morris Graves' mystical paintings, where light becomes a spiritual revelation. Or was it like that translucent light in the center of the moonstone agates I used to find after winter storms on the Oregon coast? Or then again, was it like . . . ? I finally had to stop making any more strained similes and metaphors. None of them could begin to describe the unique presence of this eerily godlike mountain.

I stood contemplating Mount Shasta in the moonlight.

Caught up in its spell, I forgot all about that overcrowded, poorly ventilated bus awaiting us in the parking lot. I forgot about all those whining children in the bus, kids who never for a minute stopped crying. I forgot about my having to wait in line for the restroom at the far end of our Greyhound bus as it swayed from one side to the other while speeding down the highway.

The night air was damp and chilly. Scattered patches of moonlight on the cement. People inside the restaurant eating, talking. A man standing under a tree, smoking a cigarette. The sound of the bus's idling engine. The faint smell of gasoline in the night air. The headlights of an automobile headed south. And rising above all of these ordinary things was the dormant volcano—self-contained and sphinxlike in its towering silence.

I heard our bus driver telling us to get back on the bus. He said we were twenty minutes off schedule. But that was all right, because I had just had a bittersweet glimpse of eternity, and of how fleeting and lovely a thing a life can be. I think I know now what that mountain was obliquely conveying to me as I stood looking up at it. I think it was the same message I sometimes hear now as I gradually discern the profile of my own death: "If you don't enjoy this brief life of yours, you're a damned fool."

We arrived in Los Angeles the following evening, exhausted from travel. My real introduction to Los Angeles began the next morning when I saw all the ornamental palm trees and yucca plants around my grandmother's house. Where were the towering cedar and pine trees, and the rhododendron, blackberry, and salmonberry bushes? In the backyard, where I would have expected to see an apple tree, grew trees laden with lemons and limes. When

I went to the kitchen sink to get a drink of water my grand-mother stopped me. Drinking water didn't come from a faucet in Los Angeles. It came from a large container of bottled water in the corner. After the northern temperate vegetation to which I was so accustomed, this southern California flora was alien to me. It was as if I had been abruptly transported to another planet.

My grandmother and Bob took an instant, undisguised dislike to each other. Our stay with her was miserable. We ate our meals glumly and made excuses to go back to our tiny guestroom. Each morning we finished breakfast quickly, caught the next downtown bus, and headed for the nearest museum or tourist sight.

The Henry Huntington Library and Art Gallery at San Marino was a high point. We saw an original copy of the Gutenberg Bible, a fifteenth century copy of Chaucer's *Canterbury Tales*, a 1623 First Folio of Shakespeare's plays, and the handwritten manuscript of Benjamin Franklin's autobiography. For the first time, we could see original paintings by van der Weyden, Constable, and Turner. There were also some famous paintings at the Huntington: Gainsborough's *The Blue Boy*, Lawrence's *Pinkie*, and Reynolds's *Sarah Siddons as the Tragic Muse*. These were paintings I had known from reproductions on the walls of my grandparents' house on Camano Island. There was noth-ing like this to be seen anywhere in Seattle during the early 1950s. The Seattle Art Museum had its great collections of classic Japanese and Chinese art. But works by the great European artists were few and far between, until the Samuel H. Kress Foundation in 1939 gave the museum a small but lovely collection of works by the old masters.

We attended a performance of *The Turn of the Screw*,

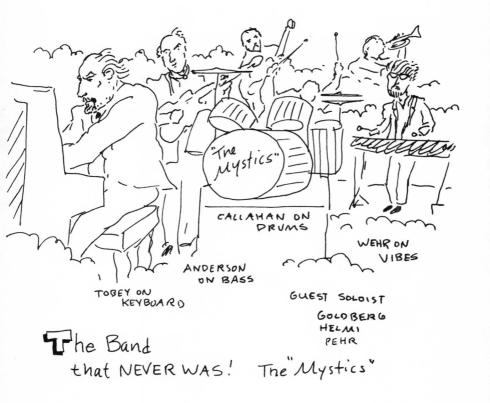

Cartoon labels:
"The Mystics"
CALLAHAN ON DRUMS
WEHR ON VIBES
ANDERSON ON BASS
TOBEY ON KEYBOARD
GUEST SOLOIST
GOLDBERG
HELMI
PEHR

The Band that NEVER WAS! The "Mystics"

"The Band That Never Was: The Mystics." Mark Tobey
on the piano, Guy Anderson strumming his guitar, Kenneth
Callahan on the drums, Morris Graves in the distant woods
playing his double bass, and Wes Wehr playing the vibes.
Guest artists included Helmi Juvonen, Pehr Hallsten, and
Joseph Goldberg. Guy Anderson disliked my newly grown
beard so much that I shaved it off. Cartoon by Michael
Dougan; Wes Wehr papers, MSCUA, University of Wash-
ington Libraries, UW22204.

starring veteran actress Silvia Sidney. (I had forgotten this until Bob reminded me recently while we were comparing memories of our trip together.) We also went to Knott's Berry Farm, on the outskirts of Los Angeles. It was a relatively small place then. Mostly I remember the trough where, for a price, you could pan for gold. And if you didn't find any you could buy a small vial of gold in the gift shop. I think they were flakes of gold leaf, rather than placer gold.

DURING THE 1950S, Los Angeles was home to two reigning titans of contemporary music: Viennese-born composer Arnold Schönberg, and Russian-born composer Igor Stravinsky. While I was a high school student, I wrote to Arnold Schönberg, asking for his autograph. He promptly responded, sending me a small piece of paper on which he inscribed the opening bars of an unidentified piece of music. Below the music he wrote: "Many people who call themselves 'great admirers' of my music do not know one note of it. That is why I wish to ask if you can identify the piece from which this is a quotation? Sincerely, Arnold Schönberg."

By sheer luck, the Seattle Public Library music department had just received a printed score of Schönberg's recently composed *Piano Concerto*. The musical quotation he had sent to me was from the opening five or six measures of this work. In my awkward scrawl I wrote him back, telling him that I did recognize this music. Several weeks later a second musical communication arrived. This time Schönberg had written out by hand several more musical passages and added another personal note: "Dear Mr. Wehr, It was not maliciousness or vanity that caused

me to include those words to you, but rather a kind of res-
ignation. Now it is a pleasure for me to realize I was wrong.
Sincerely, Arnold Schönberg." With a little patience I was
able to identify these passages from *Transfigured Night* and
a 1924 work of his, and write to him again.

Having received such a gracious note from Schönberg,
I wanted to meet him, if even briefly, while I was in Los
Angeles. Amazingly enough, his telephone number was
listed in the local directory. When I phoned him at his
home, Mrs. Schönberg answered. I told her I was a
music student from Seattle. She could not have been more
cordial: "I would invite you to our home to meet Mr.
Schönberg, but he is not feeling well at the moment. If
you are still in Los Angeles several days from now, per-
haps he may be able to receive company. Could you please
phone us back later," she said. I explained that Bob and
I had to leave soon for San Francisco. It was fortunate
that I never did manage to intrude upon Schönberg. He
would have realized instantly what a waste of his time I
was. I learned later that he was not one to suffer fools
gladly.

Schönberg must have saved most of his incoming cor-
respondence. Some of the letters I wrote him during 1947
are now in the Schönberg archives in Vienna, accompa-
nying those of Austrian composer Anton Webern and my
friend, New York composer Ben Weber. Perhaps even the
manuscript of the rambling little piano piece I dedicated
to him is also there.

Bob and I went to the Los Angeles County Museum
of Art, the Watts Towers, and Grauman's Chinese Theatre.
We visited harpsichordist Alice Ehlers, who had given a

recital at the University of Washington the year before. Wilhelmina Creel, my music counterpoint teacher, had written a letter of introduction for me to Los Angeles composer Halsey Stevens, who had just published a biography of Hungarian composer Bela Bartok. Creel had studied piano with Bartok and music counterpoint with Hungarian composer Zoltan Kodaly in Budapest when she was a young girl. When I talked briefly on the phone with Bartok's son, Peter, during the 1980s, he told me what an impression it had made upon his father that this young girl would come all the way to Budapest to study with him. This was the beginning of a close friendship between Bartok and Creel that lasted until Bartok's death in New York in 1945. Creel was at the hospital when Bartok died.

While we were exploring shops in Los Angeles, Bob and I saw some Chinese and Japanese carvings and bronze pieces in a shop window. The old woman who ran the shop spotted us through the window and waved us into the shop. We told her that we liked Asian art.

"Come with me. I'll show you something very special. Things I don't show just anybody," she exclaimed. Unlocking a door at the far end of her shop, she took us down a flight of steps into a room lined with glass wall cases. She unlocked one of the cases and took from it a Chinese-looking bronze vessel that had a lovely green patina.

"*This* piece is very special. It is very old. It has been in my family for a long time. *You* should have it now, because I can tell that you two young men appreciate fine old art."

When we got to San Francisco, an art dealer at Gump's department store told us it was only about fifty years old.

"How much did she charge you for it?" he asked us.

"Fourteen dollars," we answered.

"That's just about what it's worth," he told us.

I'D VISITED LOS ANGELES only once before, in 1935, with my parents when I was six years old. We'd again stayed with Grandmother Gertrude. She moved about and was the marrying kind, so I won't even try to recall some of her ephemeral surnames. Monogamy was more characteristic of my mother's side of the family, the Norwegian branch of the family tree. One of Grandmother Gertrude's husbands, a man in Everett, Washington, lasted only long enough for me to play a single game of pinochle with him. After that, the family never spoke of him. I realized early on that it was best I not ask too many questions about murky areas in my family's history.

William K. Peck, another paternal grandfather, served on the board of the Al G. Barnes Circus. Grandpa Peck was a wiry little man who collected antiques by the carload, some of which he exhibited at the Chicago World's Fair. When the circus came to Seattle, he arranged for my parents and me to go behind the scenes where we met the bearded lady, the heavily tattooed snake charmer, and a troupe of Czechoslovakian midgets. The midgets gave me several of their tiny metal chairs and a matching table as a memento of my visit with them. When I got them back to my house on Magnolia Bluff, my father painted both the table and chairs an awful kind of bright green. Even though that particular color almost gives me a migraine now, it was a color I liked at the time. Maybe it reminded me of the color of the Texaco Company gas signs at the service station my father ran near the south end of Lake Union.

I treasured those little chairs and that wobbly table.

But then I met a red-haired girl who lived just down the street in our neighborhood. She made it very clear that if I wanted to be in her good graces I'd better give her that furniture. I found it hard to say no to her. But a month or so later she and her family moved out of the neighborhood, taking my beloved treasures with her. After that I was much slower to be so easily bribed by such greedy little hussies.

Grandpa Peck continued to introduce me to other people besides the Czech midgets, the bearded lady, and the tattooed snake charmer. He was surprisingly well connected in the most unlikely ways. Cowboy Tom Mix's circus arrived in town. Grandpa Peck introduced me to Mix, who put me beside him on his horse. Together we went horseback riding around the circus grounds. Mix even inscribed a photograph to me personally. Several of my playmates were soon after me to put my Tom Mix picture up for stakes in a back alley game of marbles. But I had learned a good bit by then about the dangers of a gambling streak. I had come to the wary conclusion that the only so-called free lunch was not the sort of food I wanted to taste.

My 1935 introduction to Los Angeles had been very theatrical. I went with my parents to the revivalist temple of evangelist Aimee Semple McPherson. We stood on a small balcony watching her troupe of young women, glittering in spangled blue and white uniforms, spinning their batons and dancing on stage while donation plates were passed in the audience. A woman on stage announced over a microphone: "The Lord does not like the sound of loose change. He likes the sound of paper money." I didn't understand what all of this had to do with religion, especially after my visits to the more staid services at the Stanwood and Seattle Lutheran churches.

The star of the show, Aimee Semple McPherson herself, was nowhere to be seen that evening. The official explanation was that she was in a spiritual retreat in the nearby Channel islands. The local gossip had it that she was having a torrid fling out of town. When she did reappear later, the explanation was that she had been abducted. This was my introduction to religion Los Angeles-style.

Several days later we took an excursion boat to Catalina Island. The boat had a glass bottom. The tour guide pointed out the flying fishes to us. I didn't think they flew very high at all. They just jumped out of the water now and then. As we were passing one of the Channel islands, our guide pointed out a small cabin on the nearby shore. It was half concealed by a small grove of scrub oaks. Over the tour boat's loudspeaker system, the boat pilot announced to us: "Ladies and gentlemen, I have it on very good authority that Aimee Semple McPherson at this very moment is in that cabin over there having the time of her life."

WHEN I RETURNED TO LOS ANGELES with Bob in 1951, it was a much more complicated experience. After several strained days of staying with my grandmother, we headed south on a another crowded bus. By that afternoon we had taken a hotel room on the main street of La Jolla, changed into our swim trunks and were at the nearby beach cove, basking in the southern California sun. The darkly tanned sunbathers around us were dressed so skimpily. If we had worn similar bikinis on a beach in Seattle during those years, we probably would have been asked to leave. But in La Jolla such apparel seemed to be the norm.

We collected shells on the beach and found live abalone on the rocks at low tide. These seashells were not

at all like those we found on the Washington and Oregon coast, where we were used to collecting clam, oyster, and moon snail shells. The southern California oceans contained tropical cowry, cone, and olive shells that washed up on the beaches.

We bought mangoes, guavas, and bananas at a local market, fruits that don't grow in the Pacific Northwest. The cherimoya fruit we bought from a fruit vendor was utterly new to me. Bob told me its white pulp would taste just like vanilla ice cream, and it did. I thought it the most delicious, exotic thing I had ever tasted. For dinner we ate fresh fruit, cheese, and French bread from the local bakery.

La Jolla was a sleepy place in 1951. The beach cove was next to tall cliffs where the pelicans roosted. We watched them swoop down to the water to catch fish from time to time. There was a sea cave you could visit. In previous years I had collected ten-million-year-old fossil sand dollars in the beach cobbles near Seal Rocks in San Francisco. Walking along the beach at La Jolla I found fossil shells in the sandstone outcrops at the water's edge.

When I was young, I had no inkling that in time I'd become a paleontologist. But everywhere I went I came upon traces of ancient life. I encountered them in natural history museums, in tourist shops, among the surf-polished agates on the sandy beaches of the Oregon Coast, or as glistening chips of fifteen-million-year-old opalized wood scattered among the sagebrush in the eastern Washington desert. These artifacts of eons ago were constant reminders that no matter how immediate the present might seem to me, it was only a flickering instant in the ongoing continuum and flux of all things great and small.

The Scripps Oceanic Institute lay just beyond the north

edge of La Jolla. We walked there along the perilously steep sea cliffs. There was little if any beach below. We went to a house perched on a high bluff to ask for directions. It turned out to be the home of Dr. Jonas Salk and his new wife, the painter Françoise Gilot. She had been Picasso's companion for many years. Her autobiographical account of her years with Picasso records, among many other fascinating episodes, Picasso's conversations with painter Henri Matisse. Their conversations contain some of the best observations on art that I have read.

Southern California seemed to attract the most unlikely people during the first half of the twentieth century. In addition to all the glamorous movie stars, world-renowned writers Thomas Mann, H. G. Wells, Christopher Isherwood, and Aldous Huxley also lived there. Composer George Gershwin played tennis with Arnold Schönberg in Beverly Hills. Pianist Sergei Rachmaninoff lived in Hollywood, and singer Lotte Lehman taught at the Santa Barbara Academy of the West.

As Bob and I were walking back to downtown La Jolla from the Scripps Institute, Bob turned to me and said, "Let's go to Mexico! It's not far from here. Do we have enough money left for that?" I phoned my parents in Seattle, and they wired us money. By the next morning we were solvent again and on a Greyhound bus headed south. By nightfall we were in San Diego, spending a sleepless night in a cheap hotel. Our room reeked of stale cigarette smoke and some kind of disinfectant. The walls were thin. In the next room a drunken couple argued loudly most of the night, stopping now and then for another round of groaning, labored sex. Their so-called lovemaking did not sound at all romantic to me. It sounded more like grunting pigs.

We took a bus to Tijuana early the next morning. It was a dusty, crowded tourist trap. The street vendors were aggressive, trying to sell us things we didn't want. In the far corner of the local magazine shop stood a battered old glass case that contained a few probably fake Mexican artifacts and a frayed copy of Henry Miller's *Tropic of Cancer*. The cynical looking proprietor took the book out of the case but wouldn't let us handle it. In a conspiratorial whisper, he said, "This is a real *dirty* book. How do you say it? A por-no-*graphic* book! You can't get this book in your country. I can sell it to you cheap!" He watched our eyes carefully. Did we seem excited? Would we take the bait? How could we ever explain to this sleazy man that back in our student rooms in the University District we cut our baby teeth reading this sort of erotica. Anaïs Nin, Djuna Barnes, Paul Bowles, and Jean Genet were the patron saints of our vicarious forbidden pleasures. These were the books we devoured late at night after we had soon outgrown the tamer books by Evelyn Waugh, Aldous Huxley, and Christopher Isherwood. Bob and I must have looked like mere babes in the woods to this shopkeeper.

We wanted to get out of Tijuana as fast as we could, let alone spend a night there. Bob saw a local bus on the corner. People were boarding it. It was headed for Ensenada in northern Baja. Our bus was a rickety vehicle, loaded with crying babies and cages of distraught chickens. The narrow dirt road was precipitously narrow much of the time. We stopped briefly at a dilapidated building beside the road. A faded sign over the front door said *Cantina*—a place for refreshments. We got off the bus and went inside. Three men were asleep at a cafe table. The bus driver called to them. They woke up quickly, picked

up their guitars, and belted out some gaudy, almost fran-
tic music while a little boy approached us with an open
hand, asking us for a few pesos. We gave him a newly
minted silver quarter. Clutching it tightly in his hands, he
scurried out the door and ran down the road.

It was worth the nerve-wracking bus ride. Ensenada
was pleasant. Our hotel room was quiet and comfortable.
After the long, hot day of travel, the evening was cool, and
a small breeze rustled our curtains. The air was fragrant
with the sweet aroma of the orange trees growing beside
the hotel. We stood in the window looking at the lights of
the town and the scattered buildings nestled among the
scrub oaks and mimosa locust trees in the nearby hills.
There were no cars in the streets below, nor any people
walking there. A lovely tranquility had come over the town
as the night came on. This was my first night in Mexico.
I had expected something more raucous.

The next morning was Easter. While I was still asleep,
Bob slipped out of bed, dressed quietly, and found a nearby
market. When I awoke, he was sitting on the side of the
bed, reading a Walt Disney comic book aloud to me. It
was in Spanish, so he translated it as he read along. For
breakfast we had avocados, oranges, bread, and cheese. I
didn't have a single cup of coffee for several days.

Just below our hotel room window was the public
square where the town band was warming up their instru-
ments. Their Sunday concert consisted mostly of Easter
hymns. These musicians were so dolefully out of tune and
out of touch with each other that their playing sounded
very "contemporary"—like some wildly dissonant music
by iconoclastic American composer Charles Ives.

We headed for the beach. In the distance stood a large,

imposing building. Was it a palace, or the governor's mansion? No, it was the former Playa Ensenada Hotel and Casino, a grand Spanish-style structure overlooking the bay. In the late 1920s, heavyweight boxer Jack Dempsey and a number of other Americans opened this casino. It was closed down in 1938, converted into the Hotel Riviera resort, and shut down again from lack of business. After the squalor of Tijuana, this casino was our first taste of Spanish-style opulence.

There weren't many people on the beach that afternoon. We were caught up in the spell of the electric blue sky, the dazzling white sand of the beach that stretched for miles, and the sensual warmth of Mexican coastal sunlight. After all those days of travel and rushed sightseeing in crowded cities we splashed in the surf and stretched out indolently in the sun. We wondered why we should go back to Seattle. Why not just stop traveling from place to place and become two beach bums, living by our wits from day to day in this Gauguin-like taste of paradise? The Baja beaches had an expansive, unhurried sense of time about them, and a sensual leisure that was new to someone who had grown up in the Nordic atmosphere of Seattle. The nearly blinding white beach sands and the dark tropical palm trees offered such a sharp contrast to the drab gray sands and rain forests of the Washington Coast. There was an intoxicating immediacy to life at Ensenada.

OUR IDYLLIC DAYS IN LA JOLLA and Ensenada almost lulled us into forgetting that Mark Tobey's retrospective exhibition was scheduled to open in a few days at the Palace of the Legion of Honor in San Francisco. We

needed to catch the next bus north. By the time we got back to San Francisco we had just enough money left to pay for a room at the YMCA. I went to see Tobey at his hotel on Sutter Street and explained our plight. "Guy tells me you and Bob have been going up and down the coast spending money like drunken sailors," Tobey chided. "Here's a loan to tide you over. You can pay me back later. But just don't go and spend it all in one place!" He handed me several twenty-dollar bills.

The exhibition preview was the next evening. Tobey was there with Guy Anderson. Art historian Elizabeth Bayley Willis curated the exhibition. Willis was a close friend of Lyonel and Julia Feininger. She had brought with her by train from Seattle some of Tobey's first paintings when she went to New York in the early forties to work at the Willard Gallery. Once there, she had shown his work to dealer Sidney Janis, who wrote an introduction for Tobey's 1944 exhibition at the Willard Gallery. Willis worked there for several years, during which time she was able to introduce Tobey's work to many influential critics and collectors.

The following evening Guy, Bob, and I met in San Francisco's International District. We bought Chinese wooden flutes in a small shop and toodled merrily on them as we made our way through the crowds of tourists. We stopped in an all-night coffee joint and took turns working on the same drawings, each of us signing them. Guy winked at us and said, "Here, boys! Here's some money for you, and it's not a loan. It's a present. Live it up! And if you have any adventures I'll want to know *all* the details!"

Thanks to Guy's generous nature, two evenings later Bob and I had orchestra seats for actress Mae West's per-

formance in *Diamond Lil*. Miss West was the world-famous, notoriously brash movie star who had brought sex out of the post-Victorian closets of uptight America. When her play entitled *Sex* opened in New York, every imaginable celebrity came to visit her in jail, even Mayor La Guardia.

Her love affairs, both the private ones and those she celebrated in her films and plays, had an unabashed and lusty zest that were unprecedented. When she wiggled her hips and said sassily to a handsome man, "Why don't you come up and see me sometime, big boy!" the audiences gobbled it up.

Mae West had not appeared in *Diamond Lil* since early in 1930. Her performances caused such a sensation then that she decided to perform the role again. In 1948, she revived this vehicle for her classy chassis first in London and throughout the British Isles. Then she moved on to New York. After many opening night curtain calls she introduced her cast, her hand-picked zoo of beefy men, to the audience. One of them, overcome with nervousness, stammered, "Thank you, Miss West, I—I've always wanted to—to play with you." Miss West saw to it that he remained near at hand for the rest of her cross-country tour.

By the time Mae West appeared at the Curran Theatre in San Francisco in 1951, she was obviously no spring chicken. But she was still a wicked enchantress on stage, delivering her sexy innuendoes and lewd proposals to any good-looking man who happened to catch her shrewdly assessing eye.

After the show was over, Bob and I made our way to Miss West's dressing room. The door was open. About six or seven people were already there, talking with each other

while Miss West stood in a corner chatting quietly with some lady. On stage, she seemed physically formidable. But off stage she seemed almost tiny in stature. Without her ornate plumes and glittering diamonds, Miss West was surprisingly inconspicuous. She obviously knew how to turn it on and how to turn it off. I thought there was a lesson there.

A week before this I had talked on the telephone with Arnold Schönberg's wife. Now I was standing only a few feet away from the incomparable Mae West. At that moment I realized that the more unpredictable and improbable my life became, the more I would likely enjoy it.

The art museums in San Francisco contained works by painters we rarely if ever could see in Seattle. We saw paintings by Cezanne, Matisse, Braque, Klee, and Picasso at the San Francisco Museum of Art. Guy Anderson met us at the M. H. de Young Memorial Museum. He wanted to see El Greco's *Saint John the Baptist* again. I kept going back to another room to look at an early German painting and down the hallway to see paintings by Fra Angelico, Rubens, Rembrandt, and Watteau—especially Watteau. For even then I did have some occasional moments that approached aesthetic sophistication.

We collected ten-million-year-old fossil sand dollars on the beach a short walk from Golden Gate Park. We rode on the Ferris wheel and the roller coaster at the amusement park next to the beach. We went to the zoo. Across from the de Young Museum was the Steinhardt Aquarium. I had never seen such exotic-looking fish. They resembled some of the paintings Paul Klee had done after his visit to such an aquarium in Naples. We had reproductions of some of these Klee paintings on our apartment walls in Seattle.

We saw the Rodin sculptures at the Palace of the Legion of Honor and we had the obligatory seafood dinner at Fisherman's Wharf. We even rode the cable cars. We were typical tourists.

We didn't want the same kind of Chinese food that we routinely had on University Way, the omnipresent chop suey, egg foo yung, and chow mein. We wanted to have something "authentic." We went into a corner grocery store and tried to explain to the elderly owner that we were looking for a restaurant that served the kind of food that Chinese eat, not just more tourist stuff.

"I have just the place for you," he exclaimed in halting English. "It is very good Chinese food. It is a very popular place. We Chinese eat there."

With that he carefully wrote something in Chinese on a piece of paper, and he wrote down in English the name and address of the very "authentic" Chinese restaurant.

"You go there. You give the waiter this. It's a list of what you should order if you want *real* Chinese food. Tell them Sam Chin sent you!"

It took a while to find the restaurant. It was on a dimly lit side street several blocks away. The faded sign was hard to read. We went in and followed the signs pointing to a downstairs restaurant, a large, nearly empty room with no "atmosphere" whatsoever. The sole waiter sat at a table reading a newspaper. We took a table, and handed the waiter our note—our passport to exotic culinary experiences.

"Two egg rolls, one chop suey, one fried rice," he called out to the kitchen. So much for an authentic dining experience in San Francisco's Chinatown.

Reality set in. We had stayed in California much

longer than we had planned, and besides that, we were homesick for the Northwest. We caught a nonstop bus from San Francisco to Seattle. That trip didn't seem nearly as bad as the trip from Seattle to Los Angeles. By the time we got back to our University District apartment, Bob and I were flat broke again and wondering what to do next. The rent was due the following week. Our cupboard was bare.

I have always been, it would seem, on friendly terms with what painter Glenn Brumett called "The Money God." Accordingly, the hallway phone rang the next morning. It was the secretary from the Music and Art Foundation. My sonata for viola and piano had just won the $100 first prize in a Northwest composers' contest. But two of the contest judges, composers Manuel Rosenthal and Dorothy Cadzow, had helped me compose this work. I felt that this surely had to be taken into account.

I explained my financial plight to the foundation secretary, asking her when at the earliest I might be able to get and cash the check. The ladies at the organization went into a huddle and a check arrived two days later. We were solvent again. As Guy Anderson said right along, "One way or another, we *do* manage to keep going, don't we!"

Back in Seattle we had lots of visitors. Mark Tobey dropped by often. He'd study Bob's paintings and offer a few suggestions. I had an upright piano in the corner of the living room. Violinist Paul Revitt came by to read through my new violin and piano sonata with me. Late at night fellow poet Richard Selig appeared, tapping on the window, waking me up. He had a new poem. I'd let him in the back door and sit with him in the kitchen while Bob was fast asleep in the next room. Morris Graves appeared unex-

pectedly. When we got home from work in the evening, we often found that Helmi Juvonen had left a dozen or so of her latest linoleum block prints under our door.

We did tend to move a lot from one apartment to the next. Bob liked to decorate apartments, planning just the right color of paint for each wall, arranging the furniture just so. We lived in rooms that were a mixture of Japanese and Bauhaus styles, where Japanese tatami mats covered the floors, and reproductions of paintings by Paul Klee, Ben Nicholson, Ben Shahn, and Piet Mondrian covered the walls. Bob's family owned commercial greenhouses in Tacoma, and he was an orchid enthusiast. We raised orchids in a terrarium near the window. We had an aquarium filled with tropical fish. This was a very different kind of environment for me. Like Tobey, I typically lived in a clutter of random possessions. Bob was more like Morris; the space in which he lived was carefully orchestrated.

Between us we didn't own many things that could brighten up our apartment. But luck often seemed to be on our side during those impoverished Bohemian years. This time our good fortune manifested itself in the form of an interior design student from Peru who lived in the room next to us. His name was Chan Kahn. He lived in Lima and was the son of China's ambassador to Peru. Chan was at the University to study with noted interior design teacher Hope Foote. Interior designers Warren Hill, Dale Keller, and Ted Herreid, and weaver Jack Lenor Larsen had studied with Miss Foote.

Chan had brought with him from Lima an amazing collection of ancient Peruvian ritual artifacts and objects of art, some of which he would later sell to Dr. Richard Fuller for the Seattle Art Museum's collection. Chan's room con-

tained a treasure trove of Peruvian Nazca textiles, ritual ceramics, gold ornaments, and high priests' robes and head-dresses. Chan loaned Bob and me some fabulous Peruvian objects to display in our own relatively bare apartment.

Halloween arrived. There was a knock on our door. Morris Graves had driven in from Edmonds. The woods around his house at Woodway Park were too spooky that night, he explained. Never one to be intimidated by any-thing—either sacred or profane—Morris proceeded to adorn his physical presence with the sacred garments of an ancient Nazca high priest. He looked quite imposing, even regal, decked out like some fiercely commanding priest from centuries ago. But our two Siamese cats felt otherwise. They would have none of this. They perched on a bookcase facing him, and stared fixedly, almost men-acingly, at him. It was hard for Morris to maintain his priestly aloofness. Eventually the cats won out, as they invariably did. Morris divested himself of the Nazca robes and spent the rest of the evening being unusually subdued.

During the early 1950s I liked to rummage through junk stores on downtown Seattle's First Avenue. In one sec-ondhand shop, I found a bizarre object: a mummified Egyptian cat, swathed in faded linen wrappings and stuck unceremoniously in a large screw-top glass jar. The barely legible label said it dated from the "2nd Millennium B. C.," and that it had been found at Gizeh, Egypt. The store clerk seemed glad to get rid of it. But when I showed it to Morris, he was euphoric. He asked to borrow it for a few days. I didn't ask him what he had in mind.

Another party of ours took a similarly bizarre turn. While Bob was in the kitchen cooking, Morris sat next to a young poet, John Platt. John and I were fellow students

in Roethke's class. Having no clear idea of who Morris was, John went on and on about his latest hunting trips in eastern Washington. John spared Morris none of the details about the excitement that hunting wild ducks held for him. Morris stared at this young poet and ardent hunter, speechless and horrified. Finally he stood up, excused himself, and disappeared into the night. When I celebrated my seventieth birthday many years later at the Collusion Gallery in Pioneer Square, John was there with his daughter, the fabulous comedian Peggy Platt, a close friend of Paul Dahlquist. I realized again what an intricately interwoven fabric a life can be.

Meanwhile, at our apartment party, militantly Irish Elizabeth Patterson sat next to very, very English Barbara Kennedy, director of the Henry Art Gallery film series. I heard the name of Oliver Cromwell come up. Elizabeth and Barbara began snapping and snarling at each other, to the fascination of the Siamese cats. Bob came into the living room to announce that dinner was ready, and would we please come to the kitchen table and help ourselves. Peace restored, the cats found this scene only mildly interesting. They were soon at the kitchen door, asking to be let out.

Morris sometimes invited Bob and me out to his new place at Woodway Park. His new house wasn't finished yet, so we slept in the gatehouse, served breakfast in bed by Morris. His young friend, Japanese Hawaiian Yone Arashiro, was busy later that day serving us food and drinks and trying to be as inconspicuous as possible. Morris had met Yone on a beach in Hawaii, and, as Guy related to me: "Morris didn't waste any time. He must have wrapped Yone up in banana leaves and shipped him to Edmonds so fast that poor Yone never knew what hit him!" Everyone I knew

was fond of Yone, as was I. Even though he lived with Morris at Woodway Park and helped Morris build the new house there, he usually chose to be in the background. One evening he showed up at my room in the Kennedy Building, for the only time we ever were alone together. He danced for me while I played the piano for him.

Morris and his friends staged parties for the most unlikely occasions. Once, when the anniversary of Queen Victoria's birthday arrived, they celebrated it with a party at which we dined on robin's egg–blue angel food cake, toasting her majesty with vintage wine and lamenting the passing of former days, when people had appreciated the finer things in life. We strode in a solemn procession through Morris's formal gardens, admiring the lawns and the carefully placed ornamental plants. I often found myself trying very hard to appear far more discerning and difficult to please than I actually was.

It never failed that just as Bob and I were starting to acquire a taste for this luxury, Morris would whisk us back to the University District in his truck. The next morning would find me back to the weekday grind of being a dishwasher and busboy at Manning's, and Bob was back to his work at the Pinel Foundation.

In 1953 Bob left for London on a Fulbright Foundation scholarship to study painting at the Slade School. Mark Tobey and Morris Graves wrote letters of recommendation for him, ones in which they praised him highly as a young painter with exceptional talent. When he returned to Seattle the following year, many things had happened to each of us while we were apart. We went our ways. Bob soon married and settled down to raising a family. I went on much as usual.

So many of my artist friends from student days were now starting to worry about their future. They complained that the life of the artist was too precarious an existence. One by one, I watched many of them go to work for the Boeing Aircraft Company. They explained to me that this was only a temporary measure. They planned to take a well-paying job, bank their money away, and get back to being painters again—once they had some money in the bank and felt they were more secure about their futures. But I had already realized that the price of security, real or imaginary, would never be one I could afford.

On University Way

URING THE 1960S, WRITER TOM
Robbins was art critic for the *Seattle Times* and
later for *Seattle Magazine*. His reviews occasion-
ally aroused a public furor when he reshuffled the deck of
local reputations. When Robbins wrote about them, some
of our best known artists came tumbling down from their
fashionable heights, while other local painters found
themselves suddenly lifted out of obscurity. I was among
those marginal painters who were brought to the public's
attention by Robbins's reviews, especially when he praised
a seascape of mine in the Seattle Art Museum's Northwest
Annual exhibition, and then other landscapes that I exhib-
ited at the Kinorn Gallery on University Way. Robbins'
reviews of my pictures were so favorable that suddenly
people wanted to buy my things. I was soon able to cut
back my hours working as a clerk at Harry Hartmann's
bookstore on University Way.

Ann Faber was art critic for the *Post-Intelligencer*,
Seattle's other major newspaper. Her reviews were invari-
ably enthusiastic. They were never as condemning or con-
troversial as some of Robbins's reviews. You could sense

that if she didn't like a show, she still found something good to say about it.

Ann met me for coffee at Manning's cafeteria one afternoon. She asked me to bring along some of my latest paintings. Manning's was a good place for such meetings. The booths next to the windows looked out at University Way. They were comfortably large, and, even more important, the natural light coming through the windows didn't distort the colors in the paintings, unlike incandescent lights. Tobey liked to sit in these booths in the morning, watching people pass by on University Way.

Ann looked at about a dozen small paintings I had just finished. There was one landscape she particularly wanted. She asked if it were for sale. I said, yes, of course. In one of my favorite moments in the usually strained experience of selling paintings privately, Ann took out her checkbook, filled in every part of a personal check except the amount. "By the way, how much is it?" she asked. Painters never forget that sort of kindness.

I had just read Robbins's latest art review. Ann must have also read it, because out of the clear sky she said, "Tom Robbins is our art *critic* here. My job is just to be a kind of shill, drawing attention to different artists' art work, hoping people will go to the galleries and decide for themselves." Ann was not out to make a career of being an art critic. She was far too modest and noncompetitive for that.

Besides Mark Tobey, there were other regulars at Manning's during the 1950s and 1960s. I worked there briefly as a dishwasher and busboy during the early 1950s. Helmi often came to Manning's for a bowl of vegetable soup and a glass of milk during the late afternoons. She

Painting wax crayon landscapes at Mrs. Thomas's rooming house in the University District, 1964. On the back wall is Guy Anderson's study for his mural at the Seattle Opera House. The cat's name is Fauve. Photograph © Mary Randlett.

had an inordinate fondness for soda crackers and used to stuff her pockets full of them before she left the restaurant, explaining to me, "I know they're not very nourishing, but I like to put a little peanut butter or jelly on them for a snack while I'm working." Pehr would wander into Manning's exclaiming, "Is there *nowhere* in this town where one can have a *good* cup of coffee?" Pehr was diabetic. He liked to sneak away to Manning's in the afternoon for a sugary dessert of some sort while Mark was up the street, painting in his second floor studio overlooking the alley behind Miner's Paint Store. Poet Richard Selig lasted two days as a dishwasher at Manning's before he got fed up with the tedium of the job and quit.

On Sunday mornings during the early 1970s, Dr. Dixy Lee Ray, who later became known as "Madame Meltdown" because of her mania as governor for siting nuke plants in such areas as the Skagit Valley, liked to sit in one of Manning's window booths with her botanist friend, Professor Daniel Stuntz. According to a former student of Professor Stuntz, he and Dr. Ray used to relax by sliding together down the banisters of Johnson Hall on campus. That was while Dr. Ray was still a marine biologist with a popular educational series on local television, before she became governor of our state and freaked out all of the environmentalists. Anyone who didn't agree with her nuclear plant–building agenda was dismissed by her as "an ignorant hippy."

The Dixy Lee Ray gubernatorial reign was mercilessly lampooned by cartoonist Ray Collins in his *Seattle Times* cartoon series, "Dip Stick Duck." Knowing as we all did what a fearsome creature Governor Ray could be, it was a wonder that she didn't have Ray Collins beheaded. But that

was later. The Dixy Lee Ray I used to chat with at Manning's on Sunday mornings seemed pleasant enough. The nuclear power trip had not yet glittered in her eyes.

IN 1958 MARK TOBEY WON first prize in painting at the Venice Biennale. Three years later he had a major retrospective exhibition in Paris, at what we called "The Louvre," although it was actually at the Musée des Arts Decoratifs, a subsidiary museum of the Louvre. The Louvre only exhibited works by dead painters. But it sounded much better if we told everyone that Mark was having a show at "The Louvre."

The lightning bolt of fame and fortune had struck Morris Graves during the 1940s. And now it struck Mark Tobey, who soon became an international art world celebrity. University Way seemed to be a spawning ground for undiscovered, potentially successful painters. Who, the collectors wondered, lurked off stage, painting in seclusion, ripe to be recognized? Just which artists were the true successors to the mantle of the "Northwest Masters," as personified by the august Mark Tobey, the charismatic Morris Graves, the urbane Guy Anderson, or the nature-painter Kenneth Callahan—the famed "Four Mystic Painters of the Northwest?" More to the point, which painter was the best "investment?" Who should the art investors be buying next?

When Tobey returned to Seattle from Paris after attending his opening, we had lunch at the Meany Hotel. "What's it's like to have a show at the Louvre?" I asked him.

"Quite frankly, the only thing I could think about was 'Will I *ever* be able to paint another picture after this damned thing is over?' Trying to get back to painting after

I've had a retrospective is like trying to crawl out of my own grave!" he answered.

Morris Graves had already told me about how his own early fame had complicated his life. Shortly after I met him at a 1949 Christmas party at Tobey and Pehr's University District house, Morris invited me to visit him at Careläden Castle, the new house he was building at Woodway Park, a short walk south of Edmonds. Tobey briefly owned a forested lot nearby, but he changed his mind and soon sold it.

When I arrived there, Morris was in white jockey shorts, sunning himself in his backyard. Yone Arashiro prepared and served us our lunch, then disappeared into the house. After we finished our lunch on the outdoor patio, Morris offered to show me around the grounds. I mentioned to him that I had just seen a movie entitled *Sunset Boulevard* at the Varsity Theatre in the University District. It starred the legendary Gloria Swanson in a story about a former celebrity who has sunk into oblivion after many years of being in the public eye during the silent movie era.

"That's me!" exclaimed Morris. "Just another has-been trying for dear life to hang on to the last rays of a bit of early fame."

I didn't know how seriously, if at all, I should take Morris's comparison of himself to an aging Hollywood movie star, especially because he was only thirty-nine years old at the time and appeared to be in the very prime of life. He was tall and exuded robust vitality. He was hardly the image of a "mystical" painter. This was my first experience in not knowing whether Morris meant what he said. What he said next was far more comprehensible to me. He explained that before he had become something of a

celebrity his life had been comparatively simple. "I used to do all sorts of wild things. But I won't bore you with all the details. You'll probably hear them from other people anyway."

Morris continued in this serious vein, surprising me, especially considering that I had just met him. "When I'd do all those outrageous things, I did them on the spur of the moment. Even I didn't have an idea of what I was going to do next. But then I began to read about this man called 'Morris Graves,' someone who did all those madcap things. I started to become self-conscious after that. Whenever I did any more of those things that had been so spontaneous for me before, it was as if I was imitating this mythical person called 'Morris Graves.' I had lost the freedom I once had to be myself. It's never been the same for me ever since."

Guy Anderson once told me, although it is perhaps impossible now to verify this, that the famous *Life* magazine 1953 article about the "Four Mystic Painters of the Northwest" had originally been planned to include a fifth artist—a woman. If there is anything to this, and I am strongly inclined to trust what Guy told me, the question remains, who would she have been? Considering that gallery owner Zoe Dusanne had initiated the idea for this magazine article, I suspect that the mysterious woman artist might have been represented by Zoe's gallery during the early 1950s. Painter Patricia Nicholson would be my guess. I recently asked Zoe's close friend Paul Dahlquist if Zoe had ever mentioned this to him. It was news to him. I hope that some day, somehow, this tantalizing suggestion will be verified, because I personally love the idea that a woman artist, and especially a painter as fine as Nichol-

son, might join the pantheon of an otherwise male-dominated history of Northwest Art. The only woman artist frequently mentioned in the same company as the "Big Four" in recent years has been Helmi Juvonen.

Interestingly, art writer and dealer Lynn McAllister, in her 1993 essay on the Northwest modernist women artists during the 1920–1940 inter-war period, wrote: "Patricia K. Nicholson (b. 1900) developed an Abstract-Expressionist style filtered through Northwest School influences. Her oil and tempera paintings synthesize Abstract Expressionism based on study with painters Peter Camfferman, Mark Tobey, and Franz Baum. The large tempera on masonite, *Bright Moon, Clear Wind* (c. 1950s), is a composition of large expressionistic sweeps of color with a halo of gray shadows. The brushwork parallels the calligraphic strokes of Northwest School painters like Tobey and Guy Anderson." Nicholson had a solo exhibition at the Seattle Art Museum in 1933 and was included in the Northwest Art Today exhibition at the Seattle World's Fair in 1962. She was represented by the Zoe Dusanne Gallery.

For that matter, the names of other painters come to mind, ones whose work I have admired, and who more than deserve to be rediscovered by future historians and art curators: Seattle painters Kenjiro Nomura, Ward Corley, Jack Stangle, and Malcolm Roberts; Sedro-Woolley painter Sherrill Van Cott; Bellingham printmaker Helen Loggie; Walla Walla painter Ruth Fluno; Spokane painter Kathleen Gemberling Adkinson; Ellensberg painter and teacher Sarah Spurgeon, for whom the college campus art department gallery is named, and whose animal studies Tobey hung on his living room wall in his house on University Way; and Bellingham artist Patricia Fleeson.

Gary Lundell and I visited painter Ruth Grover at Lincoln City on the Oregon Coast in 1967 and admired her encaustic works. Then too, I must mention Portland painter Alice Asmar, of whose work poet Pablo Neruda wrote in an exhibition catalogue, "Your paintings are like my oldest and finest dreams." I also need to single out Lopez Island artist Margaret Tomkins, a superb painter who was so independent a spirit, running with none of the local art trends and cliques, that it is hard to define her place in the scheme of Northwest Art, despite her importance as an artist. One of my finest pleasures in writing a book such as this is that it provides me with the opportunity to draw to the reader's attention the names of such splendid artists, many of whom have been overlooked in recent years.

MY MEETING TOBEY AND GRAVES at a time when I was young and impressionable, and hearing both of them tell me in detail how fame had complicated both their lives, made a lasting impression on me. Tobey had cautioned me that success and public attention, if one should happen to have a bit of it, was not something to which one should become addicted. For his part, the more famous he became, the more important his close friendships became to him. He had complained to me that it became increasingly hard for him to find people who would be candid with him, telling him whether they liked (or didn't like, and were afraid to tell him) some painting he had just finished. He felt that his fame was beginning to intimidate people around him.

After Tobey's successes in Europe the price of his paintings soared. His Seattle dealer, Otto Seligman,

promptly added a zero to the price of each painting. A $200 painting was now $2,000. I bit my lip when I saw this happening, because some of these newly expensive paintings were pretty routine works. Tobey's old friend, art patron Johanna Eckstein, happened into the Seligman Gallery that week. Jo always said exactly what she thought, and I always found myself silently agreeing with her, although I often didn't have the guts to say so. She looked at the new price tags and exclaimed testily to Otto, "Some of these Tobeys are not very good. You know that very well, Otto! No prize makes them good pictures now!" Otto winced and excused himself, leaving the room to answer a phone which neither Jo nor I had heard ring.

At the age of sixty-nine, Tobey had unexpectedly become a very famous painter. His new fame unleashed hordes of instant Tobey "great admirers" and scrambling-to-collect-Tobey-paintings fans. But Jo Eckstein always told it like it was, so much so that at times Mark was a bit afraid of her bluntness. Jo never minced words. Her twangy, imperious voice also had its gentle side. She was an authentic "grand dame." In my book, there was something noble about Jo.

While some of the University District painters were being discovered by the international art scene, the rest of us went about our business much as usual, painting in our rooms and studios, or meeting in coffee shops and taverns. One of our favorite hangouts was Howard's restaurant on the northeast corner of University Way NE and NE 42nd Street. I was a regular customer there, starting with my morning coffee and a cigarette, and ending with an early dinner. Helmi Juvonen, Pehr Hallsten, Bill Cumming, Richard Gilkey, and Jack Stangl were there regularly.

During her 1953 stay in Seattle, philosopher Susanne K. Langer and I frequently met there for lunch.

Howard's was conveniently close to the campus and to the Parrington Hall's English Department classrooms, where Theodore Roethke, Richard Eberhart, Léonie Adams, Rolf Humphries, Vernon Watkins, Elizabeth Bishop, and many other well-known visiting poets taught poetry workshops during the 1950s and 1960s. The young poets hanging out at Howard's might include Richard Selig, James Wright, Richard Hugo, Carolyn Kizer, Sandra McPherson, Henry Carlile, Duane Niatum, and Robert Sund. Painter Bill Cumming and his wife Roxanne would also be there. This restaurant was renamed "Aggie's Hook & Ladder" during the 1960s, but the habitués stayed pretty much the same. This college-days hangout is now a photocopy store, filled with Xerox machines, rent-by-the-hour computers, and similar technology.

During the 1950s Theodore Roethke might appear with several of his students at Howard's after class. Or seated across the room, talking with philosopher Susanne Langer, might be Richard Selig. Poet James Wright sometimes sat alone in a corner booth, translating German poetry into English and vice versa. Internationally known composer Alan Hovhaness had just moved to Seattle. He often sat at the restaurant counter composing music in the small notebook he invariably carried with him. The later-to-be New York film critic John Simon somehow ended up being a teaching assistant on the English Department staff. I had coffee with him once or twice at Howard's and rather liked him. Of course, all of these people weren't at Howard's and Aggie's at the same time. But when you walked into Howard's, you could invariably count on

finding at least a few of our brightest spirits sitting in one booth or another.

John Verrall, my music composition teacher, and I arrived at Howard's one afternoon to find Theodore Roethke sitting in a booth with poet Richard Wilbur. Roethke waved us over, and invited us to join him.

"How's it going, Jack?" Roethke casually asked Verrall.

"I've been working very hard lately—trying to help some of my students find themselves. Sometimes they can be such lost souls," Verrall responded.

Roethke was annoyed by the tone of Verrall's remark.

"For Christ's sake, Jack. Leave them *alone*! Getting lost is an important part of being young. You shouldn't meddle with it!" Roethke snapped.

Verrall didn't know how to respond to this. Richard Wilbur remained silent.

I was sitting with several young friends when painter Bill Cumming came into Howard's and sat down with us. "Hey, Bill, what's your latest painting look like?" asked one of the poets. "Looks like about three hundred bucks, I'd say," Bill responded in his usual cracker barrel twang. He was too cagey to take the bait when any subject was headed toward becoming theoretical or pompous.

Poet Carolyn Kizer swept into Howard's, and plunked down next to a few poet friends and me. "People keep telling me I turn them on. Where the hell is somebody who can turn *me* on?" she broadcast to everyone around her. A ballsy-looking guy sitting at the counter looked intently at her, but Carolyn was too busy holding forth to notice him.

A wispy young girl came up to our table. None of us knew who she was, but she seemed to know us. She had a vapid, listless look about her. She pulled up a chair and

joined us, uninvited. Her taciturn, soggy presence dampened our conversation immediately. "I just want to be myself," she announced sharply. Carolyn scrutinized her cooly and replied, "God help us, leave well enough alone!"

Poet Jim Davis sat in a booth talking with his friends. The music coming through the amplifier on the wall near the kitchen was too loud for him. He complained, and was given a runaround. He reached into his pocket and pulled out a water pistol, dipped it into a glass of water, filled it, and aimed it at the loudspeaker some three or four yards away. The music ended in a crackling splutter, and the amplifier went dead. Jim gave the the waitress a fictitious address and phone number, and said, "Send me a bill for the damages. It was worth every damned cent of it."

There were many serious discussions that took place at Howard's, ones about poetry, art, and life. But I have trouble remembering any of them. What I do remember of my years at Howard's are those moments when people shot from the hip and played it by ear. Howard's attracted such mavericks. Those years were as brassy as they were golden.

During the 1960s and early 1970s, my other two favorite hangouts were Lee's restaurant on University Way, and the International House of Pancakes (informally called "The IHOP") on Brooklyn Avenue NE. Pianist John Ringgold, painters Joseph Goldberg and Glenn Brumett, classicist Jon-Henri Damski, and I were at Lee's regularly. Poet Léonie Adams ate dinner at Lee's almost every night while she was teaching at the University. Poets Elizabeth Bishop and Henry Reed dined there regularly. The steak dinner special included a small dinner salad, a steak, a hefty Idaho baked potato, garlic bread, and coffee—all for $2.69! If you wanted to have a small mound of fresh Dungeness crab

on your salad, that was an extra fifty cents. Many of the University District painters liked to eat there because the food was so good, and we could afford it. In that sense, Lee's restaurant became another hangout for the next wave of the so-called Northwest School of painting when Paul Dahlquist, Joseph Goldberg, Jay Steensma, Glenn Brumett, Ree Brown, myself, and other painters either ate there or came there late at night to drink and sketch. We amassed large collections of one another's work by trading with each other after a few hours of drinking and drawing.

My artist friends and I often met for evening coffee and pastry at the Continental restaurant and pastry shop on University Way. Owners George and Helen Lagos opened this very popular restaurant in 1968. No other University Way restaurant has so long a history as a meeting place for artists and writers. During the writing of this book and my first book, *The Eighth Lively Art*, the Continental was where my sponsoring editor, the late Donald Ellegood, director emeritus of the University of Washington Press, and I met for lunch and discussed the many drafts of these two books.

AMONG THE "LIVING TREASURE" artists who have lived or taught on University Way—Mark Tobey and Helmi Juvonen, in particular—modern dancer-choreographer and dance teacher Martha Nishitani has the longest history of ongoing cultural contribution. Born in 1920, she opened her modern dance school and established her dance company at 908 East Madison Street, across from Seattle University on Capitol Hill. In 1954 she was invited to become choreographer for Opera Theatre productions by Music Department director Stanley Chappell. She con-

sequently moved her dance studio to University Way, where she continued to teach until only very recently. During 1954 she attended the Summer School of Dance in New London, Connecticut, where she studied modern dance with the three great pioneers in the history of modern dance: Doris Humphry, Martha Graham, and José Limon. During her teaching years on University Way, Nishitani's dance class accompanists included pianist-composer Lockrem Johnson and my fellow music student, pianist Robert Kuykendall.

It is Nishitani who most notably brought professional modern dance to the Pacific Northwest. She is cited as being one of five outstanding teachers of children's dance in the *International Dance Encyclopedia*. Nishitani has written about how she became a dancer: "My love for dance began at the age of six, when I was dismissed from class at my school with a toothache. After visiting the dentist, I was taken to see a film [Victor Hugo's *Les Miserables*, starring Charles Laughton] which was accompanied by a stage show. From that moment on I knew I wanted to be a dancer. However, I never admitted it because it was not nice to be a dancer in those days [1926–27]. Instead, I said I wanted to be a teacher when I grew up. So I became both a dancer and a teacher."

DURING THE 1950S, I worked on weekends as a guard at the Henry Art Gallery on campus. It was there that I first met Helmi Juvonen and painter Paul Dahlquist, then in his mid-twenties. He and I often had coffee with Helmi, or we visited Tobey and Pehr up the street. During 1955, while I was waiting for my inheritance from my Aunt Edna to arrive, Paul invited me to stay with him at his

apartment on Brooklyn Avenue NE. When I left for New York the following April, he hosted a going-away party for me, inviting, among other friends, Guy Anderson and Jan Thompson. Later that year, while I was living in New York for six months, and while I traveled in England, Holland, and France, we wrote each other regularly. When I returned to Seattle, I moved back in with him. Of the many painters and musicians with whom I lived during the 1950s and 1960s, living with him was especially convivial. He was invariably good natured. I never knew him to be petty or temperamental in any way. Sharing a studio apartment with him for several years was one of my most pleasant and productive experiences. When we lived north of the campus during 1957, I composed music on an upright piano in the parlor of the rooming house where we lived, while he painted in our attic-loft living space upstairs. Tobey and Pehr often invited us out for dinner or to a movie.

During 1956 and 1957, we bussed and hitchhiked to Agate Beach and the Newport area of the Oregon Coast, or to Pacific Beach and Taholah on the Washington seacoast. Paul began to exhibit his paintings at the Zoe Dusanne Gallery on Lakeview Boulevard, and later in her next gallery space on Broadway Avenue on Capitol Hill. Tobey owned several of Paul's 1957 charcoal drawings and spoke highly of them. These works are now with the Seattle Art Museum's Mark Tobey papers at the Manuscripts, Special Collections, University Archives at the University of Washington libraries, along with works by Leon Applebaum, Pehr Hallsten, Helmi Juvonen, Windsor Utley, myself, and many other artist friends of Tobey's.

I didn't realize at the time how many painters from dif-

ferent generations would be meeting each other for the first and last time on University Way. Jay Steensma came into Manning's while I was having coffee with Pehr, during Pehr's last visit to Seattle. Until 1957, when she was sent to Elma, Helmi was in and out of Manning's almost daily. This popular restaurant was just down the street from the Wilson Hotel, where Otto Seligman's art gallery was located. Seligman later relocated his gallery across the street. Manning's was a few blocks away from Tobey's studio. As such, Manning's was a popular place for artists and collectors to meet.

During the early 1960s, Oregon art patron Virginia Haseltine made regular visits to Seattle to visit artists' studios and art galleries. She bought works by Tobey, Graves, Anderson, and other Northwest artists which she and her family later donated to the Museum of Art at the University of Oregon in Eugene. Haseltine was the first art museum patron to buy a work of Jay Steensma's, a frog study. Haseltine, Steensma, and I met for coffee at Manning's one afternoon. Born in Moscow, Idaho, in 1941, Steensma had just arrived from the small town of Belmont in eastern Washington's Palouse country. He enrolled as an art student at the University of Washington, studying under painters Walter Isaacs and Spencer Moseley, and print-maker Glenn Alps. He received his BFA degree in 1962. We briefly shared an apartment in the University District while he was a student. In 1962 we both began to show our works at the Kinorn Gallery on University Way. In 1965 he was awarded a prize in the Pacific Northwest Arts & Crafts Fair in Bellevue. The juror was famed New York OP Art painter Richard Anuskeiwicz. It was apparent that Steensma even then was an exceptionally talented and

well-grounded artist. He was soon befriended by Morris Graves, Guy Anderson, and Joseph Goldberg, all of whom admired his drawings.

Painter Ree Brown recalls that he first met Steensma in 1969, shortly after Brown had come to Seattle from Utah. The two of them had an antique shop within the Francine Seders Gallery on University Way, while Steensma worked for Seders. Steensma had a knack for turning his friends onto painting works of their own. By 1990, when Steensma was exhibiting at the Mia Gallery in Pioneer Square, Brown began to paint the portraits of mysterious cats for which he is now rather famous. His works are exhibited in the Outsider Art Fair in New York and are reproduced in numerous books on self-taught painters.

During 1965, Morris resided at the Plestcheff mansion on Capitol Hill, renting it from its owner Gwendolyn Plestcheff. This austerely elegant house was built by James Hill, the railway tycoon, with the intention that his close friend Queen Marie of Rumania would have a worthy guest house awaiting her in Seattle. Hill built a similarly grand mansion on the bluffs at Maryhill, overlooking the Columbia River, to house art treasures given him by Queen Marie and other illustrious friends.

On entering the front door of the Plestcheff house, the first thing one saw was an ornately framed photograph of Queen Marie, autographed in her flamboyant signature. This formidable entry room could easily intimidate a stranger coming to visit Morris for the first time. The next room, the living room, however, was simply and comfortably furnished. An adjoining room, with windows facing a heavily forested ravine to the north, was where Morris painted.

Jay Steensma, painter Jimmy McLaine, Morris, and I sat in the Plestcheff mansion's quite ordinary-looking kitchen one evening, having coffee at a small table. Jimmy had just sold a painting. He was, he told us, glad to have the money, but it bothered him that he didn't like or approve of the lady who had bought it from him. He felt that she was patronizing him. Morris listened attentively, and then said: "I'm very democratic about a check. I don't care so much about whose check it is as much as I care about its not bouncing."

Jay Steensma was working on some new constructions for a show at the Don Scott Gallery on Eastlake. Scott exhibited the most "far-out" of what was being done in Seattle at the time. Jay mentioned to Morris that the great variety of materials he was using for these works was turning out to be far more expensive than he expected. Jay's works had been, I realized later, influenced by Morris's *Instruments of Navigation* sculptures which Morris had at the Plestcheff mansion. When I visited her in 1969 in her National Endowment for the Arts office in Washington, DC, poet Carolyn Kizer had hung one of Steensma's constructions on her office wall. During the last decade of his life, Steensma's work evolved into the most original and moving response to Graves's work of any of the young painters who were influenced by Graves.

Morris frequently helped his young artist friends by funding their travels, buying their works for himself, and by giving them works of his own to sell when they were hard up for cash. This time Morris's generosity took the form of his opening up his address book and picking up the phone that was on the kitchen table where we sat. He dialed a number. When the other party answered, he

said: "This is Morris Graves. Is this Mrs. ——— [a patron of substantial wealth]? How nice it is for me to hear your voice again, even if it's only on the telephone. Now what I called about is that I have a young painter named Jay Steensma sitting right next to me here. He is very talented. He draws superbly. He is preparing a show of his new work for the Don Scott Gallery. I would like to see to it that he can give his full attention to preparing this show, and not have to be distracted by money concerns. Your patronage to me has been such a help to me in the past. Now I thought that it would be very nice of you if you could see your way clear to sending Mr. Steensma a check that will help him in preparing his exhibition. I think $200 would be a much-appreciated amount." Morris made three similar calls to patron friends. When he finished making these calls, he turned to Jay and said: "You can count on $800 in checks arriving for you soon. Now, get back to work."

The friendship between Jay and Morris continued, often by letter. Even though Jay met Mark Tobey briefly and had a good friendship with Guy Anderson, it was Morris who had the deepest influence on Jay's work. On December 12, 1990, while I was visiting at Marshall and Helen Hatch's First Hill condominium with art curator Kosme de Barañano, the phone rang in the next room. Helen returned a few minutes later to tell me that Morris was on the phone and would like to speak with me.

"Do you see much of Charles Krafft?" Morris asked me.

"Not often, but I see him now and then," I answered.

"He's sent me something called *The Zero Hour* [a local art journal]. It's somewhat porn. Do you know Jay Steensma?"

It seemed very odd to me that Morris would ask me

such a question. He knew very well that I knew Jay. In fact, I had introduced them to each other at the Meany Hotel in 1964.

"Yes, very well," I answered.

"There's an interview with him. He talks about you. He says that he and I saw each other almost every day— that we traded pictures.

"Jay was a friend of Bob Mony, Bruce Selchov, and Larry Menegas around 1963 or so. I just bought some of his drawings from him. Dale Stenning and I gave about ten of his works to the Spokane Museum this year."

"So you take him seriously. I'm glad to know you respect him. You are often in my thoughts."

"May I write you a letter? If I do, there's not to be any thought of your having to answer it," I asked him.

I wish you would. I might send you a postcard, I'm doddering these days. As I just told Helen [Hatch], I'm in the dressing room now, taking off the makeup of life," he replied.

Shortly before Jay Steensma died in 1994, Morris wrote him the following letter about one of Jay's last paintings: "Dear Jay, Last week, Victor and Jim sent on to us your heartbreakingly moving painting of your *Northwest Extinction Series* titled *Belmont Relic*. In this whole house (that looks somewhat like a flea market of treasures) it's now my favorite painting. Next time you are in this area *please* come to see it & us here at the Lake. With all best wishes for continuing what you're doing. Sincerely, Morris."

THE MID-1960S on University Way was a unique moment in the history of Northwest Art. During 1966 and 1967, Mark Tobey was paying his last visits to Seattle.

Morris Graves's visits to Seattle had become increasingly few and far between. Such young painters as Steensma and Goldberg were able to meet both of them. Steensma began to sell signed Xerox copies of his drawings. He sold some in 1985 to a young painter, Randy James, who had studied with Bill Cumming. James first met Steensma at the Grand Illusion cafe, where James worked: "He would come in and have coffee, talk about kings and snakes. One day he offered me the small xeroxes. I paid him top price for them, on a barista's wages (five dollars, I think it was). Later, he gave me the two self-portraits. Still later, but not much, you and I met."

I could never have predicted in the 1980s that in the year 2000 James and I would begin to collaborate on paintings, prints, and drawings which we would exhibit jointly at the Woodside/Braseth Gallery and elsewhere, some of which would be in several public collections in the Northwest. When anyone tries to tell me that "the good old days are over," I realize just how clueless they are to what is going on around them right now.

SHORTLY AFTER WE MET, I gave Randy James copies of two books that had been important to me as a painter: Robert Henri's *The Art Spirit* and Bill Cumming's *Sketchbook: A Memoir of the 30s & The Northwest School*, published by the University of Washington Press in 1984. In doing this, giving favorite books of mine to young painters, I was continuing a tradition begun in my life by Mark Tobey.

In 1949, soon after we had met, Tobey and I were walking down University Way together one evening when he

turned quickly and started to walk into the University Bookstore, waving to me to follow him.

"If you're going to be a painter, there's a book you had better read and take to heart. I'm going to buy a copy of that book for you right here and now, if they have it."

Ten minutes later I stood next to the book counter while Mark inscribed to me a copy of Virginia Woolf's *A Room of One's Own*. I treasured this book until 1980, when I reluctantly gave it to a young student who, like the little girl who had talked me out of my Czech miniature furniture some forty years earlier, sweet-talked me into being more generous than I should have been.

One summer afternoon in 1966, twenty-one-year-old painter Joseph Goldberg got off his motorcycle and parked it on University Way. He looked up to see Mark Tobey strolling past him. Goldberg approached Tobey, and rather abruptly asked him if he were still teaching. Tobey explained that his years of teaching were behind him now, so there would be no opportunity for Goldberg to take lessons from him.

"I will say this, however," Tobey added, "At your age you may find yourself doing different things from time to time, but if you were meant to be a painter, you'll keep coming back to it."

UNTIL 1960 I was still composing music. And whenever my finances allowed I continued to buy paintings. My Aunt Edna died in Los Angeles in 1953, leaving me a substantial amount of AT&T stock. It was meant to be my future nest egg. Not being one to put anything frugally aside for the proverbial rainy day, I sold off the stock bit

Painter and photographer Paul Dahlquist was my University District roommate during 1955–57, and remains one of my closest friends. In November 1959, he exhibited his paintings at the newly reopened Zoe Dusanne Gallery on Broadway Avenue, Capitol Hill, Seattle. Photograph by Paul Thomas, courtesy of the Seattle Times.

by bit, paid off my bills, and bought still more paintings and drawings with what was left. I especially liked drawings and small works on paper. At Zoe Dusanne's gallery I bought works by Sam Francis, Claire Falkenstein, Henri Michaux, Zoran Music, Bernard Schultze, Karl Otto Schultze, Paul Dahlquist, and John Franklin Koenig. Zoe's gallery openings were every bit as colorful as her purple-tinted hair and the dark purple amethyst cluster that sat on her coffee table. At her openings, I met artists Sam Francis, Yayoi Kusama, and Claire Falkenstein, and English poet David Gascoyne.

Another chunk of my AT&T stock went into buying armloads of paintings by Tobey and Pehr, and works by Wols, Vieira da Silva, Jean Dubuffet, Milton Avery, W. S. Hayter, Arthur Hall Smith, and others from the Otto Seligman Gallery on University Way. Even though this gallery was only a block away, Tobey often sold privately out of his studio. Collectors and other dealers were flying regularly into Seattle, wanting to visit him in his studio. They arrived with plenty of cash in their pockets, knowing this was the way Tobey preferred to do business. Almost all of the Tobey works I bought, I purchased through his gallery. But when I did buy anything directly from him, Tobey instructed me, "*Don't* tell Otto. This sale is *strictly* between you and me! This way I don't have to pay any more income tax, and you don't have to pay any sales tax."

Tobey was always afraid of being questioned by the Internal Revenue Service. For one thing, he couldn't be bothered with keeping receipts of any kind. He always preferred cash transactions. He squirreled the money away. His great fear, even when he became successful, was that a day would come when he wouldn't be able to paint any

longer. He worried that he wouldn't have any pictures left to sell. What would he live on then? How would he be able to support Pehr? Tobey's almost obsessive worry was that he would someday end up at what he called "the poor farm." I myself never worried about such things. After all, I had two patron saints: Saint Francis of Assisi and Saint Vincent de Paul. Saint Francis nourished my soul, and the Saint Vincent de Paul thrift store provided my clothing.

During the afternoons, Pehr usually stayed home reading and doing some painting. Tobey came into Hartmann's Bookstore on University Way one afternoon, bringing with him a small envelope of Pehr's paintings. He promptly sold several to Marcia Katz, even while I stood next to them. Marcia later worked for the Otto Seligman Gallery, when it was located in the University District's Wilsonian Hotel, and later when it was relocated across the street on University Way. Marcia's husband, historian Solomon Katz, was one of the most respected, effective, and influential figures in the cultural and intellectual life of Seattle.

Tobey was proud of Pehr's paintings. He showed them to his friends whenever he could. He didn't hesitate to let people know that these charming little paintings were for sale, right there on the spot. When Tobey got back to the University Way house he shared with Pehr, he would hand him the money. Pehr would thank Tobey, and then ask, "Mark, I'm hungry. When will dinner be ready?" Tobey did the shopping, the cooking, the dishwashing, and many of the household chores. When he and Pehr settled in Basel during the 1960s, Tobey assigned all these daily chores to his secretary, Mark Ritter.

John Uitti's frame shop, on the corner of NE 42nd Street and University Way, was a gathering place for such

local painters as Tobey, Graves, Anderson, Helmi, Pehr, and Callahan during the 1950s. Dealers Zoe Dusanne and Otto Seligman and many of the local art collectors brought work to Uitti to be framed. If you wanted to see what the local painters were painting, you had only to look on the matting and framing tables in John's shop. Poet Richard Selig worked for John briefly during 1951. Before coming to Seattle, Selig had worked with painter Theodore Stamos at an East Coast frame shop.

If a young painter needed something framed before he showed it to a potential customer, Uitti gave the framing of it a special priority, and charged at most the cost of his materials. Just after I started painting during Christmas of 1960, Uitti showed my little paintings to many of his regular customers and urged them to buy these works. John Uitti was one of the local painters' very best champions, their confidant, and certainly one of the most respected and beloved spirits in the University District. A good number of unsung heroes lived and worked on University Way during those decades. Of all of them, John Uitti stands out especially.

Helmi lived for a while in several rooms directly above Uitti's frame shop. In one room she had her ceramic oven, in which she fired hand-decorated tiles, ashtrays, and keychains. These she sold through downtown tourist shops. Among Helmi's best patrons were Dorothy and her sister, owners of Dorothy's Gift Shop in the Olympic Hotel. In a large central room down the hallway Helmi hung her freshly laundered clothes, next to her ironing board. She cooked on a hot plate much of the time. Her sleeping arrangements were very simple: a sleeping bag on top of a mattress. Another room, into which she let me peek once,

was her "Mark Tobey Room." It was a shrine to Tobey, filled with articles of clothing and other things that had belonged to him.

Helmi hung her block prints on a clothesline next to the entrance of Uitti's frame shop. They were priced at fifty cents each. Customers were to put their money in a coffee tin next to the prints. It was surprising how much money Helmi took in on an average day.

John Uitti and Mark Tobey had both spent their early years in Chicago. Tobey's family moved there in 1909. Although he worked as an industrial designer at an iron and steel factory when he was in his late twenties and early thirties, his ambition was to be a magazine illustrator. For the most part, Tobey rarely spoke about his years in Chicago. He did, however, tell me about a man he had known in Chicago, a man who played an important role in his decision to become a serious painter: "He had a good knowledge of what was going on in European art, and he knew many painters personally. It was he who told me I should take painting seriously. And I took his advice very seriously."

In 1982 John Uitti and I were having coffee at the Southern Barbecue restaurant on University Way. I asked him if he knew anything about this man who had been so important to Tobey. John thought he did. I took notes while John related the following account: "Ove Hoffman owned an art gallery in the Hyde Park district in Chicago. I worked for him around 1938 to 1941. I would guess he was in his mid-sixties then. Hoffman was Danish. Come to think of it, Tobey was not an American so much as he was European in spirit. Hoffman was like Jean Hersholt, the actor. He had a deep, rich voice. He was short, about 5'4",

very slight, with a small face. He smoked a huge cigar. He was a very tolerant man, unruffled. I always felt a sense of peace around him. He was keenly interested in anything having to with philosophy, art, and aesthetics, and in historical changes, in personal history. He had developed close ties with good artists all over the world. They'd come to see him. He had a family. His wife was a doctor of osteopathy and they had an adopted son.

"I knew him when he was not much interested in money. He lived from day to day. I never saw him before eleven in the morning. He dressed formally, more formally than anyone else. He was a European-style person. I never saw him with sleeves rolled up, or not wearing a tie. He reminds me a little of Otto Seligman. Ove Hoffman was the best, the most interesting employer I ever had. He was an absolutely fair man. He had ideas of equality that were way ahead of his time. The difference between Tobey and Hoffman was that Hoffman was a genuine liberal, and Tobey was not a liberal. Tobey found politics tedious. He never defended himself for this. When you scolded Tobey for his lack of social consciousness or his disinterest, he never defended himself. But he seemed to think this was a lack in himself, and this was rare, for Tobey to think there was anything wrong in himself."

John added that this man was always so formally dressed that he was called "The Duke." This intrigued me, because John's decription of Ove Hoffman reminded me a bit of Tobey, who also dressed rather formally, even when he was in his studio painting. I rarely, if ever, saw him in shirtsleeves. This was typical of many of the late nineteenth- and early twentieth-century important American painters. They often dressed formally when they painted.

The standards by which Tobey judged his own work were never provincial. Even though he lived in Seattle, far away from the great centers of art, he was surprisingly well informed about what was going on elsewhere, especially in the New York City art world. He did, however, have an ambiguous relationship with New York. Even though he was at times almost obsessively critical and dismissive of much of the painting being done there, he nevertheless felt ignored and underappreciated by the New York art critics and collectors.

WHEN TOBEY LIVED ON UNIVERSITY WAY, his mailbox was at the back of his two-storey house. Arriving at his back door one afternoon, I picked up his mail and brought it into the house for him.

"Mark, there's something here for you from *Art News* magazine. But it's addressed to 'Marcus Tobias.' Is that a mistake?" I asked him.

"No, it's mine all right. I just don't want those people to know I subscribe to their magazine, or to any other of those art magazines, for that matter," he answered.

Guy Anderson made a similar point of keeping up with what was going on in New York by subscribing to and carefully reading the East Coast art journals. Even though there was relatively little going on in the East Coast art scene that he approved of, he still wanted to "know what was cooking" elsewhere. When guests came into his house in La Conner, the first thing they saw were bookshelves filled with art books and works by his favorite authors. On his grand piano were stacks of sheet music, works by the classic composers. He stored his L.P. recordings under the piano. The latest issues of East Coast art magazines and the *New*

Yorker, and old issues of such popular erotica magazines as *Playboy* and *Playgirl* were scattered about the room.

Seattle art patrons John and Anne Gould Hauberg were among Tobey's most effectively influential champions. During the 1970s they were considering plans to construct an art museum on their property near Mount Vernon, north of Seattle. As a museum dedicated to Tobey's works and those of other Northwest artists, it would be the first of its kind. Founding it away from the city was in the spirit of a Bahai prophesy that a time would come when a holocaust would descend upon the United States, and the Bahai's would flee the cities. Anne Gould Hauberg had been told of this prophesy by Tobey.

While the Haubergs were collecting Tobey works for their planned museum, I continued to collect Tobey's work for myself. Besides frequenting the Dusanne and Seligman galleries, I sometimes wrote directly to various artists, especially when they lived far away from Seattle. I wrote to printmaker Stanley William Hayter, asking if he knew where I might buy a copy of his etching entitled *Amazon*. He happened to have one remaining copy. I bought this from him, and then a print of his etching *Death by Water*. Jackson Pollock referred to Hayter as, "my other teacher." I bought a dune study drawing directly from painter Milton Avery, sending him the money and asking him to choose it for me. The richness of color and great simplicity of form in Avery's work had been an acknowledged inspiration to Mark Rothko.

In 1960 the Henry Art Gallery exhibited the entire Vollard suite of Picasso graphics. The original plates for these etchings had been hidden during the German occupation of France during World War II. Even though these

signed original Picasso etchings were priced as low as $75 each, few local collectors took advantage of buying them. Those who did buy them were painters: Mark Tobey, Windsor Utley, and myself.

That same year the Don Scott Gallery on Eastlake Avenue exhibited works by Idaho artist James Castle, a deaf mute. His landscape and interior drawings had a unique and haunting presence. I felt that they were, at the least, every bit as good as Mondrian's early landscape drawings. William Cumming called Castle "a major draftsman." I bought a great many of them from the gallery and later donated them to the Henry Art Gallery, the Boise Art Museum, and the Cheney Cowles Museum. The Boise Art Museum became the major repository of Castle's work. Now, some forty years later, Castle's work has begun to receive press in the East Coast art magazines and to be exhibited at some of New York's most influential galleries.

I collected works by Whistler, Picasso, Sam Francis, Wols, Jean Dubuffet, Henri Michaux, Hans Hartung, Bernard Schultze, Milton Avery, Claire Falkenstein, Jacques Villon, Edward Hopper, Zoran Music, and Sonia Delaunay, among others. Much of the money I had during those years went into buying pictures, which I usually donated later to the Henry Art Gallery and other other museums. I had read somewhere that a man's wealth is determined by what he gives to others. That sounded like a Kwakiutl potlatch to me. This was also my mother's philosophy of life. If she had something that she thought someone else needed more than she did, she gave it to him.

DURING THE CHRISTMAS HOLIDAY of 1960, after collecting works by so many other painters, I began to paint

a few small landscapes of my own. I didn't know how to draw. How could I paint something that would minimize drawing, a painting that consisted mostly of color? I had just bought a small book of Avery works. The first painting in this book was exactly the kind of painting I had in mind. It consisted of a horizon line that divided two richly colored areas. One could readily see how such works by Avery had been such an influence on Rothko's later works.

Avery's seascape was entitled *Tangerine Moon and Wine Dark Sea*. I copied it quite literally, not in oil, but in wax crayon. I tried to paint landscapes that were like the mysterious vistas I saw in polished petrified wood from the Ginkgo Petrified Forest near Vantage, in eastern Washington. Or like the "landscapes" in polished thunder egg agates from the Oregon desert. Or in the banded carnelian gemstone agates I found during and after the winter storms on the Oregon Coast beaches at Newport and Agate Beach. Sometimes I even found an agatized clam that contained a water bubble. At Jump-Off-Joe, a sandy ledge just north of Nye Beach, Gary Lundell and I collected "tear drop" agates, tiny, jewel-like agates that had been highly polished by the surf until they glistened like dew drops. The best time of year to collect there was during the winter, when the storms uncovered the gravel bars, exposing the agates. During Christmas 1954, piano student Robert Kuykendall and I visited composer Ernest Bloch at Agate Beach. I returned there often during the following winters, sometimes with painters Paul Dahlquist, Gary Lundell, or Joseph Goldberg, and such friends as Henry Art Gallery editor of art publications, Joseph Newland, and sometimes by myself. We'd stay in the old hotel on Yaquina Bay or at Nye Beach. Many of the landscape paintings I did during

the following years were visual memories of the sense of vastness and eternity I felt when I was there.

Sometimes my "inspiration" for these landscapes did not come from Nature, or anything so noble. I took my visual ideas from wherever I found them, unlikely as the sources might be. The men's washroom at Manning's, for instance, had a linoleum floor that over the years had become badly scuffed and worn. It originally had been a bright yellow, I would guess. All the shoes that had trod upon it had abraded and discolored it. This patch of linoleum over time had come to resemble a stormy sky, filled with turbulent yellow clouds, perhaps even a desert sandstorm. That was the "source" for a painting that one lady wanted to buy from me at Manning's one afternoon.

This potential customer wanted to know what it was that had "inspired" this particular landscape. If I had told her that it had been inspired by the scuffled linoleum floor in the men's room at the other end of the restaurant, I'm sure the sale would have been off. So I lied and invented a story about my recent trip to the Mojave Desert with young painter Joseph Goldberg.

I usually lived in a sparsely furnished room somewhere in the University District. During 1959–1960 I lived at 5212 17th Avenue NE. I was short of money, but my walls were covered from floor to ceiling with paintings. They were mostly works by Tobey. My landlady was Mrs. Ruth Thomas. She was elderly, hard working, and a dear soul. She slept at night on a sofa in her dining room, her ever-watchful police dog sleeping at the foot of her sofa. When I started to paint during the Christmas holiday of 1960, I routinely brought my little landscape paintings to Mrs. Thomas. "*That* picture's about *winter*! Even looking at it

makes me feel cold all over," she exclaimed. "And *that* one could be summer in the desert!" Her comments were always to the point.

I had just purchased Tobey's 1955 painting entitled *Chios* from Otto Seligman. When this painting was shown at the Seattle Art Museum's Northwest Annual exhibit that year, the price on it—$1,500—was considered an outrageous price for a Tobey painting. But I had just received my inheritance, and I was flush. John Hauberg, Jr., the great champion of Tobey, Guy Anderson, and other Northwest artists, and one of the founders of the Pilchuck Center for glass at Stanwood, had seen *Chios* at the Seligman Gallery. He told Seligman that the price was well beyond his collecting budget for Tobey works. When Hauberg returned to the gallery several days later, wanting to look at *Chios* again, Seligman told him that it had meanwhile been purchased.

"Who around here has *that* kind of money to spend on a Tobey?" Hauberg wanted to know.

"A young music student bought it!" Seligman answered.

During 1960 I wrote to Pehr about Mrs. Thomas: "I'm still collecting, but it's on a terribly tight budget. Through a friend, Gordon Grant (the 'mountain climber'—Mark will remember him from New York) I'm getting a copy of the early etching *Tropic of Cancer* directly from Hayter. And I wrote to Milton Avery about getting a seascape drawing. Helmi keeps sending me new work—part of it strictly ethnic work—and some of it part of her religious streak. It's very hard to judge it—except to say that it's indeed most strange. A child's mind, but an adult. My landlady saw *Chios* today & had the most remarkable reaction. She's a little Scottish lady, about 60. 'My,' she said, 'I look at that

and think it isn't such a bad world after all. It gives me the kind of warmth I get from friends. It's as if nobody in the world is mad at anybody else.'"

Joe Harrington, a young Canadian friend, came to my room. He was an engineer and an amateur pianist. He had seen very little contemporary painting. He scrutinized the Tobey works on my walls. "These look like they were painted by a chicken—but a very *intelligent* chicken!" Mrs. Thomas's young grandson wandered into my room. He spotted Tobey's large 1956 painting entitled *Blue Canal* on my wall. "Whee!" exclaimed this eight-year-old. "That's an explosion in an ice cube factory!" I duly reported all of these responses to Tobey. "I like what some of your friends say about my work," said he in reply. "It's what some of those critics write about my paintings that I can't under-stand at all."

DURING 1961 Tobey's dealer, Otto Seligman, brought Parisian art curator Francois Mathay to my room at Mrs. Thomas' house. Mathay was in Seattle to scout out Tobey works to include in his Tobey retrospective at the Louvre's Musée des Arts Décoratifs the following year. He was star-tled to find my small room so full of Tobey's works. He turned to Seligman and said to him in French, "You have taken me to rather grand homes to see Tobey works that have often been of no particular note. And now you bring me to this student's room, and it's like being in a Tobey museum!"

While I was rummaging around in my clothes closet, looking for more Tobey works to show Mathay, he spotted a recent small painting of mine under a table next to my bed. When I came back into the room, he was holding it

in his hands, "Who did this? It's quite good." It was a wax crayon landscape I called *Skykomish*. Helen Ballard, one of my very first patrons, had just bought it from me, and John Uitti had framed it for her.

When Seligman mentioned to Mathay that I was a composer who had just begun to paint, Mathay replied: "Keep an eye on these musicians who become painters! They can be very interesting painters!" The tradition of Northwest painters who were also musicians included Mark Tobey, Guy Anderson, and Windsor Utley. In addition, Paul Klee, Henri Matisse, and Lyonel Feininger were trained musicians. Among the twentieth-century composers who also painted were George Gershwin and Arnold Schönberg. Mathay's interest in my little painting surprised Seligman, who consequently invited me to begin exhibiting with his gallery on University Way.

This painting was rarely exhibited during the next decades, until Sheryl Conkelton, then senior curator at the Henry Art Gallery, included it in her October 1999– January 2000 landmark exhibition, *What It Meant to Be Modern: Seattle Art at Mid-Century*. This important historical survey exhibition marked the first time in the history of Seattle area art exhibitions where one could begin to have a more accurate sense of this region's art scene in the past. Painters and sculptors from the so-called Northwest School were hung next to such painters, sculptors, and printmakers as Glen Alps, Virginia Banks, Fred Anderson, Wendell Brazeau, Boyer Gonzales, Vanessa Helder, Ray Hill, Yvonne Twining Humber, Walter Isaacs, Blanche Morgan Losey, Spencer Moseley, Kenjiro Nomura, and Ambrose and Viola Patterson. These artists, whose work had been overlooked in recent years, were reintro-

duced to the public and art scholars by works of often star-
tling accomplishment and memorable quality.

David Martin of Seattle's Martin / Zambito Gallery
made it possible for many of these works to be available.
Martin had recognized the originality and importance of
many of these neglected artists and was able to locate some
of their finest surviving paintings. The level of quality in
the show was very high, and the interplay of the various
styles that comprised the art being done in this area dur-
ing the first half of the twentieth century was a revelation.

In November 2002 Lisa Corrin, Curator of Modern and
Contemporary Art with the Seattle Art Museum, pre-
sented two concurrent month-long exhibitions of Tobey's
work. One exhibit consisted of Tobey's paintings and
drawings from the museum's own extensive collection. This
was the first exhibition of Tobey's work to be held at the
museum since 1976. In an adjoining room was an exhibit
entitled "Tobey's Friends," which included works by
twenty painters from the Pacific Northwest, New York, and
Europe who had been not only contemporaries but also
personal friends of Tobey. Brought together in a single room
were works by Northwest artists Guy Anderson, Kenneth
Callahan, Morris Graves, Pehr Hallsten, Paul Horiuchi,
Helmi Juvonen, Ambrose and Viola Patterson, George
Tsutakawa, Windsor Utley, and myself; New York artists
Lyonel Feininger, Marsden Hartley, Carl Holty, and
Charmion von Wiegand; and European artists Andre
Masson, Zoran Music, and Vieira da Silva. Works by sculp-
tors Claire Falkenstein and Hilda Morris were exhibited
in the outer galleries as an introduction to the two shows.

This grouping of artists was unprecedented for bring-
ing together painters and sculptors who, though they were

geographically distant from one another and represented different "schools" of painting, were nonetheless affiliated in various degrees and ways as members of Tobey's extended artistic family of friends. For me, it gave the first real glimpse into the range of Tobey's artist friendships here and abroad. I told Lisa Corrin that my being in this particular grouping was probably the happiest experience in my forty-some years of exhibitions, because the basis of inclusion was about the interplay of artistic friendships rather than "art-historical movements" or "artistic reputations." It was about the way it once had been for the participants themselves rather than about the way it was subsequently rearranged by art critics, dealers, and historians.

During 2002 two other books on Pacific Northwest art history appeared: Kitty Harmon's *The Pacific Northwest Landscape: A Painted History*, with an introduction by writer Jonathan Raban, and *Iridescent Light: The Emergence of Northwest Art*, with portraits of twenty one Northwest artists by master photographer Mary Randlett, and essays by writer Deloris Tarzan Ament. Harmon's book begins with artists who painted in the Pacific Northwest as early as 1778, and continues to the present. It includes artists not only from western Washington, but also from eastern Washington, Oregon, and British Columbia, many of whom were in obscurity until Harmon brought them to our attention again. The book by Randlett and Ament confined itself, reluctantly, to twenty-one artists so that Ament could provide a series of profiles, really small monographs, on each artist. Within only a few years, three major sourcebooks on the art of our region had appeared in print, those by Conkelton, Harmon, and Randlett and Tarzan. Earlier books include Martha Kingsbury's *North-*

west Traditions and *Art of the Thirties: The Pacific Northwest,* and Bill Cumming's memoir of the Seattle art scene during the 1930s.

During these years, the University of Washington Bookstore (UWB) book department and the small bookshops in the University District, such as The Book Worm, which is now Magus Books, were where we hung out when we weren't in the local cafes or such taverns as The Blue Moon. Helen Ballard was in charge of the art book section at the UWB. She was a good friend of many of the local artists, and she also played bridge with several women who were notable patrons of the arts. As such, she was often instrumental in introducing the work of many of University Way's indigent artists to such local art patrons as the Nordstrom, Skinner, and Stimson families. Helen's encouragement made a difference for me. She showed my first little paintings to several of her prominent collector friends. Leroy Soper, manager of the general books department, was another of my most supportive collectors. Both he and Helen spread the word around wherever they could, encouraging their friends to buy my landscape paintings. Another patron saint of my early days as a painter was Clarissa Ethel, wife of Professor Garland Ethel. She also worked in the book department. She and writer Elizabeth Patterson had their own circles of friends in the arts. Without such friends as they, I sometimes wonder how I would have managed to keep going during those years when I first started to paint.

MARK TOBEY MET HIS companion-to-be Pehr Hallsten in Seattle around 1939. Some eight years younger than Tobey, Pehr was from Sweden. Unlike Tobey, Pehr was

entirely uninhibited, sometimes dismayingly so, but most of the time charmingly so. Pehr and Tobey hit it off almost at first meeting. Tobey invited Pehr to move in with him. They lived together for twenty five years, first in Seattle, and then in Basel.

Tobey and Pehr's domestic life often erupted into scenes and mutual tantrums that at first confounded me. But I gradually became accustomed to such explosions between them. Tobey was highly self-disciplined; Pehr was not. Their temperamental differences led to all sorts of clashes between them. Tobey described Pehr to me as a man "who just wants to get through life in the easiest and most pleasant way possible."

They were often "out of sync" with one another. Tobey, for instance, had just been hard at work in his studio all day, or busy trying to sell a painting to some haggling collector. Pehr had been at home all day, reading. He wanted to go out for the evening, maybe to a movie at the Varsity Theatre on University Way, or for dinner at a nice restaurant somewhere across town. That involved phoning for a taxicab. Pehr was not given to frugality, especially since Tobey footed all their bills.

Tobey just wanted to spend a quiet evening at home, perhaps playing some music by Schumann or Debussy on his grand piano, or perhaps composing a new piano piece. Sometimes he spent the evening writing impressionistic poems that were reminiscent of Persian mystic poet Jalal Al-Din Rumi's impassioned love poems. Tobey's poems could be intensely personal, filled with ardent intensity and a kind of bittersweet resignation. Or he might spend the evening reading a novel by Virginia Woolf (*To the Lighthouse* or *Mrs. Dalloway*) or Honoré Balzac (*Père Goriot,*

Cousin Pons, or *Cousin Bette*). Even though he was at the time painting some of the most untraditional works being done anywhere, Tobey's tastes in music and reading tended to be conservative.

Tobey liked quiet evenings at home, especially after a long day in the studio. But Pehr was usually restless after supper. "Oh, Mark! I'm so *bored*! I've been home all day. I haven't been out of the house at all. *Why* can't we go out this evening?" By the time the two of them got through arguing about what they were going to do that evening it was often too late to go anywhere.

For some years Mark and Pehr lived in a large two-storey house on Brooklyn Avenue NE. When the Safeway supermarket was built just across the street from them, the reflection from the store's bright yellow façade cast a yellow glare into the street-facing second floor room where Tobey painted during the afternoons. This reflected light distorted the colors in the paintings he was working on. Tobey took me into this room so I could see this distorted light for myself. The room was bathed in an eerie kind of artificial yellow light. I could readily see why he found it impossible to paint there any longer.

Tobey finally packed up his belongings and Pehr and moved into a similarly large two-storey house on University Way. This house was drafty. It was expensive to heat. The floorboards creaked.

Just up the street was the popular Hasty Tasty, an all-night coffee shop. The night owls hung out there. If I had insomnia, I'd get dressed and walk there to have coffee and hotcakes at midnight or so. Across the street from the Hasty Tasty was a popular tavern which is now called the University Bar & Grill. Tobey was a light sleeper. When

the taverns up the street closed at 2:00 A.M., the loud voices of the carousing students stumbling drunkenly down the street outside Tobey's bedroom window were more than he could take. He couldn't fall asleep until everyone was checked in and bedded down for the night. That meant Pehr and people like me, if I was staying over with them. Several years later, when they were living in Basel, Pehr asked Tobey, "Why don't we invite Wes to come and stay with us in Basel?" Tobey replied, "He's too independent. He'd never put up with us for five minutes!"

On Brooklyn Avenue, Tobey would often phone me, asking if I wanted to come over to his house for a few games of *Scrabble*. I had already played *Monopoly* with him several times. Playing any sort of board game with Tobey could be risky. He did not take losing gracefully. When he lost a game of *Monopoly,* it set off a tirade on his part about the real estate business and how landlords exploited tenants with their high rents. If we were playing *Scrabble*, he would start to invent words we other players had never heard of. If any of us challenged him, he would leave the room and return with a hefty dictionary. He'd search, usually in vain, for that esoteric word that he insisted was in the dictionary, if he could just remember where he had seen it. Playing *Scrabble* with Tobey was, I learned later, as risky as was playing tennis with Theodore Roethke; neither of them were good losers.

Tobey liked to attend chamber music concerts at Meany Hall. Pehr barely tolerated classical music. Their common ground for evening entertainment might consist of a movie at the Varsity Theatre on University Way, followed by coffee and pastry at the Bon Ton. One evening as we were playing *Scrabble* with Portland artists Carl and

Hilda Morris, Mark and I looked up to see Pehr shuffling into the living room in his dangling stocking-cap and baggy pajamas, looking like something out of a storybook.

"I've come to say good night," said Pehr.

"For God's sake, Pehr, go *back* to bed!" barked Tobey, embarrassed.

Pehr nevertheless walked over to Mark and kissed him gently on the forehead. "Good night, dear Mark. Good night to all of you," he said as he shuffled back into the hallway and up the stairs to his second-floor bedroom. Tobey was beside himself. It took him a while before he could calm down enough to concentrate on the *Scrabble* game again. Carl, Hilda, and I took it in stride. I knew pretty well why Pehr had enacted this little bedtime scene. He liked to poke fun at Tobey's unaffectionate for-mality. He liked to tease Tobey whenever he could. As he had told me, "When I like someone I show it. When Mark likes someone he just gets complicated!"

Pehr was indeed demonstrative. During the spring of 1958, I introduced twenty-five-year-old composer Alan Stout to Pehr, who was then about sixty-one years old. Alan was a superbly accomplished composer whose works had already been performed by some of the leading musicians of the day. He had come to Seattle from Baltimore, in part to study music counterpoint with composer John Verrall, who had studied in Budapest with Hungarian composer Zoltan Kodaly. Many of Alan's fellow students in the University of Washington's School of Music often came to him for musical advice. In fact, he was so capable that he intimidated some of the members of the music faculty.

Alan was already familiar with Tobey's paintings, hav-ing seen several exhibitions of them on the East Coast. I

offered to introduce him to Tobey. When we arrived at Tobey and Pehr's house, Pehr answered the door. He explained that Tobey was still at work in his painting studio down the street and probably wouldn't return home until around dinnertime.

Pehr invited us in. He was in his lounging robe. He had been reading a recent issue of *Svenskatag,* the leading Stockholm newspaper. When he lived with Tobey in Seattle during the 1940s and 1950s, and after he settled with Tobey in Basel during the early 1960s, he subscribed to this newspaper and read it almost daily.

Pehr was delighted when Alan greeted him in fluent Swedish. Pehr rarely had occasion to speak Swedish with anyone in Seattle. While we sat in the informally furnished living room, Pehr studied Alan carefully, then exclaimed in his distinctive Swedish accent: "What a nice-looking young man you are! Tell me now, do you have a girlfriend, or a boyfriend, whichever it may be?" Alan explained that he had neither a girlfriend nor a boyfriend. Pehr looked dismayed, and replied: "You mean to tell me that a nice young man such as yourself doesn't have a girlfriend, or a boyfriend, let alone a lover! Why, that's *awful*! Doesn't *anyone* send you any love letters?"

Alan answered that he had never received a love letter from anyone in his entire life. Pehr was nonplussed. He went to a cabinet desk in the adjoining dining room, pulled open a drawer, and took a bundle of letters from it. He carefully unfolded one of the letters and began to read it to us. "Oh, my most darling Pehr," it began. It was rapturously romantic. It was from a young lady in Stockholm. He described her to us. Her name was Inga. She was twenty three or so years old. She was traditionally tall and blond,

and she had sparkling blue eyes. She and Pehr had met on a downtown bus in Stockholm. After a brief exchange, Pehr invited her to lunch at a well-known local restaurant. When Pehr traveled, Tobey saw to it that he always had plenty of money with him. When Pehr ran out of money, he wired Tobey in Basel, who would immediately send still more funds. When the staidness of Basel got to be more than he could take, Pehr usually returned to Stockholm for a month or two, or he went to Palma, Majolica, where Spanish painter Juan Miró lived. Shortly after Pehr met Miró, he sent me a picture of the two of them together. Unfortunately, the camera had only recorded Pehr's feet while he stood back from Miró. Pehr sent dozens of snapshots, letters and postcards to me while he was in Europe. He had just finished his studies in the Scandinavian Department at the University of Washington with a thesis on the work of Swedish dramatist and novelist August Strindberg, along with his taking courses in anthropology with Erna Gunther. Now that he had a Master's Degree, Pehr liked to be addressed as "Professor Hallsten" when he was traveling about Europe.

Pehr read a bit more of Inga's letter to us. Parts of it became almost indecently amorous. Pehr lingered over reading those parts to us. Sometimes he read them aloud twice. He opened another letter. This one was from a nineteen-year-old Swedish boy named Lars. He was a strapping youth, and, like Pehr himself at that age, had grown up on a farm in northern Sweden. Now he was in Stockholm, studying to be a doctor. He and Pehr became fast friends. Lars's letter to Pehr was endearingly affectionate. And these were only two of the dozens of ardent fan letters that filled the thick folder Pehr held in his hand.

Pehr studied Alan intently and exclaimed: "Young man, something is very, *very* wrong here. You are a young man, and you don't receive any love letters from anyone at all. I am an old man, but nevertheless I receive lots of love letters—from beautiful young girls and handsome young men all around the world. Now *why* should this be? I think it may be that I know something you don't know. I will wager that it's your shyness that is keeping you from having the romantic sort of life that you should be having at your young age. I will tell you something now. If you like someone, you should *tell* them so. But, and this is *very* important, you have to know how to tell them *nicely*. Otherwise you may scare them off. And you wouldn't want *that* to happen!" By the time Alan and I left Tobey and Pehr's house that afternoon, I think Alan, like so many of us young folk, had fallen quite in love with the perennially romantic and entirely uninhibited Pehr.

At first impression, one might have thought that Tobey and Pehr had very little in common. That was hardly the case. Tobey's meeting Pehr in Seattle in 1939, when Pehr was forty-three, and Tobey was forty-nine, "brought some real some stability into my life. I was able to settle down to painting," Tobey explained to me. Mark Ritter, who lived with Tobey and Pehr in Basel during the 1960s and 1970s, told me a somewhat different version: "Just after they met, Tobey looked at Pehr and thought to himself, 'My God, if I'm going to support this big new baby of mine, I'm going to have to really get down to painting, and get out there and sell those paintings.'"

Tobey spoiled Pehr in every imaginable way. Perhaps this was Tobey's way of trying to strengthen the bonds of their companionship, by making Pehr dependent upon

him. Nevertheless, the friendship between them went so deep that, as Tobey said to me, "At times it might have seemed that there was nothing between us." But was it always Tobey who supported Pehr? Portland painter Hilda Morris, who knew them both very well, remembered the days when Tobey and Pehr first met. According to Hilda, Pehr was a tall, husky Swedish immigrant who worked as a laborer in Seattle, at times supporting both himself and Tobey during part of their early years together. Zoe Dusanne confirmed for me that Tobey "came into his own when he had to take care of Pehr."

HOW DOES A YOUNG PERSON learn what it is to become an artist in the world? For all of my studies at the University, the real instruction I had came from knowing Tobey, Pehr, Graves, and Anderson, and the different ways they constructed their lives, either alone or with each other. Anderson lived by himself, painted, and had a good number of close friends. He was gregarious and easily approachable. But he was not, as far as I knew, intimately close to anyone. Graves lived at Woodway Park, just south of Edmonds, with Yone Arashiro. Yone was more like Morris's houseboy than an intimate companion.

It was the friendship between Tobey and Pehr that intrigued me the most. Their life was a very settled one. As I gradually got to know both of them, I had glimpses into how deep and subtle their friendship was. In many ways, they could not have been more unlike. Tobey loved music. Pehr was indifferent to it. Tobey was highly disciplined. Pehr just wanted to enjoy life in the most pleasant way possible. Tobey was rather formal and not given

to affectionate hugs and embraces. If Pehr liked someone he was very demonstrative.

Tobey was thoroughly wed to Pehr in friendship because of, rather than despite, their many differences. These differences had a great deal to do with the stability of their friendship, although it was difficult to figure out why. Each of them had a well-defined personality. There was a true equality between them. Their friendship reminded me of German poet Rainer Maria Rilke's description of love—the joining together of two solitudes that protect each other and yet go their separate ways.

WHILE TOBEY PAINTED in order to support himself and Pehr, I decided to try to live on what I could earn from having only part-time jobs. While I was studying with Roethke, I worked as a dishwasher and busboy at Manning's cafeteria on University Way. The pay was modest, but my meals there were free. During the Christmas season of 1960 I worked in the evenings as a book salesman at Hartmann's Bookstore on University Way. It was there that I first encountered Erich Scott. He was twenty three years old. He was from upstate New York. He had left home when he was nineteen or so and had been on his own ever since. He'd lived in San Francisco and Hawaii, where he'd found temporary employment in the pineapple fields. He'd even been kept along the way.

But now he was tired of being on the road, rootless. He wanted to settle down. Shortly after we met, Erich got a mystical sort of notion that his meeting me was some preordained Act of Fate. At the time, I was rather lonely myself and not about to take issue with his somewhat

spooky reasons for wanting to settle down with me. But from the way he spoke about other people he had known, I did, however, realize that he had the potential for being something of a scoundrel. I realized that moving in with him could very well become a real folly. I also realized that the opportunities one has for folly don't arise every day. There is a season for folly in ones life. Erich embodied it.

Several months after I met Erich, he began to wonder how dependent upon living in Seattle I was. Would I be able to live in a different city, one in which I knew hardly anyone. This question intrigued me. I wouldn't know its answer until I could find out for myself.

My parents arranged for Erich and me to spend part of the summer of 1961 in a beach cabin at Totem Beach on the Tulalip Indian reservation, just north of Everett. Those weeks were one of my rare experiences in "living off the land." In the mornings, we walked from our beach cabin to Anderson's dairy ranch, where we bought our fresh eggs. Taking a shortcut through the woods, we picked blackberries and raspberries. My parents, who lived down the road, had crab pots in Tulalip Bay. They provided us with fresh crab and vegetables from their backyard garden. In the evening, having no radio, we played *Scrabble,* or we went for long walks along the beach. During the late summer nights the smoke of many campfires along the beach curled up into the air. In the distance, to the south, the lights of Everett lit up the sky.

There were still vivid traces of the Tulalip Indians' former ways of life visible at Tulalip that summer. Chief William Shelton's daughter, Harriet Dover, lived near my parents' house at Hermosa Beach. Several of Chief Shelton's hand-carved totem poles were in her backyard. These

tall slender poles reminded me of Romanian sculptor Constantine Brancusi's totemic sculpture entitled *Endless Column*. Both Chief Shelton's and Brancusi's sculptures seem to continue upwards into the sky, even when one's eyes came to the very top of them.

Near the spillway and old mill was a small promontory on which, we were told, some of the burial sites had once been. Corpses had formerly been interred in the trees there. Whether this was true or not, it made Totem Beach much more mysterious for us, especially when Erich and I walked past this ancient burial site in the dark. How many of the myths and legends we were told were actually true? In a way it didn't really matter to us. Based in fact or not, they added much to the high romance of our being at Tulalip that summer.

Later that year, Erich and I moved to Bellingham and took a small apartment on Garden Street, next to the campus. Our windows looked out on Bellingham Bay, Lummi Island, and the Olympic Mountains. We had a small fireplace. Our elderly landlady, Mrs. Thad McGlinn, saw to it that we always had plenty of firewood. We had an old-fashioned washing machine, and when the weather allowed it we hung our clothes out to dry on a backyard clothesline. I was having another of my domestic episodes.

My parents drove up from Seattle to take Erich and me for excursions in the country. Jean Russell also drove up from Seattle sometimes to take us to Vancouver, just across the border, for an afternoon. We started to collect Indian artifacts during those months in Bellingham. The local secondhand shops had Thompson River, Nootka, and Makah baskets, Nez Perce cornhusk bags, and Plains Indian beadwork for sale. It was a good time in which to

be collecting this Native American art. There was not much local demand for this art then, and the prices the dealers asked for these artifacts seemed very reasonable.

Vancouver's Canadian Cabin Crafts, run by two outgoing gentlemen, Harry and Tim, was filled with fabulous things: Northwest Coast bentwood boxes, ancient ivory carvings, Haida, and Kwakiutl masks, totemic carvings, and baskets from the Thompson River, Haida and Tsimshian Indians to the north. Harry and Tim would notify Jean when they had just come back from touring the coastal Indian villages with their private boat, buying artifacts.

Sometimes Erich and I went with Jean Russell to spend a weekend with Philip and Anne McCracken on Guemes Island. Or my parents drove to Bellingham from Tulalip and took us for excursions in the country. It was a new experience for me to live in relative isolation in Bellingham. There was little if any nightlife there. I read a great deal, painted, or made linoleum prints. I spent a great deal of the time exploring the area.

Sometimes we watched the sunset from Seahome Hill, high above the Western Washington University campus, where my mother had been a student during the 1920s. When the sun went down and the night came on, the distant San Juan islands and the Olympic Mountains to the west glowed like embers. Late at night, the sound of the fog horns on Bellingham Bay would wake me from a heavy sleep. Like some kind of highly abstract music (such as John Cage might have composed), the long intervals between their ponderous sounds became a meditation upon the importance of silence in a world of incessant noise.

But mostly I read that winter. Erich introduced me to J. Krishnamurti's *Commentaries on Living* and *Education*

and the Significance of Life, and to Eric Fromm's *The Art of Loving*. He also introduced me to Swiss writer Herman Hesse's books, especially to his early novels: *Demian, Narziss und Goldmund*, and *Peter Camenzind*. We ordered several of Hesse's books by mail through publisher Peter Owen in London.

One evening, sitting at our little kitchen table, looking out at Bellingham Bay, Erich had an idea. "Let's write a letter to Herman Hesse!" he said.

"But he probably gets too many letters already. What could we possibly say to him?" I asked.

That evening, we drafted a letter to Hesse in Switzerland: "Dear Mr. Hesse, We want to tell you how much your wonderful books mean to us. But you undoubtedly receive many such letters. So instead of writing you one more fan letter, we're sending you a few gifts from the part of the world in which we live—some polished opalized wood from the Ginkgo Petrified Forest in the eastern Washington desert, and a polished agate nodule from the Oregon desert. This stone was called a "thunder egg" by the early Indians, and by the local collectors today. Sincerely, Erich Thrun, Wesley Wehr."

Several weeks later a small packet arrived in our mailbox on Garden Street. Hesse had inscribed a photograph to us, and he sent with it a small book of reproductions of his own landscape watercolors. We wrote him back, thanking him. Several weeks passed, and another packet from Hesse appeared in our mailbox. He had written an open letter to young people and published it in *Universitas*, a German publication. This open letter of his was a response to the many young people who wrote him, often complaining to him that life had no meaning for them. Hesse's

published letter to young people said: "You will sometimes write to me that life has no meaning. I assure you that life itself has a great deal of meaning. What you mean is that you don't feel that your own life has any meaning. It is for each of you to find for himself the meaning of his own life."

I wrote to Mark Tobey in Basel, to Susanne Langer in Connecticut, and to painter Paul Dahlquist and pianist Jack Ringgold in Seattle that winter. Corresponding with them was a bittersweet experience, because I felt so isolated at times. But these communications back and forth made me realize just how important such letters can be.

THAT WINTER IN BELLINGHAM lent itself to contemplation. I thought of other places I had visited during previous winters, especially the Oregon Coast, and of those afternoons when I collected the surf-polished moonstone and cloud agates at Agate Beach, a few miles north of Newport. I visualized the narrow path that led up from the beach to the wood-shingled house where composer Ernest Bloch lived and wrote some of his greatest music, his last string quartets in particular. Just up the beach was Yaquina Head, with its lighthouse casting its rays out to sea at night. This promontory was a remnant of the lava flows that covered eastern Washington during the Miocene epoch, some fifteen million years earlier. The same lava flows that encased the trees at Vantage, turning them to gem-like agatized and opalized wood, had, according to regional geologists, continued down the Columbia River gorge to the present Oregon Coast, and ended at Yaquina Head, several hundred yards from the house where Ernest Bloch once lived.

The best time for finding agates on the Oregon Coast

*In 1953, Lucienne Bloch photographed her father beaming
proudly while his grandson, George Ernest Dimitroff, played
the piano for him. On December 18, 1954, piano student
Robert Kuykendall and I visited Bloch here. Two years later,
I arrived at his front door with the manuscript of an orches-
tral work I had just dedicated to him. Many of the seascapes
I painted in later years came from my memories of beach
combing here during the stormy winters. Photograph by
Lucienne Bloch, courtesy of Sita Milchev.*

beaches was after the winter storms had washed away the sand, exposing the expanses of gravel. Late in the afternoon, when the sun to the west was low on the horizon, its rays crept across the beach, illuminating the surf-polished agates until they glowed like small votive candles among the drab gray and black cobbles.

This was the beach where Ernest Bloch often walked alone, looking for his beloved agates, ones he treasured, he told me, more than all the prizes awarded him for the music he wrote.

I also recalled summers when I spent time alone in the eastern Washington desert. Collecting arrowheads near Vantage on the Columbia River. Waking at dawn at Crab Creek, below Saddle Mountain and its petrified wood–bearing cliffs. Or hiking at Cayuse Canyon, north of the Ginkgo Petrified Forest, when the sun blazed above me. Sitting in the afternoon shade of the cottonwood groves that grew beside the small creek that flows into the Columbia River at Scammon's Landing. Or climbing up the talus slopes to the Indian rock-shelters in the Moses Coulee, near Chief Joseph's former winter campground. Watching the sunrise as it slowly illuminated the distant Frenchman Hills to the east of Vantage.

It had not always been like this. This landscape that seemed so serene, silent, and desolate now had known many dramatic changes. During the Miocene epoch lush forests grew here instead of today's sagebrush-covered desert. The Miocene forests included *Taxodium* swamp cypress, Chinese dawn redwood, tupelo, Ginkgo, and locust trees. To find a similar forest now, one would need to go to the southeastern parts of the United States. The Vantage area was a Miocene landscape where herds of

peccaries, rhinoceros, and camels roamed, until violent volcanic eruptions to the east sent flow after flow of molten lava across the land, engulfing the forests, entombing the trees that would in time become opalized logs weathering out of the basalt cliffs.

In the desert at night, looking at the basalt cliffs and the full moon above them, I began to visualize what the landscape had once been. Those nights in the desert became meditations on how all things change: the landscape, human relationships, and the values that dominate one's life from season to season.

Those were the times when I left behind me all the routines and social conventions to which I'd become accustomed. Those were the times when I went to the desert, the sea, or the mountains, to be alone for a while, contemplating what Pascal called "the silence of the infinite spaces."

Susanne K. Langer:
Philosopher of
Art & Science

PHILOSOPHER SUSANNE K. LANGER WAS one of the first women in the United States to become a professional philosopher. To be accepted by a community of male philosophers during her early years was a formidable challenge. As she once explained to me: "To be taken seriously by other philosophers during my early years, I had to be at least twice as 'logical' as they were. After all, women were usually dismissed as being flighty, illogical creatures."

Langer was visiting professor of philosophy at the University of Washington during 1952 and 1953, and she revisited Seattle in 1966. During her time in Seattle she met, and in some instances became good friends with, a number of painters and musicians—notably, painters Guy Anderson, Mark Tobey and Morris Graves, poets Elizabeth Bishop and Richard Selig, and musician Eva Heinitz.

Langer's well-known book *Philosophy in a New Key: A Study in the Symbolism of Reason, Rite, and Art,* a highly popular and very readable introduction to her philosophy of art, was first published in 1942. It is still read and admired by scholars, artists, and a wide public, as are several other

books of hers. In sharp contrast to the popularity of some of her books, Langer was a very private person, one who disliked excessive public attention. Her friendships, her daily life, and her conversations were private matters.

She would have strongly disapproved of the memoir that follows. When she read some of my published conversations with Mark Tobey, she warned me that I was wasting my time recording and writing accounts of my friendships with various artists, writers, and musicians I had known: "You should be concentrating on your serious work, your painting and paleontology. If you spend your time writing memoirs you will not develop intellectually," she said firmly.

Despite her dislike of memoirs, I began to take notes on my encounters with her. What follows is a brief account of her conversations with various Pacific Northwest painters, writers, and musicians during her visits to Seattle.

When I first met Susanne Langer she was nearly sixty years old and I was twenty-three. One of her students, Paul Mills, was also curator of art at the Henry Art Gallery on the University of Washington campus. Paul was so enthusiastic about Langer that I wanted to meet her myself. But I knew nothing about philosophy; my formal training was in music composition. At best, I had browsed through Will Durant's *Story of Philosophy*, a popular introduction to the field, and I had taken an introductory course taught by visiting aesthetician Morris Weitz.

I knocked on Langer's office door and introduced myself. I explained that I was a music student, and that I knew her cellist friend Eva Heinitz, and also Paul Mills. Trying to justify my unexpected visit to her, I added that I had taken a class from Weitz. We had a brief, quite pleasant

Philosopher Susanne K. Langer (second from right) with her father, Antonio Knauth (far right), her two sisters, Ursula and Ilse, and their riding groom, probably in Central Park, circa 1910. Shortly after this picture was taken sixteen-year-old Langer began her formal studies in philosophy, at a time when women were not considered eligible material for entering the male-dominated world of American professional philosophy. Photograph courtesy of Leonard Langer.

conversation. Langer had already invited Eva and Paul to her rustic cabin in the woods, a short drive north of Seattle. She rented it from music professor Theodore Norman. She suggested I might like to join Eva and Paul for an afternoon in the country with her.

When we arrived at Susanne's cabin she had already packed a picnic basket. We hiked to a nearby stream and had our lunch there. Susanne seemed to be in her natural element when she was in a forest. Nothing escaped her nature-loving attention. Whether it was an animal's tracks on the trail, or whirring insects in the bushes, or a bird flying past her in the sky, or even a croaking frog in the stream, she knew the names of nearly all of them. During that afternoon in the woods with her, I had my first glimpse of the newfound friend with whom I would comb beaches and collect fossils in years to come.

Wherever Susanne traveled, two things invariably accompanied her: her card catalog files and her cello. She always had to be within easy reach of her card files, which contained hundreds of her carefully notated file cards. These cards were filled with copious notes from her far-ranging reading in philosophy, biology, anthropology, art, and a long list of other such subjects, with her personal observations, and with remarks made to her by friends, remarks that stimulated her reflective imagination.

We began to meet regularly for lunch in the University District. Howard's restaurant served Danish meatballs with onion gravy. This was exactly the sort of food that Susanne liked. One time while we were there, poet Richard Selig came up to our table and joined us. He and I first met in Theodore Roethke's poetry workshop in 1950 and had become fast friends. I had just finished showing Susanne

a polished zeolite specimen from the Oregon coast. It was snow white, with shimmering halos of crystals like moonlight radiating out from its center. She had never before seen anything like it. She passed it to Richard.

"Wes is like Saint Francis. Beautiful stones come to him on the beach just as the birds came to Saint Francis!" she exclaimed.

I explained to Susanne that Richard and I studied poetry with Theodore Roethke, and that Richard was soon leaving for Oxford as a Rhodes Scholar. Richard made a remark about poetry that delighted Susanne.

"That's very interesting! I may need to remember that!" Susanne exclaimed, taking a small brown manila folder out of her purse. It was filled with file cards. She recorded Richard's remark, and then read it back to him, wanting to assure herself that she had quoted him correctly. I often saw her write down a remark that particularly interested her. These duly recorded remarks, she explained, might eventually fit somewhere into her work.

Susanne Langer's other traveling companion was her cello. It could be cumbersome to travel with it in her station wagon, but she would not dream of traveling anywhere without it. After all, there was always the possibility that a few musician friends might be in the neighborhood, and there could be an evening of chamber music. Susanne liked to be prepared for such a possibility, even when it was remote.

While she was teaching here during 1952 and 1953, she studied cello privately with Eva Heinitz. When she was at home in Old Lyme, Connecticut, she enjoyed playing chamber music with her musician friends, "That is, if I can find anyone who is willing to play music with such a

weak sister! My cello teacher once told me, 'You are my best student, and my worst student! My best because you only have to be told once, and my worst because you even have to be told at all,' " she said.

At Paul Mills's suggestion, I had been reading Susanne's book, *Philosophy in a New Key*. Over coffee one afternoon, I exclaimed to her, "Susanne, you are a *great* philosopher!" She found my praise excessive: "It is very nice of you to say that, Wesley. Despite your generous claim for me, I am most certainly *not* a great philosopher! Aristotle and Plato are great philosophers! I *am*, however, working with a great idea. But it's not even my own idea. I swiped it from [Ernst] Cassirer!" she explained, setting the matter straight.

Then she said something that offended me: "Although a scholar most assuredly has to understand what he reads, it doesn't matter so much that an artist understands what he reads. The important thing for an artist is the excitement, being inspired by things. That's what leads to new work. Some very interesting paintings came out of a misunderstanding of Cezanne's statements about painting, works by some of the post-cubist painters, for example." I disliked the import of what she had just said, resenting her implication that painters are merely mindless oysters, producing lovely works of art when they are stimulated or irritated. But I said nothing at the time, feeling too anoyed for discussion.

While Langer was in Seattle she met painters Mark Tobey, Guy Anderson, and Morris Graves, and poets Elizabeth Bishop and Richard Selig. She was very interested in what creative people had to say about their first-hand experiences in practicing their respective arts. She believed that they can often have important artistic

insights, and that they can also have what she called "pre-scientific insights" into the nature of biological processes. She had reservations about artists reading her books: "Perhaps artists should not read my books. It can make them self-conscious and overly theoretical."

I objected to her saying this. After all, Seattle painter William Ivey was a serious admirer of Langer's writings on art. He could talk about them with intelligent familiarity. His paintings were assuredly never self-conscious or "theoretical."

Susanne had many far-ranging conversations with Guy Anderson, who recalled: "I saw her on a number of occasions. She lived out north of town, not too far from where I lived in Edmonds at the time. Sometimes I'd go over to her place, a little house out in the country near a brook, a very pretty little place, and have supper with her. Then she would come over to my place. I had a little outdoor fireplace. We'd sit there on summer nights and talk about various things. One evening I had the fire going and we were looking at the flame. She was saying how fascinating the fire was. Here it is! And then it isn't! Here's the flame! Then it isn't! Then she said, 'There's a possibility, you know, that the world will be destroyed by fire.'

'Yes, I know. I know that's very possible!'

'Well, how do you know?'

'I've been taking *The Bulletin of Atomic Science* from the University of Chicago.'

'Yes, then you know,' she answered."

I interviewed Guy Anderson for an archival project. He described a different conversation he had with her: "I had been reading *Philosophy in a New Key*. I read it twice. When I was reading it, I could understand what she was

saying. At least I thought that I was understanding what she was saying. Of course, I couldn't remember anything five minutes later. That's typical of my mind. This is when she explained that her book was never intended to appear in a paperback edition. She was surprised at how popular a book it became. I noticed what a remarkable memory she had. I remarked on this to her.

'My memory is like flypaper. Everything sticks to it. I don't have to try to remember things. I just remember them,' she answered.

'Being a philosopher, do you feel responsible for the state of the world? It seems to me that people like you who have so much information, that if you're going to reach people you simply have to arrive at complex things through simple terminology,' I remarked, asking her very pointedly, 'Are you interested in saving mankind?'

'Yes, I am,' she answered, adding that she had done a number of things in conjunction with the United Nations. Finally she said, 'But you know, when you asked for complex things to be reduced to simple terminology, this is the hardest thing in the world to do!'"

SUSANNE AND I HAD LUNCH on campus with painter Mark Tobey. I wondered what they would make of each other. As soon as we finished ordering our lunch, Tobey launched into a long monologue on art, science, and philosophy. As usual, he was strikingly articulate, but he soon became so caught up in his own eloquence that I had to remind myself that he had once wanted to be a preacher, and he had always liked center stage. He had even performed in a John Galsworthy play at the Cornish School when he taught there during the 1930s.

Susanne leaned forward, listening intently to his words. When he finished, she responded: "That was very interesting, Mr. Tobey. You made several points that particularly interested me." She proceeded to reconstruct from memory a good part of what he had just said. Tobey was visibly alarmed. He wasn't at all used to having a trained logician listen to him.

They began to talk about music. Tobey studied piano privately with his friend Berthe Poncy Jacobson. He complained to Susanne that being a painter, he sight-read piano music "visually," rather than "musically." The distinction puzzled her until he explained, "I have a terrible time counting notes and figuring out rhythms. I see the music page visually, just as I would look at a painting or drawing. If I see a few notes, and large ones, I react and play too slowly. If I see clusters of little black notes, like swarms of insects, my eyes get excited and I play much too fast!"

Susanne was fascinated by all of this. She was interested in how artists perceive things. Even though artists frequently use words vaguely and loosely, or speak a private dialect with each other, Langer was adept at grasping what they were trying to get at. But when it came to how her peers expressed themselves, she had no patience with imprecise language or quasi-mystical mumbo jumbo.

It was apparent that Tobey was quite impressed by Langer. He seemed even intimidated by her. This surprised me. It was rare for Tobey to be intimidated by anyone. When she left the room briefly to make a phone call, he exclaimed, "Ye Gods! What sort of food does she eat? High protein, obviously!"

In 1953, Susanne Langer gave a campus lecture enti-

tled *Artistic Perception and Natural Light* at Savery Hall. Assuming that a talk with such a title would have something to do with painting, I invited Morris Graves to attend. The subject turned out to be far over our heads. Morris suffered through its entirety with stoic self-control. As Susanne methodically developed her philosophical points Morris glanced at me, a perplexed, even pained look on his face. After the lecture was over, I introduced them. Morris thanked Susanne and took off into the night, looking back at me, still puzzled by why I had invited him to such an esoteric talk.

During the summer of 1969, painter Joseph Goldberg and I visited Morris in Loleta, California. I mentioned to Morris that I wrote Susanne almost daily. He was dumbfounded.

"And just what do you write to Dr. Langer about that could possibly justify your writing her so often?" he wanted to know.

I mentioned my interests in paleontology, geology, and botany, and how I often wrote to Langer about such things.

"I see. You're on a 'head' trip these days!" Morris responded dryly.

NEAR TUKWILA, just south of Seattle, stands a fossil outcrop called Poverty Hill. Here one can collect thirty-million-year-old fossil shark teeth, corals, and cowry and cone shells. This outcrop contains fossil evidence of what was once a tropical lagoon. When I sometimes tried to describe for Seattle visitors this dramatic difference in our prehistoric environment, I occasionally took them to this fossil-bearing hill. As soon as any one of them found his own fossil shark's tooth or a bit of coral, he could visual-

ize for himself what a very different world had once been here.

I took Susanne to Poverty Hill one afternoon. We had our picnic lunch on a grassy ledge that overlooked the meandering Duwamish River below us and the Seattle sky-line to the north of us. Susanne was enthralled by the fossil shells she found in the gray clay at Tukwila. She wrapped them carefully so she could take them home with her. As we were driving back to the University District, she said, "I was thinking earlier today that people can turn into fossils, and often do. They settle into always responding the same way to any given situation. They don't learn from their experiences. They just blindly react to them. They have fixed opinions that nothing can change. Worst of all, they even take pride in all of this predictability of theirs by calling it their 'identity.' Yes, now that I think about it, people themselves can become fossilized—just like the fossil shells we collected today!"

IT IS NEARLY IMPOSSIBLE for me to figure out now just when and how I began to evolve toward becoming a paleobotanist. It was hardly a conscious decision. Like much of the rest of my life, irresistible opportunities arose, or I met remarkable people, such as Susanne Langer, Mark Tobey, and Elizabeth Bishop, who encouraged me to follow the interests I had in fossils, minerals, crystals, and the world of natural history. My visits to the paleontology rooms of great museums—especially the Smithsonian Institution in Washington, DC, and the Museum of Natural History in New York City—introduced me to a world of endlessly fascinating rare minerals, crystals, and fossils, and their extraordinary aesthetic beauty. My

embryonic painter's eye responded to them. I began to want to know about how they were formed, about the geologic times and environments in which they once lived, just as I now lived in my own time and place.

I think it was Susanne, with her insatiable interest in the scientific nature of things, combined with her naturalist's appreciation for the outdoors, who was the single most important personal influence in directing my life toward that of a paleontologist. Recognizing Langer's importance to both himself and me, renowned paleobotanist Jack Wolfe and I named a new genus of fossil plant for her in 1987: *Langeria magnifica* Wolfe & Wehr. Paleobotanist Ruth A. Stockey and her student, Diane Erwin, in turn named a new genus for Wolfe and me: *Wehrwolfea*. They weren't aware at the time that some forty years earlier I had interviewed the legendary portrayer of Count Dracula, Hungarian actor Bela Lugosi, in his dressing room at Seattle's Metropolitan Theater, where the Four Seasons Olympic Hotel now stands. Time has the oddest and most unpredictable ways of coming full circle in one's life.

SUSANNE LANGER WAS UNLIKE anyone I had ever met. I gradually developed a few general impressions of her. She spoke in a straightforward way, right to the point, and with no rhetorical flourishes. Her voice was soft and animated. Her speech was clear and precise. When she was annoyed or riled, she still spoke softly, but her words now had an edge. She would not so much lose her patience as let one know that she was on the verge of losing it. It was a warning signal not to be ignored or taken lightly. If she became angry it was usually for a reason I could antic-

ipate. For instance, she particularly disliked snobbery and pretentiousness of any kind.

Susanne turned out to be far more adventuresome than I would at first have anticipated. One Saturday morning the phone rang at the apartment I shared with painter Bob West. It was Susanne.

"Wesley, it is such a beautiful morning, and I do need to take a break from my work. Would you be free this afternoon for some beachcombing? I can pack a lunch for us and pick you up at your apartment. If you would like to do that and can spare the time."

When she arrived in her station wagon a few hours later, she was wearing casual Levi pants and a woolen shirt. She had prepared and brought along our picnic lunch and even a thermos of coffee. We headed for the beach at Golden Gardens, a short drive from the Ballard District of Seattle. I had told Susanne about the tidal pools there, and the large boulders of basalt in the beach bulkheads, ones that contained small pockets of radiating zeolite crystals. She wanted to see them for herself.

On a ledge above the beach are railway tracks. Next to them is a trail along which one can walk, admiring the snow-capped Olympic Mountains, some sixty miles to the west. Looming above the railway tracks are tall bluffs covered with Scotch broom and blackberry bushes.

We walked along the beach, stopping to inspect the marine life in the tidal pools. We climbed up a dirt bank to the trail above the beach, the one beside the railroad tracks. Walking there could be dangerous. You never knew when a train might unexpectedly come around the corner.

Susanne was standing on the trail next to the cliffs,

and I quite stupidly was walking along the railway tracks. I spotted a white stone between the railway ties. It was quartz, and it had a slight cast of pink. I picked it up and stepped off the railway tracks to show it to Susanne. Just as I handed it to her, a train came speeding past us, on its way north. It passed within a few feet of me. Susanne and I stood staring at each other, saying nothing. We decided we'd had enough of beachcombing for the day. It was time for dinner.

While we sat in a Chinese restaurant in the International District, drinking tea, waiting for our dinner to arrive, Susanne said, "Wesley, you were almost killed by that train today, you know."

"Yes, I know," I answered.

What I was really thinking to myself was, "Young people don't die. It's only very old people who die. I am only twenty-three."

Three years later, while I was visiting Susanne in Old Lyme, we sat having supper in her backyard patio. It was early evening. After a particularly warm summer afternoon the cool evening was refreshingly pleasant.

Susanne pointed at the patio where we sat.

"Look at the stonework next to you. You may recognize something."

The quartzite pebble from my nearly fatal episode at Golden Gardens was embedded in the patio cement.

"I asked the stone mason to put it there when he made this patio for me. I wanted to keep that stone as a reminder of how precarious our lives can be," she explained, looking unusually reflective.

She got up from her garden patio chair and walked into the house.

"Our dinner should be ready by now. I hope you like chicken. After dinner I'll bring out a bottle of our family wine to celebrate your being here. Perhaps we should toast that stone, too. After all, if it weren't for that stone, you wouldn't be here this evening."

After Susanne returned to Old Lyme, we kept in touch regularly. I sent her such gifts as moonstone and cloud agates from the Oregon coast, or fossil leaves from Chuckanut Drive, south of Bellingham. Sometimes I sent her opalized wood from the Ginkgo Petrified Forest at Vantage, near Ellensburg. In turn, she sent me gemlike quartz pebbles she'd collected on the beach at the mouth of the Connecticut River, or mineral specimens she bought in gift shops during her travels. Many of our letters to each other began with an acknowledgment of these gifts we sent each other.

Susanne and Guy Anderson also kept in touch. During the autumn of 1956, she wrote him, "Wes told me that you had moved into town. I wonder whether you have found a place where you can put up an umbrella and live in the yard, or plant a palm tree to keep your paintings dry! I found a frame-maker (a very good painter, too. You may have seen some of his things reproduced in *Art News* or in *Art*—Walt Killam), who still had some chestnut wood from our trees that died about 40 years ago, and he framed your *Sleeping Lioness* in wormy chestnut. You can imagine how fine it looks. Wes can tell you, he has seen it. With all good wishes, Susanne."

THE LAST YEARS of Susanne's life were primarily taken up with the writing of her magnum opus, *Mind: An*

Essay on Human Feeling. When this book was nominated for the National Book Award in 1965, Guy wrote her:

Dear Susanne,

A Spring greeting and congratulations as a nominee for the National Book Awards! I have just sent Robert Bly a card for same—the two of you being most admirable in every respect. Bly was out here for a reading, and I had the pleasure of knowing him a little. I saw Wes the other evening and we had pleasant words for you.

With warm regards, Guy Anderson

During June 1966 Susanne flew to Seattle and stayed for a few days at the Meany Hotel in the University District. Jean Russell and I picked her up at the airport. As Jean drove us back to Seattle, Langer mentioned that English art critic Sir Herbert Read had just reviewed the first volume of her *Mind*. She was incensed that Read had referred to her new book as "a metaphysical system." I should think that by now Sir Herbert would surely know the difference between a metaphysical system and a scientific line of inquiry!" she said sharply, even dismissively.

SUSANNE LANGER was not the only friend of mine who had been upset by Herbert Read. That same week, I encountered Mark Tobey sitting in Manning's coffee shop with a *Time* magazine article in front of him. He was incensed by something Read had written about him. Read's review described Tobey as a painter who did not paint "out of an inner necessity." I thought Tobey had taken these words out of context. They were intended to be an

ironic comment on the soul-searching manifestos of the New York Abstract Expressionists. I thought that Read's comment could be taken instead as a compliment to Tobey. I could not convince Tobey of this. As usual, he was already nursing a newly found grudge.

Susanne looked forward to seeing Eva Heinitz again. The three of us met for lunch at the Meany Hotel, and the two women conversed in their animated way:

"Eva, I'm so glad to see you! I had begun to wonder when we would *ever* meet up again. Between my philosophical work and all those daily chores that take up so much of one's time, I just don't have the chance to see my friends as much as I would want. And now that I'm finally here, do tell me, how are you? How is your teaching going? Do you have many students?"

"I have some very good students to work with. But as you well know, there are never enough hours in the day," Eva answered.

"The cello lessons I had with you have been of great help to me. My nephew, Jim Dunbar, and I have been playing the Corette *Duo* [a little-known duet for cello and violin] which you sent me long ago. My regular chamber music group is a piano trio, and I'm hankering to play in a string quartet. But I cannot find fiddlers who will play with such a weak sister at the cello, and yet play seriously enough so that this old kitty will play with them."

In 1956, the Kaufmann Foundation awarded Susanne an ongoing stipend that allowed her to devote her time entirely to doing the research for writing her three-volume book, *Mind*. When Eva Heinitz asked Susanne how her work was going, Susanne answered: "Eva, I've been so very fortunate since I saw you last. My good friend Edgar

Kaufman Jr. has most generously provided me with a foundation grant that now allows me to concentrate solely on my writing. This all came about while Edgar and I sat having a picnic lunch on the stone ledge behind my house. I complained to him that I didn't see how I could ever finish writing *Mind*, what with the way my teaching duties at Connecticut College were cutting into my research and writing time. I told Edgar the situation was beginning to look quite hopeless. My grant from the Kaufman Foundation has given me the financial freedom to concentrate on my work. Edgar has my eternal gratitude. If there is anything he wants that I have, it is his!"

"Do musicians read your books about music?" Eva asked Susanne.

"Yes, they do. As a matter of fact, Hindemith told one of his classes that my philosophy of music was the only one which made any sense to him," Susanne answered. She was referring to German composer Paul Hindemith, who was then teaching at Cornell University. American composer Ned Rorem also singled out Langer's writing on music for being some of the most convincing and perceptive he had read.

Eva later confided to me, "I'm very fond of Susanne, but when she theorizes about music I can't make head or tail out of what she's talking about. But I'm a musician and she's a philosopher!" Neither Eva nor Susanne traveled much now. As I listened to them conversing, I realized that this might very well be the last time they would see each other.

In the evening, Susanne, Guy Anderson, Jean Russell, and I met for dinner at a local restaurant, The Bistro. This was a favorite restaurant for Mark Tobey, pianist Berthe

Poncy Jacobson, and just about everyone else in the Seattle arts scene. Matt and Siri Djos, who had previously owned a Swedish import shop in the University District, now ran The Bistro. Matt was locally famous for his Oysters Rockefeller and delicious Swedish pancakes smothered in freshly whipped cream and imported lingonberries. Siri, his wife, was equally noted for her lilting Swedish accent and charming hospitality when she served our meals.

The dinner conversation turned to the subject of teaching. Guy Anderson announced confidently: "I do believe that a teacher should be a great enchanter! He should make the subject interesting for his students."

Guy unknowingly had struck a nerve with Susanne. He had touched upon a pedagogical sore point of hers. The amiable banter of our dinner conversation came to an abrupt halt when Susanne replied sharply, "And I don't believe that for a moment! I assume that because students have signed up for my class they already have a serious interest in the subject. I refuse to spoonfeed them! I give them the work to do, and if they don't want to do it, that is *their* problem, and most certainly not mine!"

I quickly stepped into the conversation and tried to change the subject. I had been attending several physics lectures on campus, ones given by physicists Edward Teller and Hans Bethe. I mentioned that. We began instead to talk about the role of science in society and the dangers of a nuclear holocaust. Guy had just read a book about physicist Robert J. Oppenheimer. Had she ever met him, he asked Susanne. "Yes, I have. I once attended a meeting of physicists. They were in the midst of a heated debate. I could see that the issues were becoming more and more

muddled. Finally, I could not take any more of it. I stood up and tried to clarify matters. When I had finished, Robert Oppenheimer arose from his chair and said, 'Gentlemen, I have listened very carefully to what Dr. Langer has just said. I found her words to be lucid and noble!' He even sent me a letter shortly after that," she replied.

Susanne, the skilled logician, was often called upon to clarify philosophical issues when her colleagues got bogged down in some polemical impasse. Once she got the hang of what someone was saying to her, Susanne was usually several jumps ahead of him. As a logician she pretty well knew where the drift of his thought was inexorably carrying him. She often knew what someone was going to say even before he himself did. This was a price she paid for being a logician.

Jackson Matthews, a distinguished translator of French symbolist poetry and a Paul Valery scholar, taught at the University of Washington during the 1950s. He was now living on the East Coast. He came back to Seattle briefly around 1967 and stayed at the Wilsonian Hotel in the University District, where I went to visit him. I told him about my recent fossil-collecting expeditions with Susanne, and about the letter she had received from Oppenheimer.

"I find your friendship with Dr. Langer charming! I haven't met her myself, even though we were both on campus here at the same time. But I saw her at an aesthetics meeting in Portland once. That would have been in 1953. It was a situation very similar to the physicists' meeting you described to me. The discussion was out of hand and going nowhere. That is, until Dr. Langer stood up and calmly set everyone straight. She saw the problem and how to resolve it. She impressed me very much. Now she's your

fossil-collecting companion. Yes, I am quite charmed by the thought of that!" he said.

The 1960s were a time of social protest and demonstrations, particularly on university campuses. I tended to go about my business, painting landscapes and collecting fossils. But then it started to bother me that I was not personally involved in these increasingly urgent social, political, and environmental issues. I was like the proverbial ostrich with its head buried in the sand.

I mentioned my concerns to Susanne. We talked about what it meant to be "politically involved." She had firm ideas on the subject: "So many people who claim to be 'concerned' about what's happening in the world run around like chickens with their heads cut off. They make a lot of noise, but they don't accomplish much beyond letting everyone know how concerned and upset they are. They could be much more effective if they would just stop running around in circles and take the time to figure out exactly how they can do something *constructive*. It's a matter of looking at the overall problem and then determining if there is some aspect of it in which one *can* be effective. Otherwise, one is swamped by the situation and doesn't do anything of any use at all."

When Susanne and I were at Berkeley, the campus and its adjoining streets were crowded with dozens of students who were passing out pamphlets and having petitions signed as we made our way past them. "I'm receiving so many requests now to contribute to environmental groups, to different charities, besides the usual requests for autographs. I've begun to feel a little guilty lately, because I'm concentrating so much on only my own work," Susanne remarked.

"Tobey told me once that people will devour you alive if you let them have even half the chance," I replied.

"Yes, I surely know what he meant by that," she responded.

"I asked Giovanni Costigan, the historian, about this once."

"I know who he is. He wrote a good book about Freud. What did he say?"

"He told me pretty much what Saul Bellow said when he gave a talk on our campus. He said that there are people who are very much involved in public matters, and there are those who are not. Such people, Dr. Costigan explained to me, are important in different ways. As an example of an 'involved' artist, he described Verdi's role in the social and political issues of his time in Italy. For an 'uninvolved' artist, he gave as an example Heinrich Heine, who wrote great lyric poems. What it comes down to, Dr. Costigan explained to me, is a matter of individual temperament."

"I can certainly agree with that," Susanne responded.

DURING HER 1966 RETURN to Seattle, Susanne was in town for only three days. In recalling her visit I'm surprised to realize how many people she managed to see during that short visit. I arranged for her to have lunch with Elizabeth Bishop at Woerner's European restaurant on University Way. At first, Elizabeth was very nervous about meeting Susanne. She didn't know how to converse with such a legendary figure in a field about which she herself knew so very little, philosophy. These two women hit it off immediately. Among other things, they discussed their mutual experiences as teachers. Listening to them converse, it was obvious how much they respected each

other. They addressed each other with an almost solicitous decorum, like two remarkable women conversing formally but amiably in a story by some late nineteenth–century New England writer such as Sarah Orne Jewett or Mary Wilkes Freeman, or in a painting by Mary Cassatt.

Susanne was such a rigorously demanding teacher that only a few of the students who enrolled to study philosophy with her lasted very long. Elizabeth, who felt that she was incapable of teaching poetry, had four students in her 1966 poetry class—Sandra McPherson, Henry Carlile, Duane Niatum, and Michael O'Connor—who went on to establish fine reputations for themselves as both poets and teachers. Susanne had only a few students when she taught briefly here, the most notable of whom was Paul Mills, Henry Art Gallery curator, who later became director of the Oakland Art Museum. Among Langer's most distinguished former students at Connecticut College is writer Arthur Danto. (For a detailed account of Bishop as a teacher while she was in Seattle, see my earlier book, *The Eighth Lively Art: Conversations with Painters, Poets, Musicians, and the Wicked Witch.*)

When I was alone with Susanne we talked a lot about art. She explained to me that an artist does not so much express his own feelings but instead works with his "knowledge of human feeling." She asked how my painting was going, and what sort of thoughts did I have about it. We talked about the various kinds of reasons and motivations an artist might have for painting a picture.

"Artists shouldn't worry about their 'motivations' so much. No spark ever burned down a house. It's the fire that does that. The spark, like an initial motivation, is what

gets the fire started. An artist should work on his best ideas and sidestep all the polemics," she said, setting me straight again.

Japanese potter Shoji Hamada wrote: "When one is seated before the potter's wheel, it makes no difference whether the impulse comes from the inside or the outside." Hamada and Langer seemed to be saying pretty much the same thing.

I BEGAN TO EXHIBIT PAINTINGS in Seattle, and later in San Francisco and New York. I routinely sent my art reviews to Susanne. She considered these reviews to be mixed blessings:

"I've been reading the reviews you've sent me. I'm glad your local critics like your work. But when these critics start writing about an artist and his work, there's a real danger that reading such stuff can easily make one self-conscious. I would suggest that every time you have a painting exhibition, you head for a microscope, or for a telescope, or go to the zoo, or to the aquarium—anything that will make you aware of the vastness of the world. Head off on a camping trip with one of your friends. Or go agate collecting on the Oregon coast. Doing such things can get you away from thinking about yourself too much, or from becoming some sort of public personality. After all, it isn't society that does in an artist nearly so much as it is the artist's own pride." Her remarks to me about the dangers of having too much attention reminded me of what Morris Graves had said to me about himself in 1949.

Susanne was upset by my tendency to be a miniaturist. I wrote short pieces for the piano. My poems were

invariably short lyrics. And now I was painting very small
landscapes. She had still more advice to give me. Usually
she was right, but it often wasn't the sort of advice I wanted
to hear at that time: "I do hope you'll let loose some day
and do some *large* works. Your small paintings don't offer
you enough challenge. You avoid tackling the difficulties
of doing larger and more complex paintings. There can be
very small works that will have a monumental quality—
some of Henry Moore's small bronzes, for instance. You
really should keep in mind that when you work in a small
scale you run the risk of making little paintings which are
more like Chinese snuff bottles and overly precious little
'objets d'art' rather than real art. You would develop more
as a painter if you would set yourself those challenges that
come with working on large, complex works. If you con-
tinue to paint only small pictures, I don't believe you will
grow as an artist."

Whenever a new book of Susanne's appeared in print,
she sent me an inscribed copy. Shortly before she revis-
ited Seattle in 1966, I received a copy of the first volume
of *Mind*. I eventually donated these inscribed editions to
the rare books collection at Stanford University's Green
Library, along with several of Langer's especially impor-
tant letters to me and the original manuscript of an unpub-
lished essay of hers.

When I saw Susanne again in Seattle, she knew that
I had been reading her new book. But she didn't ask me
any questions about my comprehension of it. Why wasn't
she quizzing me, directly or indirectly, I wondered.

"Susanne, I've been reading the copy of *Mind* you sent
me a few months ago. You haven't been asking me any
questions about how I've been faring in trying to make my

*Susanne K. Langer at her work desk in her 1780's house
in Old Lyme, Connecticut. Starting in 1956, I stayed
with her here many times. On weekends, we would look
for water-worn crystals on the beaches at the mouth of
the nearby Connecticut River or collect ancient fossil shells
near Langer's secluded cabin at Kingston, New York.
Photograph courtesy of Leonard Langer.*

way through it. So much of the material in it is very new to me, subjects I knew so little about: biology, neurology, and zoology.

"I haven't needed to ask you any such questions. Because I've already noticed that the questions you are asking me lately are much better questions than you used to ask me. My book appears be having an effect on you," she explained. She thought for a moment: "This reminds me of the time when Professor [Alfred] Whitehead was giving me an oral examination at Radcliffe College. When it was over, I remarked to him that it had seemed like a rather easy exam. 'But Susanne,' he said, 'I wasn't out to give you a bad time of it. I wanted to find out what you are learning, and I can tell that you are doing very well. Any bright student could shoot me down in an instant, if he knew where my weak points are. I don't let any of my students know where my weak points are.'"

"Professor Whitehead told me," Susanne continued, "that it is not a matter of how much you know. There were many things, he told me, which he didn't bother to memorize, because he knew where to look them up when he needed them. He said that the important thing is that what you do know becomes a part of your transformational processes."

I noticed that in private conversation Susanne could sound entirely sure of herself on some given matter. But in her published writing she could be very circumspect about that very same point. I asked her about this puzzling discrepancy.

"When you talk about animal values and behavior privately with me you seem quite confident that you're on

solid ground. But when you write about these things in your book, you will . . . "

Susanne broke in quickly, "Are you saying that I'm just mousing around?"

"Yes, you sure are! You're saying 'perhaps', 'maybe', and 'could be' in your book, while you are so much more emphatic about these very same points when we talk about them. Why?"

"But Wes," she countered, "I'm a professional philosopher. Even though I can be pretty sure of it, if I'm not yet able to prove a certain philosophical point, I have to be cautious in print. If I want to find out what a scientist is really thinking, I look in his footnotes. That's where scientists record their best hunches, the things they can't prove, even though they may be already quite convinced of them. In the formal text, one is necessarily cautious. But you can smuggle some of your most interesting ideas into your footnotes."

LANGER WAS BOTH A PHILOSOPHER and a naturalist. From the kitchen window of her farmhouse at Old Lyme, she could watch the deer feeding on apples that had fallen to the ground from a gnarled old tree in her backyard orchard. She studied the deer's habits. Did they feed together? Did they arrive at any set time? In her living room she had a terrarium in which she kept two crayfish, studying their life cycles. She called her pet snake "Esmeralda," because it was bright green, like an emerald. For a while she even had two flying squirrels in a small cardboard box in her living room. They were nestled in a shredded newspaper habitat she had prepared for them. In the evenings,

they would make their way out of the box, climb up the living room wall, and float slowly down to the floor, like hang-gliders.

Langer was studying animal behavior as part of her ongoing work on behavior, of both the human and animal kinds. Sometimes she was impatient with the articles written by animal psychologists: "When I'm studying animal behavior, I read journals by hunters and trappers. They're not all tied up in their pet theories, wanting the animals to conform to those theories. Hunters and trappers have to be keen observers of animals. Sometimes they notice and record things about animals that are quite fascinating—observations that give me new clues to animal behavioral patterns."

WANTING TO SEE WHERE and how I lived, Susanne and Guy once came to my room at Mrs. Thomas's rooming house in the University District, a room I shared with my cat, Fauve. It was filled with an eclectic clutter of books, paintings by artist friends, fossil leaves, petrified wood, polished agates, Northwest Coast Indian baskets, wax crayons, and a typically unmade bed. Dominating the room was a large painting by Guy Anderson, a study for his mural at the Seattle Opera House. It had been in his backyard in La Conner for some years. The rain had streaked its surface and even warped parts of it. I liked the way Nature had added a few finishing touches to it. Noticing how much I liked this weathered painting, Guy gave it to me. Jean Russell and I managed to strap it to the top of her station wagon and transport it to my room in the University District.

Susanne was admiring Guy's painting when I told her,

"Guy used to sketch with Tobey at our local zoo. Tobey did some very beautiful line drawings of the deer, and Guy did drawings of a lioness that Tobey told me were "as good as Delacroix!"

"I can certainly understand why Mr. Tobey liked your drawings so much, Guy," she said to him, explaining to me, "Guy gave me one of his sleeping lioness drawings. It's wonderful! It hangs in a place of honor in my house."

She looked carefully around my cluttered room, and exclaimed, "Everywhere I look in this room of yours there are such interesting things to look at! Obviously, an artist lives here. There's a real feeling of 'work in progress' here!"

When Guy had to leave, Susanne stayed on. There was a knock on the door. It was my friend Bob West. He appeared distraught. When I introduced them to each other, Bob apologized to Susanne for being so distracted: "I'm in the middle of going through a divorce. It's very upsetting and confusing!" he explained.

"Yes, indeed. I know what that can be like, having been through it myself. At first it tears you to pieces. Then you just want to get through it and be done with it! You just want to get on with your life!" she replied. She had been married to historian William Langer. Their divorce was a painful episode in her personal life. Susanne was silent for a moment, and then added. "I know all about attachments. I can at least say this: sometimes a bit of nonchalance can be of help."

SUSANNE COULD BE TERSE and blunt. She could also be generously tactful. Before Bob arrived, I mentioned to her that a young Seattle painter, Ralph Aeschliman, had accused me of being "a name-dropper." Apparently,

I had been talking too much about Mark Tobey, Morris Graves, and Theodore Roethke. It was true enough, my being a name-dropper, but it bothered me that Ralph would *say* it.

"It rather hurt my feelings!" I said to Susanne.

"I do know you pretty well. The different people you frequently talk about—Mark Tobey, Morris Graves and the others—are not interesting because they're famous. They're famous because they're interesting. You happen to like interesting people," she replied diplomatically.

There was an upright piano in Mrs. Thomas's living room. It was rarely used, and it was noticeably out of tune. I had just written a short piano piece entitled "End of Summer." It was a very simple piece, an evocation of the kind of sadness a child might feel when the autumn approaches and he realizes it's almost time to go back to school. I asked Susanne if I might play it for her. When I finished and looked up at her, I noticed that she was immersed in some private thoughts.

Then she broke the silence and said to me, "As you were playing your little piano piece for me, I began to recall a time very long ago, in a very similar setting. My family and I were sitting next to the piano, very much as you and I are now. Two members of my family had just finished playing some of the Brahms four-hand piano waltzes. My aunt, who was very old, sat in the chair next to me. She had been as quiet as a church mouse, so immobile during the music that I couldn't tell whether she had been listening or had dozed off. When the music finished, my aunt opened her eyes. 'I'll never forget the first time I heard that piece,' my aunt said. The rest of my family stopped conversing with each other immediately. 'There was a knock

on the front door,' my aunt continued. 'I answered the door. There was Herr Brahms. He seemed very agitated.'

'G'schamster Diener, Herr Brahms,' I said, amazed to see him at our very doorstep.

'Quick, girl! Is your mother at home?'

'No, I'm sorry, Herr Brahms. She's gone out for a while, and I don't know when she will return.' I replied. 'My mother was a pianist. Herr Brahms had heard her perform several times at musical gatherings.'

'Do you happen to play the piano?' he asked me.

'Yes, I do.'

'Good! Where is your piano? Please take me to it immediately, if you would be so kind.'

The next thing I knew, I was sitting at the piano next to Herr Brahms, sight-reading the manuscript of his piano waltzes, the very pieces you have been performing. He had just finished composing them, and he needed to try them out. Fortunately, I was fairly proficient at sight-reading. The ink on his music manuscript was still fresh."

Just then, there was a sharp knock on Mrs. Thomas's front door. Mesmerized by Susanne's story, I was still in a time warp when I answered it. I half-expected to find Johannes Brahms standing there, a music manuscript clutched in his hand, saying, "Quick, young man, do you happen to have a piano handy?"

It was Eddie, the skinny, red-haired newspaper delivery boy, wanting to see my landlady. "I'm here to collect for the paper. Is Mrs. Thomas here?" he asked. With that, I was back in the so-called real world again.

SUSANNE'S THREE DAYS in Seattle passed quickly. It was time now for her to return home. She was anxious

to get back to work on her book. I asked my parents if they would give her a ride to the airport. My mother had not met Susanne before, but she heartily encouraged my friendship with her. When they finally did meet, they hit it off very well.

As we drove from Seattle to the airport Susanne looked out the car window at all the cheaply constructed buildings lining both sides of the highway and sprawling across the nearby countryside. She complained to my mother about how uniform and uninteresting these mass-produced houses were. My mother in turn launched into a mildly sarcastic commentary on conformists. Susanne enjoyed what my mother had just said, but when she said something in response, my mother only half agreed with her.

Susanne was delighted by my mother's directness: "Mrs. Wehr, I'm so glad you don't agree with me! And I'm glad that you say so! I seem to scare people off. They don't take issue with me, or come back at me the way you just did. I do wish they would more often. If people don't respond to what I say, how can I ever find out what they're thinking?"

I SPENT PART OF THE SUMMER of 1967 in Port Townsend, a nineteenth-century town on the Strait of Juan de Fuca, a few hours travel west of Seattle. Its ornate Victorian mansions, so many of which are now converted into bed and breakfast inns, are vivid reminders of a thriving and opulent past, when Port Townsend was the major seaport north of San Francisco.

Actor Marjorie Nelson and her architect husband, Victor Steinbrueck, loaned me a key to their summer residence in the upper part of town. Built in 1888, this two-

storey Victorian house was a short walk from the down-
town main street and waterfront.

I was the only one staying at the Steinbrueck's house.
Late at night, the winds howled in the holly trees outside
my upstairs bedroom window and tapped at the panes. The
house creaked and groaned like a storm-tossed ship. Each
night seemed like some relived childhood memory of
Halloween. Each day I was stir-crazy and constantly at loose
ends. I started to wonder if I would ever get used either
to Port Townsend's Victorian ghosts or the casual pace of
the people who now lived there.

When the tide was out, I collected shards of nineteenth-
century pottery in the beach gravel along the town's water-
front. One day melted into the next. When it wasn't
raining, I walked for miles and miles, out to the lighthouse
at Fort Worden, then back into town again. When it was
raining, I drank countless cups of coffee in the local cafes,
sitting at their windows, staring out at the strait, the tide
flats, and the islands beyond. Or I sat in a sheltered place,
watching the tide come in and then go out again.

When the sun came out, I basked in secluded coves
on the sandy beach that stretched for miles along the Strait
of Juan de Fuca, all the way out to Neah Bay, Cape Flattery,
and the Pacific Ocean. Or I read Meister Eckhart's
Sermons. At times, Eckhart sounded subversive, especially
when he wrote: "Art is an act of attention, not of will."
Susanne Langer had been forever lecturing me on how
important "the will" was—as in will power, self-determi-
nation, high resolve, and all those other self-directed,
heroic enterprises.

But I was in one of those vaguely poetic moods out of
which insipid poems are made. Without any resistance, I

melted into the summer's slow rhythms, marveling at the wonder of it all. I sprawled in the dune grasses, contemplating how exquisite a small leafhopper insect on a dew-laden blade of grass can be. I didn't smoke any pot. I didn't need to. I was on a Nature high.

I wrote Susanne daily, sending her dozens of letters and postcards, ones that contained far more adjectives than verbs. Caught up in the lethargic spell of that summer in Port Townsend, I began to neglect, and even worse, I began to forget all about William Butler Yeats' "monuments of unaging intellect," that battle cry of high achievers.

When I returned to Wilma Smith's boarding house on 18th Avenue NE, my phone rang. It was Susanne, phoning from Old Lyme. She was distressed: "Wesley, I've been quite worried about you. At one point, I was receiving a letter from you almost every day. They were all brimming with enthusiasm, until enthusiasm became just a kind of sensationalism. You've been drifting *up* the beaches, and you've been drifting *down* the beaches. I started to worry that you were going to drift down one of those beaches and never come back! It sounds to me like you are having your hippy summer. You are only doing what is in tune with you. Unless you have a challenge, your 'will' could disappear. This is what's wrong with the fringies, although you are not a fringie!"

As Susanne lit into me, I scrambled to jot down what she was saying. I finally had to excuse myself for a moment. I lied, telling her I had to go to the bathroom, and I would phone her right back. When I did, I had managed to straighten out some of my notes. Meanwhile, Susanne had obviously not run out of advice-giving steam: "Going along as you are now, I just don't think you'll develop any fur-

ther. Many painters developed when they went to Paris or
New York. You could give the next decade of your life to
being in the center of things. You could have a New York
show of your paintings. You could even live in New York.
You could always 'drop out' later," she told me, adding, "I
feel time breathing down my neck. Like you, I'm in a state
of inner excitement. But it's different to have it at my age.
You're young now, but you won't be later. You won't always
have the self-confidence and energy in competitive situ-
ations that you have now. The crowds will grow bigger and
bigger. When you try to make your way through all those
crowds, your elbows won't be as sharp as they used to be.

"You need to travel more than you do, and meet artists
who stimulate you, and disagree with you in productive
ways. Have lots of painting shows, because a time will
come soon enough when you are just not up to it any more.
You won't have the stamina you once had. Or you'll have
other things to do with your life. Or you just can't be both-
ered. I do think it's time for you now to walk away from
this idyllic summer of yours and jump into the center of
things!"

I knew Susanne was right. I had already noticed that
all the tranquility and the carefree feeling of those sum-
mer days in Port Townsend were making me very restless.
In one of her Brazilian travel poems, Elizabeth Bishop has
a line which began to haunt me:

"Have we room for one more folded sunset?"

I for one had had my fill of Port Townsend's "folded
sunsets." Now I dreamed of traffic snarls, congested
streets, and noisy, crowded restaurants. I missed the abra-
sive energy of a metropolitan city. Elizabeth's former stu-
dent, poet Henry Carlile, had written a line about a great

blue heron that expressed my sentiments exactly: "Your silence makes me fidget."

As the old saying goes, words are merely words; it's actions that count. I phoned Francine Seders at her gallery in Seattle, and the Humboldt Gallery in San Francisco. We set dates for two painting exhibitions. During the next decade, I also had shows in New York, Basel, Bern, and Munich. In fact, I took Susanne's advice so much to heart that now she began to worry that I had gone overboard. My phone rang again:

"Wesley, this is Susanne. I've been reading your letters, and it seems to me that you are having a great many exhibitions now, perhaps *too* many. I think it may be time now for you to 'drop out' for a while. You might spend more time in the desert, or go back to the Oregon Coast again. Otherwise, all these painting shows of yours may become repetitious, and your work could readily become stale and mannered."

This was very typical of the sort of friendship I had with Susanne. No matter which course of action (or non-action) I took at any given time, she was quick to point out to me its possible pitfalls. She was not one to "take it easy," or to try to get through life in the easiest way possible. She thrived on intellectual challenges.

I tried to put down on paper some of my impressions of Susanne. One evening, I wrote, "With her highly disciplined, severely regimented work habits, Susanne was a master of so many aspects of her life. I did sometimes feel, however, that she never mastered the art of doing absolutely nothing."

I had barely written those words when I realized how wrong I was. It wasn't so much that the relentlessly hard

work to which she devoted her life had resulted in some of the major philosophical works of her time. There was more to it than that.

When Elizabeth Bishop taught poetry at the University of Washington in 1966, she told her students: "Don't think that being a poet is going to solve the great problems of your life. Those problems will still be with you. I can tell you, however, that when you are a poet, you may now and then have the satisfying feeling of just having put in a good day's work."

I began to remember the many summer evenings I had spent with Susanne at Old Lyme. I recalled one evening in particular. She had been at her desk all day. She was working on the second volume of her final book, *Mind: An Essay on Human Feeling*. We had just finished having dinner together. I studied her as she sat drinking her coffee. I shall not forget the expression of infinite well-being I saw in her eyes that evening. It was the very pleased look of someone who had, indeed, just put in a good day's work. For Susanne, her deepest joy and renewal were in her work. She flourished in giving her life to what William Butler Yeats called "the fascination of that which is difficult."

Elizabeth Bishop
in Seattle &
San Francisco

D URING EARLY JANUARY OF 1966,
shortly after Elizabeth Bishop arrived in Seattle
to teach at the University of Washington, a wel-
coming party was given for her at Niko's Japanese restau-
rant in the International District. The guests included
painters Morris Graves, William (Bill) Cumming and his
wife Roxanne, Richard Gilkey, and Leo Kenney, poet
Carolyn Kizer, and Beatrice Roethke, widow of Theodore
Roethke.

Morris Graves and Carolyn Kizer sat next to each other
at the far end of the table. Not surprisingly, Carolyn was
dominating the dinner table as she conversed rather loudly
with Morris. Being in a Japanese restaurant seemed to dic-
tate the direction of their conversation.

"I think life has a purpose but no meaning, Morris.
Don't you agree?" she asked him.

"No, Carolyn. Life has a meaning, but no purpose
whatsoever," Morris responded.

"Oh, God, here we go again!" I groaned to myself.

I glanced across the table to see Elizabeth busily sam-
pling the various dishes that had been set before us. When

she saw me watching her, she said, "Of course, I don't understand *anything* about such matters, but I do know that this shrimp tempura is simply *delicious!*"

While Morris and Carolyn were busy playing their Zen word games, their dinners grew cold on their plates. Elizabeth, never one to stoop to showing off, just wanted to savor all the exotic dishes set before her.

It was Roxanne Cumming who was soon to rescue Elizabeth Bishop from a dismal situation. Elizabeth was already desperately homesick. Not having taught before, she had grave doubts about her abilities as a teacher. She was miserable, lonely, and constantly debating with herself whether she should cancel her teaching contract with the University of Washington and take the next plane back to Brazil. One consideration made her hesitate, however. The very generous salary she had been offered was a strong inducement for her to stay, especially because her house in Brazil needed a new roof. Lonely and frustrated, Elizabeth was slipping into a pattern of solitary drinking that sometimes made it impossible for her to teach the next day. Her close friends had to cover for her, explaining to the administrators and her poetry students that Miss Bishop had the flu and would not be able to meet with her class.

Roxanne Cumming was vivacious, outgoing, and keenly intelligent. She was exactly the sort of friend Elizabeth needed, especially during that critical time of her stay in Seattle. They shared a sharp-witted, mutually conspiring humor. They usually liked the same people, as they similarly disliked the same people. Their criticisms of the people they didn't like could be gleefully incisive and devastating. When I watched them talking quietly together

What sort of presents could I give to two such remarkable women as Susanne Langer and Elizabeth Bishop? Like a cat leaving a mouse at each of their doorsteps, I dedicated these two short pieces for piano to them. Collection of the author.

and then abruptly breaking into raucous laughter, I suspected that another head had just rolled, another local snob or fraud had just been deftly relegated to oblivion.

Roxanne's husband Bill was already one of the best painters around. His conversations were richly anecdotal. He was incapable of any sort of pomposity or pretentiousness. Elizabeth later wrote a close friend that, in Seattle, it was the painters she most enjoyed. For one thing, she was a painter herself.

Bill Cumming claimed, and I believe he was right, that the notion of a "Northwest School" of painters was hardly based upon any sort of artists' manifesto or an agreed-upon approach to art. What brought the various painters together, he claimed, was food and booze. Always needing a square meal, the artists met wherever there was a party going on.

I always enjoyed going to Bill and Roxanne's house on the north shore of Lake Union, a short walk from the University District. I looked forward to Bill's stories, and I looked forward to Roxanne's cooking. She would invariably ask me if there was anything I especially wanted for dinner. She already knew I was addicted to mashed potatoes. One evening, when I arrived with Morris Graves, Roxanne came out of the kitchen carrying a monstrously large bowl of freshly mashed potatoes and a gallon or so of gravy. "Here, *this* should last you for a while," she said, setting the massive bowl of steaming hot potatoes next to my dinner plate.

Bill owned an early oil painting by Morris, a Skagit Valley landscape. I had begun to paint very small wax-crayon landscapes several years earlier. I beckoned to Morris, who was sitting across the room. "Morris, would you come over here and look at something, please." I

pointed to his landscape painting and said, "Now I know why you like my little landscapes! All I've been doing is just cutting little pieces out of your landscapes, making little pictures of my own out of small parts of yours."

Elizabeth and Roxanne began to spend more and more time with each other. Roxanne's effect upon Elizabeth was a joy to watch. They shared, among many other lively traits, a well-matched sense of highly playful humor. In Roxanne's company, Elizabeth could let down her hair. The worried, lonely, miserably unhappy Elizabeth was soon replaced by an entirely different sort of person. She became more relaxed, outgoing, and self-confident. I watched this transformation take place in Elizabeth as she and Roxanne became companions. It was wonderful to observe the high-spiritedness that Roxanne brought out in Elizabeth.

Not all of Elizabeth's experiences in Seattle were as felicitous as was her friendship with Roxanne. Some of her experiences among the natives dumbfounded her: "Oh, Wes, the oddest thing happened to me yesterday. I went into that little restaurant next door to my motel, and I ordered a cup of tea. Can you imagine what they brought me? A tea bag in a Dixie cup! It's going to take me a while to get used to some of your local customs."

Even though Elizabeth liked the outgoing friendliness of many of the people she met in Seattle, there were times when some of them behaved in ways that quite baffled her. We often ended the day with a phone call to each other, one in which Elizabeth described her past few days to me:

"I was downtown yesterday morning. While I was on the bus back to the University District, a woman sat down

next to me. Before I knew it, she was telling me all about her children. She even began to show me snapshots of them. I was puzzled why she would assume that I would be at all interested in such things. I had not encouraged her in any way. Perhaps she mistook my silence for an interest in what she was saying.

"Then she began to tell me some quite personal things about her marriage. She was almost *confessing* to me, a complete stranger! I didn't know what to say to her. She never introduced herself to me or asked me anything about myself. It was very peculiar.

"When the bus arrived at her stop, she got up from her seat and left without saying so much as a goodbye. When we happened to pass each other in the street a while later, she didn't seem to recognize me. Does this sort of thing happen very often here? Sometimes the outgoing friendliness I encounter here can start to seem a bit impersonal!"

A recently widowed English Department faculty member invited Elizabeth to her apartment in the University District. Elizabeth described the visit: "When she found out that I had spent part of my life in Nova Scotia, and that we even had mutual friends from there, she invited me to her apartment for tea. I was having quite a pleasant visit with her when she announced, 'I have my late husband's organ in the next room. Would you like to see it?'

"What do you say to a question like *that*? Before I knew it, she had waved me into the adjoining room where she pointed at an ornately carved organ standing in the far corner. She told me very proudly, that it had been in her husband's family for at least seventy years. She even asked

me if I might like to play it? She explained to me that no one had touched it since her husband died."

ELIZABETH WAS NOT one to be easily impressed by status symbols. She did, however, like having nice things, just as long as they weren't, as she said, "ostentatious."

"I was awarded some money while I lived in New York. I was supposed to use it for writing. But I spent it on a pair of diamond earrings instead. I'd seen them in a jewelry shop window. And I'd gone back several times to look at them again. Of course, they weren't very big diamonds. I could not have afforded big diamonds, and even if I could have I wouldn't have wanted to wear anything ostentatious! I just needed to have some little diamonds to wear, so I wouldn't feel quite so impoverished as I did then in New York!"

Sometimes, when she thought the occasion called for it, I could receive one of Elizabeth's put-downs. I had just returned from San Francisco. One afternoon, after seeing the Rodin sculpture collections at the Palace of the Legion of Honor, I walked to Coit Tower to look at the city below. I was startled to see a rather dignified looking elderly woman take off her mink coat, put it down on a dingy-looking cement bench, and then nonchalantly sit on it. I told Elizabeth how surprised I was by this woman's casual treatment of such an obviously expensive coat. "Wes," she sighed, "*Why* are you fussing so much over a mink coat? If you had told me that she was wearing a *chinchilla* coat, I might have pricked up my ears. But a *mink* coat?' She thought for a moment, and added, "Chinchillas are the most adorable little animals. Have you ever held one in your hands? I have!"

I thought to myself, there she goes again. I have been carrying on about a mink coat, and Elizabeth comes back at me with something to the effect that, "If you are trying to be a bit snobbish, dear, mink is hardly something to fuss over, but chinchilla *could* be." In three quick skips, we had gone the gamut of how Elizabeth could, if she were so inclined, out-snob anyone, then quickly become bored with such a trivial social game, and finally go right back to her true delight, real chinchillas, not status-laden chinchilla coats.

I always had to be on my toes around Elizabeth, because she was not one to let pomposity slip past her unnoticed. When I began to have painting exhibitions in San Francisco, New York, Switzerland, and Germany, I often had to fly from Seattle to various cities, even to Europe. I phoned Elizabeth at her Lewis Wharf apartment in Boston. While I was telling her about these different shows, I exclaimed, "I'm starting to feel so 'international!'"

"Did you say *international*? When you said that, I had an image of you wearing a tuxedo, boarding airplanes, and flying off in all directions. Quite frankly, I prefer you in your old blue jacket, and with that battered old briefcase of yours, the one with the broken zipper," she responded.

On the other hand, after I had first taken Elizabeth to meet her, Jean Russell remarked to me, "Did you notice the suit Miss Bishop was wearing last night? It was so simple but so beautifully tailored that it must have been very expensive. You would have to be a woman to notice such things, I suppose. But we women always do."

Not long after they met in Seattle, Elizabeth and Roxanne moved to San Francisco and settled into an apartment on Pacific Street. It was early February. Elizabeth's

birthday was rapidly approaching. I wanted to mail a present to her from Seattle. I had a Nez Perce Plains Indian cornhusk bag. It was about sixty years old. Its bold design and earthy colors were very appealing. I had found it in a Public Market antique shop. It was something I thought Elizabeth might like. Gary Lundell examined it carefully and handed it back to me saying: "Instead of mailing this to Elizabeth, why don't you take it to her in person?" Why not, I asked myself. I was on the phone the next day to make a flight reservation.

Roxanne wrote me shortly before I arrived, inviting me to stay with her and Elizabeth. "The Bed is now in the guest room. Elizabeth works each day at polishing it. That's the room we call Dorothee and Wesley's room." Roxanne was referring to their friend Dorothee Bowie and also to the brass bed I had given Elizabeth for her University District apartment in 1966. I had bought it at a used furniture store in Ballard for twenty dollars in 1962.

I arrived just in time for Elizabeth's birthday on February 8th. Roxanne had planned and cooked the dinner, one that included all the kinds of food she knew I especially liked: pot roast, mashed potatoes and gravy, peas, green salad, and chocolate cake. Elizabeth had decided that a mynah bird would give a festive Brazilian touch to the apartment. She needed more exotic reminders of her life in Brazil.

Elizabeth and Roxanne's apartment on Pacific Avenue was sparely furnished when I got there. They were still shopping for furniture and utensils. Their collection of artwork was already hung on the walls, and it startled me. There was the early Picasso etching *Frugal Repast*, a rare early impression.

Elizabeth stood beside me as I admired her lovely Picasso, and explained: "When I had this print in Brazil, it developed some awful kind of fungus, one that discolored it. I thought it was ruined. But my old friend at the Fogg Museum, Agnes Mongan, took charge of it. She had the museum conservators examine my Picasso and do what they could to save it. She'd periodically write me, "Your Picasso is coming along very nicely!'"

Elizabeth also had a Kurt Schwitters collage hanging on her living room wall. There were paintings by her artist friends Loren MacIver, Kit Barker, Patrick Humble, Joe Glasco, and Morris Graves, as well as a group of Elizabeth's own watercolors, which hung in the hallway. She and Roxanne together owned so many paintings that Elizabeth said, "We don't know where to put them all. We haven't enough closet space to store them." Elizabeth even owned a pair of silver earrings that sculptor Alexander Calder had made for her. She wore them on special occasions.

And there were, of course, books everywhere in the apartment. Stacked on the floor, or in unpacked cartons. Elizabeth had, however, carefully placed her favorite books on the shelves of a bookcase near the window. Many of them were first editions, inscribed to her by her friends Marianne Moore and Robert Lowell. She let me look at them. Miss Moore's book dedications to Elizabeth were almost effusive in their affectionate admiration for her.

While I was in San Francisco, I also stayed for a few days with a young painter, Ralph Aeschliman, in the Haight Ashbury district. By then, there were no more demonstrations, no riots. I had arrived too late. Ralph introduced me to a young friend of his who asked me if I would like a driving tour of the coastal beaches south of San Francisco.

Ralph's friend must have been a mind reader. Two days later, when he picked me up at Elizabeth's apartment, I introduced them to each other. I had not mentioned to him that Elizabeth was a poet, let alone a very famous one.

Elizabeth brought us coffee. We conversed for a while, mostly about the charm of living in San Francisco. My friend and I said goodbye to her. We headed toward his car, which was parked in the street outside her apartment building, and started to drive toward the coastal beaches, toward Half Moon Bay and the sea caves at San Gregorio.

"Jim, that lady you just met is one of the best poets in this country. She has won more awards than I can count. Would you have guessed that she is a very famous poet?" I asked him.

"Come to think of it, it doesn't surprise me that she's a good writer. She used her words so well that I barely noticed how well chosen they were. No extra words, no fancy words!" he replied.

I repeated this to Elizabeth later. She was surprised, but obviously pleased.

"I don't recall that any of my students ever made such an observation about how I speak. They usually talk about how I write," she said.

Chinatown, the International District, was only a few blocks from Elizabeth and Roxanne's apartment. When the Chinese New Year came, Elizabeth suggested we walk down the hill to the holiday festivities. She was too fascinated by the throngs of merrymakers to be afraid of all the firecrackers exploding in the air about her. But when the din did become too much for us, we took refuge at Sutter's Mill, a popular soup and sandwich restaurant on Sutter Street, at the edge of the International District.

During the afternoons I took off by myself to visit the local art museums and rock shops. During one afternoon, I walked through Golden Gate Park to the beach. Wading in the surf, I started to find fossil sand dollars in the water-worn beach cobbles. They looked like stone flowers, somewhat like daisies. From what I knew of the local geology, they were said to be about five million years old.

When I returned to Elizabeth and Roxanne's apartment for dinner that evening, I spread my fossil "flowers" out on a pale blue towel on the living room floor. Elizabeth came into the room from the kitchen.

"Here's a cup of coffee to keep you going until dinner is ready, which should be very soon now." She spotted the flowerlike fossil sand dollars on the living room rug. Placed on the bright blue towel they looked quite mysterious and even lovely.

"What in heaven's name are *those*? They're very pretty, but what *are* they?"

"They're fossil sand dollars. They're supposed to be about five million years old," I answered.

"Roxanne, please come in here! You won't believe this! We send Wes out into the streets of San Francisco and what does he do? He comes back to us with *fossils*. Very pretty ones at that. And they're from right here in San Francisco!" she exclaimed, gleefully.

Elizabeth did not finish writing any new poems while she lived in San Francisco. She worked instead on a bilingual anthology of Brazilian poetry that she was editing with Emanuel Brasil. Her correspondence with her former students in Seattle kept her occupied, especially when they sent her their new poems, asking her what she thought of them. One poet, a former student of Theodore Roethke's,

sent her a group of his latest poems. She set aside her own work to read them carefully and to comment on them.

"I worked quite hard on those poems of his, trying to point out to Mr. Sund where I thought he could improve them. I don't think he especially appreciated my comments, even though I thought that some of my suggestions were rather good ones. I don't think he thought so. When he wrote me back, his letter seemed rather distant."

A young Seattle poet improvised rather pneumatic poems that were filled with lofty feelings. When I asked him if he ever considered reworking them, he was indignant.

"I don't change *anything* I write. The way I wrote it the first time is how I *felt* it," he answered.

His point was that any form of revision was artificial and, as he put it, "insincere"—a distortion of the original feeling that inspired the poem. There was no point in my taking issue with this.

He gave me a rambling poem of his, asking me to show it to Elizabeth. He had been listening to classical music. This poem was his "tribute" to Beethoven. When I asked Elizabeth if she had looked at his poem, she answered, "Please don't repeat me to your friend, but I'm afraid it sounds to me like one of those slightly-finer-than-every-day thoughts that occasionally hit us all—perhaps in this case after listening to some Beethoven recordings—and, when spaced as free verse, makes us think we have written a real poem when we haven't."

When I got back to Seattle a few days later, I stayed in touch with Elizabeth and Roxanne by telephone. Elizabeth was enjoying her social life in San Francisco: "Did I tell you about our grand and glorious party? It was a big success. There were about forty people there.

Roxanne Cumming, painter Bill Cumming, poet Carolyn Kizer; maverick artist and gallery owner Don Scott, and painter Jim Johnson at Howard's restaurant on University Way, April 1964. Photograph © Mary Randlett.

Everyone danced until three in the morning. I invited Josephine Miles, but when she arrived and was in the street downstairs, I realized she was infirm and would never be able to make it up all the stairs to our apartment. I realized that she and I could have our own little party in her car, which was parked in front of the apartment. I took a cocktail shaker and glasses down to her car, and we drank our martinis in the backseat. There were an awful lot of party guests upstairs, so I was glad to have some time alone with Miss Miles."

Wherever she happened to be, Elizabeth often sent me the most wonderful gifts. One package contained water-worn deep green olivine crystals that she had collected in the Galapagos Islands. Elizabeth explained that, "The tiny stones are called 'Olive Stones' and were picked up on one small part of one beach in the Galapagos Islands. Maybe you can tell me what they *really* are."

She sent me Brazilian yellow citrine, deep purple amethyst, pale blue topaz crystals, and nodules containing ninety-million-year-old fossil fish. In a Greenwich Village lapidary shop in New York, she found crystal clusters of red, green, and blue Brazilian tourmalines, and a lovely pair of banded chalcedony cabochons from Norway, ones she thought I might like to have made into cufflinks. She sent me polished, brilliantly red rhodochrosite stalactite pieces from Argentina. And a polished agate from Brazil, one that was filled with water and had an air bubble that darted about inside it when you held it to the light and turned it this way and that.

I sent Elizabeth thunder egg and fortification agates from the central Oregon deserts, polished slices of fifteen-million-year-old petrified wood from eastern Washington,

or waterworn orange and red carnelian agates from Lucas Creek, near Chehalis, several hours drive south of Seattle. I was glad to have a new friend who shared these two interests of mine: art and natural history. Morris Graves had already noticed that the fossils and stones I collected strongly influenced how I painted. Seeing a landscape painting entitled *Rosa Canyon* in an exhibition in Eureka, he said, "Wesley can look at an entire mountain range and see it as a fossil specimen to be collected and admired."

When I visited Mark Tobey's studio in Seattle and later in Basel, I thought I had stepped into a natural history museum. Everywhere I looked, there were such exotic things as tropical seashells, Brazilian amethyst geodes, banded onyx from Mexico, and fossil fish from Wyoming. Guy Anderson's studio and home were also filled with minerals and fossils. Interspersed among the Russian icons, Persian miniatures, ancient Peruvian textile fragments, and Guy's own driftwood sculptures and collages made of rusty pieces of iron, were ancient trilobites and ammonite shells, polished thunder egg agate geodes from Oregon, and deep green dioptase crystals from Tsumb, Africa. He had fifty-million-year-old fossil flowers and leaves that sculptor Mark Reeves and I brought him from our fossil-collecting trips to the fossil outcrops at One Mile Creek, north of Princeton, British Columbia, and Republic, in the Okanogan Highlands of eastern Washington.

Composer Ned Rorem said that originality is just a matter of having obscure sources. Many Pacific Northwest artists, including painters Mark Tobey, Guy Anderson, Morris Graves, Kenneth Callahan, Richard Gilkey, Neil Meitzler, Joseph Goldberg, Spokane artist Kathleen Adkinson, and myself; sculptors James Washington Jr., Philip

McCracken, George Tsutakawa, and Mark Reeves; and photographers Mary Randlett and Johsel Namkung, often found their visual inspiration in the world of natural history, from things we found beachcombing or casually strolling, or traveling to remote places where the flora and fauna were arrestingly different from what was familiar to us. Painter Theodore Stamos collected thunder egg agates from the Oregon deserts, as I later did with Joe Goldberg at the Priday Ranch, near Madras, Oregon.

DURING OCTOBER OF 1968 Morris Graves exhibited works from his private collection at the Humboldt Galleries on San Francisco's Sutter Street. This show was reviewed by veteran art critic Alfred Frankenstein. Although most of the works in this exhibition were for sale, Morris included a small 1965 landscape of mine, *Whidbey Space*, which he marked "not for sale." That it was not for sale made it a more interesting picture in the eyes of some of the local collectors. "Who is this painter anyway?" they asked gallery owner Sam Figert, "What's so special about this particular picture that Mr. Graves doesn't want to sell it?"

Elizabeth and Roxanne visited the exhibition and mentioned to Mr. Figert that they knew me personally. That same evening, Elizabeth phoned me in Seattle to suggest I contact the gallery and show Mr. Figert some of my work when I was next in San Francisco. When I returned to San Francisco, I did indeed show Mr. Figert a group of my landscape paintings. They were monotone, even drab compared to the other colorful works in his gallery. He invited me to have a small show of landscapes at his gallery within the year. When I was back in Seattle, preparing the show, a letter from Elizabeth arrived in my mailbox at the

University Post Office. It contained a letter and a copy of what Elizabeth casually referred to as "a gallery blurb."

I was welcome to use what she had written for my exhibition at the Humboldt Gallery, she said, if I felt it was good enough. But Sam Figert thought the piece too long. He blithely chopped it up and rearranged the wording of it into what he felt was better suited for his gallery announcement. Elizabeth was incensed, "How would Mr. Figert like it if I came into his gallery with a pair of pinking shears and started cutting up his paintings. I am a professional writer. I cannot allow anyone to mutilate what I write in the way that Mr. Figert seems to think he has a right to do!" she snapped.

Several days later, Mr. Figert received a formally worded letter from Roxanne, written in Elizabeth's behalf. Enclosed with the letter was a short version of Elizabeth's gallery exhibition statement. The letter stated that Elizabeth would authorize Mr. Figert to use either one of her two versions. But in no way whatsoever would she allow him to rewrite her own words.

Mr. Figert was so upset by the tone of Roxanne's letter that he decided not to use either version. The full version of her statement was later printed by the Shepherd Galleries in New York, as a gallery brochure for a 1973 exhibition of my landscapes. Elizabeth said that this was one of the few "blurbs" she had ever written. Elizabeth Bishop's biographer, Brett Millier, quotes the statement in full:

I have seen Mr. Wehr open his battered brief-case (with the broken zipper) at a table in a crowded, steamy coffee-shop, and deal out his latest paintings, carefully encased in plastic until they are framed, like a set of magic playing

cards. The people at his table would fall silent and stare
at these small, beautiful pictures, far off into space and
coolness: the coldness of the Pacific Northwest coast in
the winter, its different coldness in the summer. So much
space, so much air, such distances and lonelinesses on
those flat little cards. One could almost make out the moon
behind the clouds, but not quite; the snow had worn off the
low hills almost showing last year's withered grasses; the
white line of surf was visible but quiet, almost a mile away.
Then Mr. Wehr would whisk all that space, silence, peace
and privacy back into his briefcase again. He once remarked
that he would like to be able to carry a whole exhibition in
his pockets.

It is a great relief to see a small work of art these days.
The Chinese unrolled their precious scroll-paintings to show
their friends, bit by bit; the Persians passed their miniatures
about from hand to hand; many of Klee's or Bissier's paint-
ings are hand-size. Why shouldn't we, so generally addicted
to the gigantic, at last have some small works of art, some
short poems, short pieces of music (Mr. Wehr was originally
a composer, and I think I detect the influence of Webern
on his paintings), some intimate, low-voiced and delicate
things in our mostly huge and roaring, glaring world? But in
spite of their size no one could say that these pictures are
"small-scale."

Mr. Wehr works at night, I was told, with his waxes
and pigments, while his cat rolls crayons about on the
floor. But the observation of nature is always accurate; the
beaches; the moonlight nights, look just like this. Some
pictures may remind one of agates, the form called "Thun-
der Egg." Mr. Wehr is also a collector of agates, of all kinds
of stones, pebbles, semi-precious jewels, fossilized clams
with opals adhering to them, bits of amber, shells, examples
of handwriting, illegible signatures—those small things that

are occasionally capable of overwhelming with a chilling sensation of time and space.

He once told me that Rothko had been an influence on him, to which I replied, "Yes, but Rothko in a whisper." Who does not feel a sense of release, of calm and quiet, in looking at these little pieces of our vast and ancient world that one can actually hold in the palm of one's hand?

Elizabeth considered this gallery note to be the finest page of prose she had written. Brett Millier wrote in her biography of Bishop: "Her interest in Wehr's accurate works is no surprise. The [gallery] note anticipates values she had held for a long time and in method recalls *The Map* and *Large Bad Picture* and anticipates *Poem* as it moves between Wehr's paintings and her memory of the landscape they depict." Elizabeth wrote personal statements about several other artists: Key West folk painter Gregorio Valdes, and her close friend, New York painter Loren MacIver.

Elizabeth and philosopher Susanne Langer had met the previous year in Seattle, when they had lunch together at Woerner's European bakery and restaurant on University Way. An occasion for them to meet again, this time in San Francisco, arose unexpectedly when Langer was invited by the chairman of the Philosophy Department at the University of California at Berkeley to give a talk. She wrote me, suggesting I might meet her at Berkeley. Besides my attending her talk, she said, we could plan to do some beachcombing together on the California coast south of San Francisco. I wrote back to her, "The combination of your lecture at Berkeley and a bit of beachcombing seems ideal. Luckily, after my February visit there, I do know my way around a little of Berkeley and some of the beaches

south of San Francisco. Half Moon Bay has good seashells and nice moonstone agates. But the San Gregorio beach has good seashells and a large, wonderful cave with fossil strata in the walls. The beach across the highway from the Fleishhacker Zoo and pool in San Francisco has lovely Pliocene sand dollar fossils, but the sand's exposure of them varies from day to day."

Susanne began to wonder if I could afford a plane ticket to San Francisco. She phoned me from Old Lyme, offering to loan me $300. Her personal check arrived several days later, accompanied by a note, "Here is the obstacle-remover to our visit in S.F. I'm glad that's all that was in the way. I was afraid you had commitments. The lecture is a poser. How can one say anything significant, of a philosophical sort, to a heterogeneous audience in one lecture? I gave Matson 3 possible titles, one on a really limited and philosophical topic, the abuse of metaphor in the 'new' sciences, but he preferred a very general, talky-talky theme, 'Philosophy in Times of Stress,' so that's what it is. He said he would rather hear the other (knowing him, I believe that). See you in a month then."

There was a flurry of letters between us as I wrote back to Susanne on September 6, "Your letter & check arrived this morning. Again, how very grateful I am to you! I'll probably arrive in San Francisco and Berkeley on Monday, Sept. 30. Elizabeth Bishop will be posted where I am. A young Seattle couple [Ralph and Susan Kennedy] is living in Berkeley, & I might stay with them, or just a hotel near the campus. This is an awfully exciting thing to look forward to! If you haven't seen the Berkeley fossil collections, & there's time, you have a pleasant surprise."

To simplify matters, Elizabeth and Roxanne invited me

to stay with them again. Elizabeth added that I would be able to sleep again in the antique brass bed I had given to her for her Seattle apartment several years earlier. This was the same bed that she took with her to Lewis Wharf in Boston several years later. My roommate and I had bought this bed for $20 when we lived across from the Hiram Chittenden Locks in Ballard in 1962. I could never have imagined then how many illustrious poet friends of Elizabeth's would be sleeping in it in years to come, when it became her guest bed for visitors in both San Francisco and Boston.

On October 2, Susanne gave her paper at Berkeley. It was entitled "On the Uses and Abuses of Metaphor and Simile in the New Sciences." I was considerably relieved, as was she, that she had not been stuck with the topic of "Philosophy in Times of Stress." I couldn't imagine her giving such a talk. I attended the lecture with philosophy student Ralph Kennedy and his wife, Susan. Elizabeth and Roxanne joined us. We had, all of us, somehow gotten the impression that we were invited to the reception for Susanne which Professor Matson was hosting at his house in the Berkeley Hills after the lecture. When we all met together after Susanne's talk, it was clear that Matson plainly regarded us as party-crashers. Philosopher Kingsley Price tried his best to rescue the situation, while Susanne stood helplessly silent, embarrassed and frustrated by Matson's gracelessness. Elizabeth, Roxanne, the Kennedys, and I said goodbye to Susanne and left the lecture hall. We finally ended up at a nearby delicatessen at the north edge of the campus. This was to be the second and last time Susanne and Elizabeth would meet. It consisted of a brief handshake and a few words between them after

the lecture, while Professor Matson impatiently reminded Susanne that members of his faculty were waiting for her at his house.

The following morning, Ralph and Susan Kennedy picked Susanne and me up for the drive to the beaches south of San Francisco. It was a lovely, sunny day as we visited Mondara and Half Moon beaches, and stopped for lunch at Princeton, a small coastal town. At San Gregorio beach, we parked the car and hiked down the trail to the beach. I was anxious to show Susanne the sea cave and its fossil-bearing layers of sandstone. Susanne was anxious to start looking for five-million-year-old fossil sand dollars for her fossil collection, which she kept in an old-fashioned china cabinet in the basement of her 1780s house in Old Lyme, Connecticut. The cabinet was filled with Devonian fossils she had collected near her cabin at Kingston, New York, and with fossils I had sent her from my own collecting trips in Washington and Oregon.

We spent a full day beachcombing. Susanne had looked forward for so many months to our outing on the California coast. She had not been in any way disappointed. Now she was ready to fly home to Old Lyme, Connecticut. She had enjoyed a good vacation. Now she was restless to get back to work on her book.

Elizabeth returned to Seattle several times during the 1970s. The first occasion was when she was invited to give the Theodore Roethke memorial reading at the University of Washington during May 1972. She arrived at Dorothee and Taylor Bowie's house in the Laurelhurst area of Seattle a day before the reading, bringing with her from Boston ten fresh lobsters and several pounds of steamer clams. She and Dorothee planned to have a New England seafood

party after Elizabeth's reading. Dorothee had meanwhile added another seafood delicacy to the buffet table: a large platter of Dungeness crab legs from the Olympic Peninsula. Elizabeth and Dorothee had really splurged on that buffet of delicacies.

The Bowie's living room and dining room were filled with guests. University President John Hogness was there with his wife. There were the to-be-expected faculty members standing together in little groups, conversing and drinking. But where was Elizabeth? I'd assumed she'd be the center of attention. Instead, I found her sitting alone in a corner of the living room, wolfing down a plate of crab legs. There were many other kinds of delicacies on the Bowie's buffet table, but the Dungeness crabs legs were an especial treat for her. The guests standing around Elizabeth were so busy talking with each other that they barely noticed her.

"Oh, *there* you are," she said, as I made my way through the crowd. "Have you tasted this crab? It is *delicious*. I do know that it's *terribly* expensive, even here in Seattle."

I made a beeline for the buffet table, loaded my own plate with delicacies, and brought another small dish of crab legs to Elizabeth, who was devouring them with unladylike rapacity.

The women's liberation movement was in full swing when Elizabeth arrived in Seattle to give her poetry reading. She herself maintained a distance from feminist poets, partly because she so strongly disliked being referred to as a "woman poet." She upset some of the other women poets by refusing to be included in anthologies of women's poetry. The editor of one such anthology had written in

its preface, "It is ironic that one of the women poets who would have added the most luster to this anthology has declined to be included." President Hogness introduced Elizabeth to the audience with a remark that raised some hackles: "Miss Bishop is not here this evening to read her poetry to us because she is a woman poet. She is here because she is a very fine poet."

Elizabeth next returned to Seattle in 1973, when she was again invited to be visiting professor of English at the University of Washington. She stayed this time at the University Motel, which was a considerably long walk from where she taught on campus. Teaching was an ordeal for Elizabeth, and the walk to and from her motel apartment wore her out. The University, however, paid its visiting poets so well that Elizabeth gritted her teeth and made the best of the situation. She needed the teaching salary to keep up her payments on her apartment at Lewis Wharf in Boston.

Elizabeth's motel suite at the University Motel was reasonably comfortable, but her stay in Seattle was so brief that there was no time for her to furnish it with anything other than her everyday needs. I went to visit her with painter Glenn Brumett just after she arrived in Seattle. She hadn't had time to shop for groceries, so we went to the house next door, one that had been converted into a rather makeshift restaurant. The waitress was also the cook and the cashier. It was a bizarre experience. The kitchen freezer and larders must have been as empty as Elizabeth's refrigerator, because the waitress-cook kept racing across the street to a grocery store. She was out of bread, and then she realized she was out of butter, and then it was

cream for our coffee. Elizabeth was cheerfully stoical, but from then on she avoided that haphazard restaurant.

I had just returned from New York and the opening of my landscape exhibition at the Shepherd Galleries. Elizabeth had written of me to her close friend, painter Loren MacIver, who called the gallery, inviting me to visit her on Perry Street in the Village. Two days later I went to see her, this legendary artist whose work was so admired by Guy Anderson, Morris Graves, William Ivey, and other Northwest artists. She had originally exhibited her work with the Willard Gallery, but she was now represented by the Pierre Matisse Gallery. I spent several very pleasant hours with her talking about art, drinking coffee, and consuming many Oreo cookies.

When I returned to Seattle several weeks later, I visited Elizabeth at her University District motel room. "I've just received a letter from Loren MacIver, part of it is about you. I don't suppose that you would like to hear what she wrote me about your visit with her, would you?" she said. Elizabeth took MacIver's letter out of its envelope and read a few lines of it to me: "Your painter friend, Wesley Wehr, came to see me the other day. I served him coffee and Oreo chocolate cookies, which he seemed to like very much. He ate quite a few of them. He showed me photographs of his paintings (which were quite nice), and explained that the paintings themselves were not much larger than the photographs of them. He talked very easily about many different things."

Elizabeth refolded the letter and put it back in its envelope. She looked amused: "Loren says you talked very easily about many different things. I find that very interesting,

although I don't exactly know why." She picked up a book that was lying on the table next to her chair. "I've just read the funniest story. It's by Mark Twain. Instead of my trying to tell you about it, let me read it to you." Mark Twain's story was about a young man who was courting a young lady and wanted to take her for a ride in a horse and buggy. The only horse he could get was one that had just been retired after many years of being a milk-delivery dray horse. This horse was so set in its ways that through habit it would stop at each house along the street, wait just the same amount of time that it had taken the milkman to deliver the milk, and then move on. Nothing the young man did could speed the horse up. His courting of his young lady was turning into a disaster. Elizabeth began to read the story aloud. I had rarely heard her laugh so hard. The lively inflections of her voice were punctuated by her gleeful bursts of laughter at a line here and there. I think Mark Twain himself might have applauded Elizabeth's reading of his story.

SHORTLY AFTER SHE ARRIVED in Seattle in 1966 Elizabeth met art patron Jean Russell. A good friendship quickly developed between them. Elizabeth would often have dinner at Jean's spacious apartment on Queen Anne Hill, overlooking Elliott Bay. She had heard about the Skagit Valley ever since she first arrived in Seattle. But she had not been there. One Sunday afternoon Jean Russell picked up Elizabeth, Gary Lundell, and me at Elizabeth's University Motel apartment, and we headed north for an outing in the country. It was a good day for such a drive. The sun was out and the rain had ceased.

Near Anacortes, Elizabeth spotted a tourist gift shop

beside the road. Could we stop there for a moment, she asked. This roadside tourist shop had, besides the usual local driftwood sculpture and sea shells, a surprisingly large assortment of tropical seashells: pink conch shells from Florida, brightly colored tree-snail shells from Cuba, banded cowry and cone shells from the South Pacific, and iridescent abalone shells from Mexico. Elizabeth bought several of the most colorful shells exclaiming, "These will brighten up my makeshift apartment in Seattle. I'm so used to having lots of *color* around me when I'm in Brazil!"

The shop also had some locally manufactured metal stoves for sale. Elizabeth was elated, "This is *exactly* the kind of stove I've wanted. You can't find *anything* like this in Brazil. If I bought one of them here, do you think they could ship it to me in Brazil?"

The store manager assured Elizabeth that it would be a simple matter to ship the stove to her in Brazil. To further reassure her, he told her that he had already shipped similar stoves to people "as far away as Ohio!" Elizabeth began to suspect that the clerk had no idea how far away Brazil was from the Skagit Valley. She bought the stove, however, and it eventually arrived safely at her Oro Preto home in the mountains of Brazil.

Guy Anderson lived in La Conner, in a one-storey wooden building on the main street of La Conner. Adjoining his front room, where he both painted and slept, was a small, enclosed garden patio where he entertained guests when the weather allowed. We had phoned ahead so that he would be expecting us.

Elizabeth was fascinated by the eclectic accumulation of objects that greeted her in Guy's front room—by the rich clutter of new paintings, art books and magazines, the

waterworn pieces of driftwood and rusted metal he had found on the nearby beach, bouquets of dried flowers, and exotic objects from all about the world. He especially liked weathered, broken things, ones that showed the effects of time. In the center of all of this was his grand piano, piled high with sheet music.

Most of Anderson's most recent paintings were so large and unwieldy that he had to unroll them on his studio floor for us to look at them. Elizabeth noticed several cat footprints in one of the paintings.

"Mr. Anderson, are those *cat* footprints?"

"Yes! My cat Uni is something of an art lover, or an art critic. She likes to walk right across my paintings while I'm working on them, right here on the floor." Just then, Uni walked into the studio from the adjoining kitchen, stared at us, looked annoyed, and left.

WHEN WE GOT BACK to the Elizabeth's apartment at the University Motel that evening, she invited me in. We were both tired from a long day's outing, but we wanted some time alone with each other. Elizabeth reviewed the day, commenting on what she had seen. I could always count upon her to notice the most unlikely things. She was well known for her sharply observant eye for "Elizabethan" details.

This time it was a humble donut that caught her attention: "When we stopped for coffee in that little cafe in La Conner, the view of the slough and fishing boats was really quite pretty. But that plain donut the waitress brought me looked so forlorn on that stark white saucer. I almost felt sorry for it. I thought I should decorate it with something. Anything! I wanted to cheer it up a bit!

"Some of the old houses we passed today looked so sketchy, as if they had been drawn very quickly and uncertainly. But the weathered barns I saw today looked solid enough. When you told me they're 'very old', and meant they're only some fifty years old, I realized what a frontier this still is!"

"Did you see anything today that you might want to write about someday?" I asked.

"Probably not. After all, it was only a very short visit. I've written almost nothing while I've been in Seattle. As you know, I write very slowly." Elizabeth had urged me to travel more. That day she had been introduced to one of the reasons why many of us in the Pacific Northwest travel so seldom. She commented to me: "It's quite easy for me to understand why you artists use such a monochromatic palette in your paintings. It certainly reflects the weather here. I can see why some of you painters who live here don't travel very much. The landscape here is very beautiful. When Roxanne and I stayed at Doe Bay on Orcas Island for several days, we were struck by how quiet and lovely it was there. We took long walks on the beach. We even saw an Orca whale. Your San Juan islands remind me of some of the islands off the coast of Maine.

"I enjoyed meeting Guy Anderson. He appeared to be a very good-natured, out-going man. For that matter, Morris Graves is certainly charming. I had heard so much about the 'mystic' painters in this area ever since I arrived here. It might lead one to believe that you artists are solitary, uncommunicative people. Not at all! The ones of you I've met so far actually seem a bit gregarious."

To her dismay, some of Elizabeth's poetry students had been writing poems in the haiku style. Only a few of her

students wrote about the things immediately around them. This puzzled and disturbed her: "Some of my students are forever talking about 'mysticism' and Chinese philosophy, and Zen philosophy—as if they're Chinese and Japanese poets who have somehow been uprooted and replanted here. When we were in his studio in La Conner today, I noticed that Mr. Anderson has a few cows in several of his paintings.

"If I ever were to write a poem about this area, I just might include a cow or two in it! If I lived in the Skagit Valley I most certainly would *not* be writing poems about bamboo trees and Chinese carp. I'd want to write about the things I see around me."

Guy Anderson
in the Skagit Valley

*"To fully appreciate Guy's charming personality
and venerable oeuvre, one probably needs to have
lived in La Conner when it was just a two-tavern
town and danced down First Street with him in
the moonlight for a nightcap. It was at moments like
those when I actually felt connected to a uniquely
regional tradition of bohemian* joie de vivre *that's
gone forever and been replaced by a simulacrum of
itself in the form of rampant coffeehouse culture
and country stores full of art glass and animal-
shaped oven mitts."*—Charles Krafft, 1998

SOME SIXTY MILES NORTH OF SEATTLE
is the Skagit Valley. To the east of it are the Cascade
Mountains, and to the west the Olympic Mountains.
The drab gray rocks that underlie this valley contain
dinosaur-age Jurassic marine sediments from a time some
150 million years ago when this area was an ancient sea
floor.

In contrast to these barren ancient rocks, the overly-
ing fertile soil of the present-day Skagit Valley makes it

one of the richest agricultural areas in the entire Pacific Northwest. This is especially evident during April, when the tulip and daffodil fields at La Conner come into bloom. The Skagit Valley's fields become Mondrian-like rectangles of red, yellow, orange, and white flowers, defined by the narrow country roads bisecting them. For several weeks the valley is filled with multitudes of visitors, many of whom have come to see the fields in full array.

As the summer ends and the tourists go back to the cities, the rains return and fog again envelops the fields and their scattered farmhouses and barns. The now cloud-enshrouded hills surrounding the valley become gigantic Orca whales, barely discernible in a sea of opalescent haze. Then a great silence comes over the valley, broken now and again by the dissonant, mournful honking of a flock of migratory geese, or the faint thrum of an automobile on a country road, several miles away.

If there were to be one place in the Pacific Northwest that is most closely identified with its regional artists, it would surely be the Skagit Valley. The work of the "Northwest School" artists who have lived and painted here has often contained, like the Skagit Valley landscape itself, a muted, subtle, and luminescent quality of light.

Even Guy Anderson's figurative paintings will often evoke a strong sense of this local landscape. His semi-abstract paintings, such as *Channel Meadows by Storm* (1959) and *Deception Pass through Indian Country* (1959), have a strongly individual response to the spirit of this region. During the 1940s Morris Graves painted his *Little Known Bird of the Inner Eye* series at his isolated studio on "the Rock" near Deception Pass, a few miles from Anacortes, the largest city in the Skagit Valley. Mark

Tobey's painting entitled *Northwest Space* (1950) resembles a classical Chinese landscape. With a few sweeping, simple lines and a soft wash of color, it suggests the distances and the solitary, rounded hills that randomly appear here and there in the expanses of the valley. Richard Gilkey's landscapes capture the elusive, silvery light of the Skagit Valley's fields and solitary barns. Paul Havas's landscapes are filled with the diffuse light of spring and summer in the valley. Jay Steensma's *Skagit Relic* works, painted shortly before he died, are powerful, brooding evocations of the Skagit Valley's abandoned homesteads against the bleakness of the winter skies.

GUY ANDERSON WAS BORN in Edmonds, Washington, on November 20, 1906. His parents loved music and painting. In 1913, at the age of six, his elementary-grade teacher at Edmonds, Mabel Thorpe Jones, introduced him to Japanese ukiyo-e Hanga prints she had collected during her travels. His sixth-grade music and art teacher, Anna V. Bassett, had been the wife of a missionary. While she and her husband were in Asia she had assembled a large collection of Asian art objects. Mrs. Jones's Japanese prints and Mrs. Bassett's Asian art works were Anderson's childhood introduction to an aesthetic that would play a major role in his development as an artist.

Anderson studied piano under Mrs. Bassett for ten years. In his house on the main street of La Conner during the 1970s, and later in his house on Caledonia Street, his grand piano filled much of his living room. It was stacked high with sheet music, phonograph records, art books, and vases of dried flowers. Underneath the piano were still more stacks of art books and classical music

Guy Anderson with La Conner's "rainbow bridge" behind him.
Seattle Times *art critic Deloris Tarzan and photographer*
Josef Scaylea came to La Conner during July 1982 to do a
story on Anderson for the Seattle Times. *Photograph by Josef*
Scaylea.

recordings. Beethoven's piano sonatas and J. S. Bach's *Partitas* and *Two Part Inventions* were open on the piano stand when one sat down to improvise something for Guy while he was cooking dinner in his small kitchen. On his walls hung sculptures he fashioned from the weathered driftwood and pieces of rusted metal he found on the beach, in the fields, or along the roads.

When I first met Guy Anderson in 1949 he lived near Edmonds, and soon after that, in Seattle. He exhibited his work with Zoe Dusanne, at her gallery on Lakeview Boulevard. When Otto Seligman, with Mark Tobey's financial assistance, opened a gallery in his private apartment in the Wilsonian Hotel on University Way, Guy switched dealers and went with Tobey and painter/musician Windsor Utley to show with Seligman. While Guy lived in a downtown Seattle apartment, I would have dinner with him now and then, after which he would take me tavern-hopping along the Skid Road. He was gregarious and seemed to know everyone. He filled me in on the history of some of Seattle's legendary bars and their long-dead star performers. He seemed very much a "city person." When he moved to the University District, he invited me to some of his parties. I didn't really know him all that well at the time. Our richest friendship commenced after he moved to La Conner.

After a year of teaching art at the Helen Bush School in Seattle, in 1965 he moved to La Conner, a small fishing village in the heart of the Skagit Valley. Writer Tom Robbins describes Anderson's first years in La Conner: "Within a half-mile of each other, Anderson keeps two small studio-homes. His 'mild weather nest' is in a converted lighthouse oil shed, which has been moved back

from the water to the edge of a pea patch and is towered over by firs. The cabin has *shoji* doors and screens, a garden-court with out-door dining facilities and one wing with a Herculite roof which acts like a skylight. His 'bad weather nest' is in the village, a huge old room which formerly functioned as the whorehouse above the Arctic Tavern."

Guy Anderson was generous with his time and concern for his friends, especially if they were young artists. He also was quick to offer financial help when he felt a friend was having trouble making ends meet. For instance, we were on the phone to one another nightly. If it was turning into an unusually long conversation, and I had called him, I started to be concerned about my next phone bill. Guy, however, was one of the most considerate friends I have ever known: "How are your finances these days? I'm not a mind reader you know. I can imagine you must have quite a phone bill, what with all the work you've put in on my San Francisco show and other things. When things were going well for him, Tobey used to help me out. I'm in pretty good shape these days. I'm receiving Social Security now. I'm sending you a check tomorrow. Put part of it on bills, if you need to, and take a friend out to dinner, to a nice restaurant. If you could use any more money later on, let me know," he would say.

DURING THE GREAT DEPRESSION years, Anderson found employment with the Works Progress Administration Federal Art project. He was sent in 1938 to Spokane with artist Vanessa Helder to teach for two years at the Spokane Art Center. Painters Clifford Still, Worth Griffin, and George Laisner were on the art faculty at

nearby Washington State College in Pullman. Anderson and Still met frequently at parties and were able to discuss art during Anderson's stay in Spokane. It was here that Anderson began to experiment with abstraction and found-metal collage. Anderson and Hilda Deutsch Morris were the only teachers at the Spokane Art Center experimenting with nonobjective art, while the other artists on the project painted regional landscapes.

I asked Guy about his years on the Spokane Art Project. He remembered those years very well: "I was there for two years, between 1939 and 1940. Carl and Hilda Morris were there. Carl was the first director. We received $100 a month and had to live on that, but we were invited out a lot and everyone was so hospitable—Carolyn Kizer's family, Jan Thompson's family. Upstairs in my little sleeping room I had Tobey's *Cirque d'Hiver* on one wall, and on the other wall I had Paul Klee's *In the Spell of the Stars.*"

"Where did you get *that* painting?"

"Jane Greenough loaned it to me. She had worked for a New York Gallery. I think it was the Kurt Valentine Gallery. She took some of her salary in Klee works, and she loaned me that Klee. She owns the most beautiful C. S. Price painting I've ever seen. It's of two birds, flying, against a stone wall.

"Jan [Thompson] and Jane Greenough did a catalogue of the Indian rock paintings which are now all under water. You should talk to Jan about that catalog. Jane lives in California. They did rubbings in chalk of the petroglyphs.

"The Spokane Art Center was up on the hill. We decided that we needed to advertise it. I painted what must have been the biggest painting I've ever done, something like ten by thirty feet. It was very abstract, in black, brown,

white, and ocher. Earl Carpenter was on the project and he knew how to do printing, so the painting could be transferred to large sheets to be pasted up on the billboard."

"Do you remember the name Vanessa . . . "

"Vanessa Helder! She was a watercolorist. She did interesting and very careful, realistic watercolors. They were well done. I think there even may be one of them in the Museum of Modern Art collection. She worked daily and very hard in the basement. She was the only other person besides me from Seattle."

Anderson first met Morris Graves in 1929, when Anderson's work was included in an exhibit at Harry Hartmann's Bookstore on Fifth Avenue in downtown Seattle. Graves, who was nineteen at the time, saw Anderson's exhibition and sought him out in Edmonds. Anderson's father was a carpenter who built small houses and used to hire his son at five dollars a day to help him during the late 1920s and early 1930s. While working with his father, Anderson designed and built an elegant chair and a chaise lounge.

Graves was similarly interested in handcrafted furniture. When he heard about Anderson's self-crafted furniture, he sought Anderson out. He felt he had found a kindred spirit. Soon after that they began to share a studio. They spent much of 1934 and 1935 traveling through Oregon and California in a pickup truck that served as both their studio and home. Anderson traveled on alone to Texas and into northern Mexico. By late 1935 both artists returned to the Northwest, where they converted a stable into a studio in Seattle. They later lived in La Conner, where Graves was able to secure an abandoned house that had been damaged by fire in exchange for repairing the roof.

After moving into town from his somewhat makeshift house at the end of town, during the 1970s, Anderson lived in a storefront on south First Street. In the late 1970s, he built a two-storey house on Caledonia Street. He lived on the first floor and had his studio on the second floor. Every morning he would walk into town to pick up his mail at the post office.

During the long, rainy winter months of the 1970s and 1980s, Anderson phoned me regularly, sometimes almost nightly, from La Conner. Or I phoned him. Sometimes we had a specific reason for phoning each other. Most of the time, however, we called each other because we were feeling oppressed by the weather and at loose ends. Our conversations often tended to ramble. I finally decided it would be better if Guy and I talked more about things I might someday need to know, especially if I were ever to write about him, or about some of the people he had known. I began to ask him about Morris.

"Guy, you've known Morris pretty well, haven't you?"

"I've known him since he was nineteen. I probably know him better than anyone else does. He always had this great sense of taste and technical facility from the very start. But most of Morris's energy and attention in recent years has gone into architecture and building houses, the house in Ireland, and now the house in California. Morris's environment has to be perfect to the last detail, and that is very consuming for an artist. There simply is not enough energy left over for painting. Tobey lived in a more makeshift way. He couldn't be bothered by all those details. His mind was on his work."

Anderson told artist Ray Kass, who has written on Graves and other artists associated with the Northwest

Visionary School: "Morris had remarkable taste and the experience of extraordinary color at his command. We both had an affinity with the oriental school." Anderson had what he called "recurring showdowns" with Graves over the issue of pictorial versus decorative values: "I don't believe in the decorative sort of thing where the material and surface do most of the work for you. So we used to talk about that a great deal, about the importance of a painting, you know. Is it something more than to be put on a wall, or fill a frame with?"

Throughout his life, Anderson continued to be wary of the easy effects that some art materials produce: "You have to be careful not to let the bloom of the watercolor on an expensive watercolor paper trick you into thinking you've just done a real picture, when you really haven't at all!" Tobey had a similar wariness of the easy effects that washes of color could have, and he had his own reservations about Graves's work. Around 1956, he told me how he had expressed his concerns to Graves: "I told Morris the other day that he doesn't know how to render his ideas *plastically*. I told him that he doesn't always know how to *integrate* his paintings. He will lay down a paint wash for his background, and then put something on it that is too literal and illustrational. He asked me if I thought that just the background would have made a better picture for me? I had to be honest with him. I told him, yes. When I finished laying into him, he said to me: 'You are a great painter, Mark, and I respect your opinion.'"

Tobey at times did seem to have it in for Morris. At one point he went around telling everyone: "Morris was only good when he was under my wing!" In a similarly self-centered way, in a 1963 interview with a Victoria, BC, news-

paper reporter, Tobey said: "Without me there would be *no* Emily Carr!" He was referring to painter Emily Carr, a towering figure in the history of Canadian painting. Tobey used to visit her at her boardinghouse in Victoria, along with painters Ambrose and Viola Patterson and anthropologist Erna Gunther, and give her advice on her paintings. Carr always acknowledged the importance to her of Tobey's advice, but seemingly never enough to satisfy Tobey. During another occasion, Tobey was sharply annoyed with me when I said that Helmi Juvonen had first encouraged Tobey's long-time companion, Pehr Hallsten, to try his hand at painting. Tobey wanted to claim such credit for himself. Tobey always had to feel that everything began and ended with his own work when he compared himself with his contemporaries. He was especially quick to claim credit for whatever merits he conceded to Morris's work.

In my own judgment, if Morris had never even met Tobey, let alone seen Tobey's signature "white-writing" style, Morris would still be one of the most original figures in twentieth-century American painting, a painter of sublimely intimate and lovely works. Morris was never, to my knowledge, spiteful toward either Tobey or Guy. During the mid-1950s, when Tobey was being almost obsessively dismissive of him, Morris continued to remind his friends that one should never forget for a moment that, despite how badly Tobey could behave, at times being petty and vindictive, he was nonetheless a great artist.

Shortly after Morris Graves died, I asked his sculptor friend Hans Nelsen whether Morris had talked to him about Guy Anderson. Guy had often talked of Morris to me. Hans responded that Morris spoke often of other friends and figures from the Northwest, but with less fre-

quency of Guy. "I first heard the stories of their early friend-
ship from Morris—traveling the coast together in a pickup,
reactions to the war, and how they might be translated into
action. I visited Guy with Morris when he had a little cabin
in the back of Axel Jensen's pea patch. Morris obviously
had the greatest respect and regard for him. He said that
Guy was a person of extremely high character and very
pure spirit. These two things were not at all the same for
Morris—the character was of this world, and the spirit,
of the other world. I believe it was Morris who told me
that Guy's paintings were about the most important mat-
ters of the human spirit and the meaning of God and
nature, and also that although they appeared to borrow
heavily from Pacific Northwest Native American art, their
real debt was to Eastern thought and religion."

Both Guy and Tobey seemed to nurse a grudge toward
Morris. It took many forms, but it was usually expressed
in oblique ways. Their complaints about Morris never pro-
vided any real clue to what was really angering them. I sus-
pected, and finally had occasion to have confirmed, that
for all three of them there existed a long personal history
of mutually hurt feelings and wounded pride. The rest of
us sometimes forget that these three remarkable artists
were in many ways very much like the rest of us. They were
subject to all the conflicting traits of being in turn vul-
nerable, proud, self-confident, and insecure.

I first met Guy in 1949. During the 1950s in Seattle I
occasionally had dinner with him or ran into him at social
gatherings. It was not, however, until he moved to La
Conner that I began to see more and more of him. Some
friendships peak immediately, and from then on neither
deepen nor intensify. My own friendship with Guy was

such that the longer we knew each other, the closer we became. I soon was a regular visitor to La Conner, bringing with me many of the young painters I continued to meet, artists who in turn wanted to meet Guy. By then, he had become a mythic presence in Northwest Art, a role-model for many young artists.

DURING THE 1960S, art patron Virginia Haseltine often came to Seattle to scout out works to buy for the University of Oregon Art Museum. For advice, she would ask *Seattle Times* art critic and writer Tom Robbins, and different painters, including Bill Cumming and me, to look at the works she was considering buying. She was interested in purchasing a large work by Guy. Many of his best and largest works were in a Seattle warehouse, so he authorized me to show them to Mrs. Haseltine.

On May 24, 1966, Guy wrote me:

How very good of you to go to the warehouse with Virginia Haseltine to help select something of mine in big size. We were completely nonplussed with her visit but thoroughly enjoyed her. She is very intense. [She is] essentially a good person and perhaps more romantic than mystic. She would like to reestablish the likes of the little group that existed hereabouts when Tobey was working in his truly heavenly strata and Morris was doing his best interior birds and Kenneth was at his better self. This of course is quite ridiculous to consider.

It seems she discussed this with Phil McCracken over on the island, and of course he said the same thing—that is gone by and we must look to other things. I guess there was copious weeping at one point.

Well, it is sad that there is no real friendship any more

except between Mark and myself. I had a card from Mark on his way to Haifa. He was not well when he left on the cruise through the Greek Islands, but was getting along. He extended a most cordial invitation to visit him in Basel, or did I tell you this in my last letter? Hope you are enjoying these wondrous sunny days. Yours, Guy

SOME OF THE FRIENDSHIPS between "The Big Four" of Northwest painting—Mark Tobey, Morris Graves, Guy Anderson, and Kenneth Callahan—were strained at times, even mutually hostile. Guy's friendship with Tobey, however, never suffered any such ups and downs. I never knew Guy to express any sort of animosity toward Tobey, or ever to be critical of him. Their letters to each other were mutually respectful, even affectionate. That would have necessitated some flexibility on Guy's part. Tobey could be very difficult. He constantly found so many things to complain about. Guy, on the other hand, was nearly always so good-natured and easygoing.

Guy invited Tobey to La Conner for a visit, and put him up in the Planter Hotel on the main street of town. He described the occasion to me: "Mark didn't think the latch on his door was secure enough. He pushed furniture against the door. He complained to me that he could hear drunks down the hall, and that it just wouldn't be safe for him to spend a night in a place like that. So I had to drive him all the way to a hotel in Coupeville during a very foggy night. The fog was so bad that I had to keep getting out of my old model-T truck to make sure we were still on the road."

Anderson wrote his friend Herbert Steiner: "How very thoughtful of you to send me [Paul] Valery. He is one of

my most favorite people and at the moment I'm engrossed in *On Mallarme*. Without peeking, I try to read the French, which looks to be most beautiful—but of course it has become something of a different oyster. But so my academic life goes as slow as a slug uphill.

"Now that we are having our typically, typically English grey weather I am back in the studio all day having a great time with rusty tin collage. I'm off on a new theme which at the moment I can't talk about—but it interests me a great deal. I wish you could have been with us last Sunday when we went out to an almost untouched place on McGlynn Island, which is out past my cabin and beyond the dunes. The Camas Lily and the Fritillaria were at their best, and I have never seen the Camas so thick and so rich a blue on the ledge. The head of the island is fairly high and we looked down into the richly patterned mouth of the Skagit River. The Madronas are coming into bloom also and they are heavy with flowering buds on this particular promontory and somewhat dwarfed. We were all highly exhilarated and following the outing Barbara and Clayton James asked us to a sumptuous dinner at their place. It was really a triumph of a day."

I kept a diary, recording such occasions as, "When Guy comes to Seattle it will usually be to attend a gallery opening, or because a great singer is performing at the Opera House, in which case he will invite several friends to dinner and to the concert. Guy took Deryl Walls, painter Edward Kamuda, and me to concerts by Leontyne Price and Dutch singer Elly Ameling, and to a performance by the Pilobolus Dance Theatre. Guy was fascinated by the ways in which these dancers merged and split apart like sculpture in motion. For him, they redefined gravity."

We heard Swedish singer Birgit Nilsson perform the title role in *Turandot*. We also heard her perform the final scene from Richard Strauss's *Salome*. This scene, in which Salome sings a passionately enraptured love song to the severed head of St. John the Baptist, is one of the most breathtaking and terrifying moments in all of opera. Nilsson's performance was electrifying. But backstage, Nilsson was no longer that seething, vengeful Salome as she sat in a chair in the green room receiving her admirers and signing autographs. She was good-natured and outgoing.

A young girl came up to her and boldly announced, "Madame Nilsson, *I* would like to be an opera singer!" Nilsson responded in a deep, resolute voice, "Well then, my dear, if *that* is to be, you must work, work, *WORK!*" The young girl looked alarmed, even disenchanted, when Nilsson spelled it out to her that being an opera star was not for lazy people.

Guy stood next to me, listening to Madame Nilsson put the fear of God in the poor young girl. "I'm glad I didn't have *her* for my music teacher when I was young!" he whispered to me as we left the green room together.

DURING APRIL 1979 Anderson had a one-man exhibition at the George Belcher gallery in San Francisco. The preview was attended by Deryl Walls, Edward Kamuda, Seattle art patrons Helen and Marshall Hatch, art historian Peter Selz, Stanford historian Paul Mosher, painter Albert Fischer, and other friends of Anderson's. Belcher hosted a private dinner at the Bush Garden the following evening. Guy sat next to veteran art critic Alfred Frankenstein, who asked him to name his favorite painters. "Ryder,

Inness, Corot, and upwards," replied Guy, and he then complained to Frankenstein that modern sculpture was becoming "too industrial" and was getting too far away from the human figure. Frankenstein later remarked to Belcher, "I'm glad that Mr. Anderson is having a show here. I think he's one of the great American painters."

Art critic Tom Albright's review described Guy as a painter who was willing to take great risks in his work. Anderson aimed very high, Albright wrote, adding that when Anderson didn't succeed, his paintings could land with a real thud on the floor. But when Anderson succeeded, Albright pointed out, such works were among the very strongest and most original works being painted anywhere at that time. Albright's review called Guy's painting *Flight: Three Positions III* (1972) a masterpiece.

Later that month, when my fiftieth birthday was approaching, Guy invited me to La Conner for a small birthday party. I mentioned to him that a young local painter wanted to meet him.

"Does he have a car? If he does, you and he could come up together. I'll reserve a room for the two of you at the Country Inn. My studio is in such a mess just now that I wouldn't know where to put you," he explained.

The young painter picked me up the next afternoon and we drove to La Conner. For a birthday present, Guy paid for a room for us at the Country Inn on South Second Street. During our dinner with Guy that evening, the new acquaintance kept steering the conversation to the subject of drugs, insisting that the old masters had routinely used them and must have been "high" when they painted their best works. To hear him tell it, almost every famous painter of the past had been something of a drug addict.

Guy remained silent, listening carefully. The young painter did not realize he was on very dangerous ground with Guy, who finally snapped, "You are *quite* wrong! Van Gogh did his great work when he was *not* disturbed, during his times of stability. I don't believe for a moment that all these painters you talk about used drugs. I think you're just using their names to justify your own use of them!" The young painter wanted to pursue the subject, but Guy clearly did not.

Several days later the painter appeared unannounced at Guy's doorstep. Guy phoned me the next evening, "Is that young man something of an operator?"

"I really don't know him very well, but I don't think he's very sincere," I replied.

"He told me he has friends who would like to meet me, and that he knows girls who would come up here with him and pose for me. I told him that I already have enough models, and that he is *not* to start dropping in on me without phoning ahead. Sometimes I let young friends stay in my studio overnight, or even for a day or so. But then they want to bring their girlfriends up next. They start getting some idea that they can shack up here. I let one boy stay in my studio when he said he was out of work and didn't have a place to stay. The next thing I knew, he started to move his furniture and girlfriend into the studio, too. But you and Glenn [Brumett] and Kirk [Johnson] are always welcome to use the studio whenever you want."

Guy could be very generous in giving his works to friends or occasionally selling some of his work at a lower price. But he was no dummy when he realized that someone was trying to butter him up only to take advantage of him. Private collectors and dealers often appeared at his

door in La Conner, wanting to buy something privately and more cheaply. Two dealers visited Guy, bringing presents for him with them—champagne, See's chocolates, freshly picked fruit—things they knew Guy would like. They looked through the paintings in Guy's studio and selected three that they were interested in buying.

"How much would this painting be, Guy?" one of the dealers asked.

"That one would be $900," Guy replied. This was the same price that he set for each of the other two paintings they were interested in.

"And if we were to take all three paintings, Guy, how much would that be?"

Guy was silent for a moment, looking reflective. Then he replied, "Now let me see. How much is three times $900?"

NOT HAVING A CAR of my own or even knowing how to drive one, I often went to La Conner with young friends who did own cars, especially when they were painters who wanted to meet Guy. In this symbiotic way, I was able to introduce young painters Jay Steensma, Joseph Goldberg, Ron Kellen, Mark Reeves, and Glenn Brumett, young pale-ontologist Kirk Johnson, and architect-to-be Dale Stenning to Guy. If neither of us had a car, we stood at the on-ramp just off of the University District, and thumbed a ride north, as Dale Stenning and I did the first time we went to visit Guy. Or we caught a bus to Mount Vernon, camped that night on the banks of the Skagit River, and hitchhiked to La Conner the next morning, as Ron Kellen and I did.

Guy often invited my friends and me to stay for din-ner and camp out in his studio or in his backyard for the

night. If the weather was good, my traveling companion and I hiked to the secluded beach cove at Hole-In-the Wall, where the the deep-flowing Swinomish Channel joins the North Fork of the meandering Skagit River, and spent the night there. Many of Guy's friends also came to visit him. When painter Jeffree Stewart stayed with him, they read poetry aloud to each other, listened to music, and talked long into the night. Guy's ability to quote poetry was remarkable. He loved poetry and could recite entire poems from memory.

Guy hosted our visits to him by often taking us out for dinner in town, usually to the Lighthouse Restaurant on the La Conner waterfront—before this building was moved to La Conner from Bellingham, Mark Twain had once given a public reading in it. In addition to hosting many meals for his friends, Guy often gave us small works of his, encouraging us to sell them discreetly if we ran short of money. He also continued to send me personal checks. But he always did this in such a way that I wouldn't feel obligated to him. He simply explained that Tobey had been generous with him in the past, and now it was his turn to spread the money around.

This generosity of Guy's saved my neck. I was spending more and more time at the Burke Museum as an unsalaried affiliate curator of paleobotany. I was painting less and less. Budding paleontologist Kirk Johnson (he was then nineteen) and I were involved in collecting fifty-million-year-old fossil leaves, flowers, insects, and fish remains at the little town of Republic, in the Okanogan Highlands of northeastern Washington State. We made our first visit there during 1977 and quickly realized that the surface had only been scratched. In turn, Guy realized that

I was going to need help to do fieldwork, especially because the Burke Museum was unable to help with any of my field expenses at that time.

If it had not been for Guy's checks I wouldn't have been able to concentrate on my new interest in paleobotany. How could I best express my gratitude to him? That was the perplexing question for me, until paleobotanist Jack A. Wolfe suggested that he and I name a new species of ancient leaf for Guy. We settled upon *Paraprunus andersonii* Wolfe & Wehr, new species, the earliest known fossil cherry leaf, and named it in Guy's honor. This delighted Guy. For a while he answered the phone with a new greeting, "Hello! You are now speaking to the world's oldest cherry tree!" Guy had nicknames for Kirk and me. Kirk was "Dev." He was named for the Devonian Period. I became "Cam," named for the much older Cambrian Period. Some of Guy's nicknames for others of us were quite risque. You never knew how he was going to answer the phone from one call to the next. When you phoned him, he might answer with the name of an imaginary restaurant of which he was now the proprietor: "The Hog's Trough." Sometimes he answered with a cheery, "Bog Tule!" For years he took to saying "Wooky-Walky" as some kind of generic greeting.

WRITERS CAN WRITE THEIR MEMOIRS, and, in doing so, write about those individuals who have most influenced their lives, and those friends and colleagues whom they most want to honor for having been an inspiration to them. Paleobotanists rarely write personal memoirs or leave any published traces of their private lives and friendships. Paleobotanist Henry Andrew's wonderful

book, *The Fossil Hunters,* is a rare exception. It contains historical profiles of the leading paleobotanists of his time, and personal accounts of his friendships with many of them.

Paleobotanists, however, name new species after those colleagues and teachers who they most admire and would want to honor.

In 1987 Jack Wolfe and I named a new species of fossil linden leaf for Kirk Johnson: *Tilia johnsonii.* Kirk had found it at the corner lot fossil site in Republic. We named other fossil leaves from Republic for other friends whom we wanted to honor. For Dr. V. Standish Mallory, who had given me a remarkable vote of confidence in offering me a Burke museum position as affiliate curator of paleobotany, we named a new species of extinct sumac leaf, *Rhus malloryi.* For the incomparable paleobotanist Estella Leopold, we named a new species of birch, *Betula leopoldae.* We named a new genus and species of fossil leaf for both the town and for Yale University paleobotanist Leo Hickey, who authored several of the major paleobotanical works of his time, and as a teacher trained one of the rising stars of the next generation, Kirk Johnson: *Republica hickeyi.*

Wolfe and I named fossil genera for paleobotanists Ruth A. Stockey, Matsuo Tsukada, and Elso Barghoorn, for philosopher Susanne Langer, and for Margaret Stoneberg, curator of the Princeton, BC, museum, and new species for paleobotanists Leo Hickey, Kirk Johnson, Virginia Page, and Howard Schorn, and for collector Michael Spitz, who did much of the important early collecting with me at Republic. During 2002, in an antic moment, paleobotanists Gar Rothwell and Kathleen Pigg went so far as to name a new genus of fifteen-million-year-old opalized fossil fern from Yakima Canyon after me:

Wessiea yakimaensis. With that, a previously private nick-
name of mine became a part of the botanical literature.
In a playful moment, paleobotanists Stockey and Roth-
well's young son, Jesse, and I transposed our names. He
became Jess, and I was now Wessie. Paleobotanists have
far more fun at times than the public would suspect.

Many of the young friends who went with me to
Republic and Princeton, BC, to dig fossils were artists:
Joseph Goldberg, Hans Nelsen, Ron Kellen, Mark Reeves,
Pete Dunthorne, Jeffree Stewart, Matthew Waddington,
and others. I tempted them to help me collect fossils by
telling them that there was always a good chance that they
might discover a fossil that was new to science, and in
turn it might be named for them. I reminded them of how
fickle and fleeting "recognition" was in the art scene, here
today, gone tomorrow. "Come help me look for fossils," I
urged them. "If you find something new, and it *is* named
for you, then you can forget about the vagaries of fame
that beset artists. You can always look yourself up in a
botany book instead." This had already happened to me.
On those gloomy days when I felt wraithlike and doubted
that I even existed, I looked at pictures of *Wehrwolfea* and
Wessiea in textbooks and erudite scientific journals. After
that, what else could possibly happen to me in matters
of art world "recognition" that would ever be so exuber-
antly off-the-wall?

THE HISTORY OF REPUBLIC's Stonerose Interpret-
ive Center begins during the mid-1980s, when Republic
City Councilman Bert Chadick, a true visionary, proposed
that the town purchase the fossil-bearing site across the
street from Republic's city hall, protecting it from com-

mercial exploitation. Plans to open an interpretive center next to the fossil site led to the hiring of anthropologist Madilane Perry as the center's first curator. The interpretive center was soon after that relocated in a historical landmark house just across from the city park. When Perry was offered a government job surveying archeological sites in the Republic area, educator Lisa Barksdale became the center's next curator. During Barksdale's fourteen-year tenure as curator, the museum has become world famous. It presently attracts some 8,000 or more visitors a year. Barksdale and historian Mary Warring published a newsletter entitled *Leaves of History,* in which articles about both the pioneer and paleontological history of Republic appeared side by side. In 2003 paleobotanist Kathleen Pigg and I named three new species of Republic fossils for Lisa Barksdale, Madilane Perry, and Kirk Johnson in recognition of their important roles in the history of Republic's fossils.

Paleobotanists Jack A. Wolfe, Howard Schorn, Estella Leopold, Steven Manchester, Margaret Collinson, Leo Hickey, Ruth A. Stockey, Gar Rothwell, and Kirk Johnson, and paleoentomologists Mark Wilson, Conrad Labandeira, and Bruce Archibald have visited Republic and the Stonerose Interpretive Center to study the collections. Several of them have published scientific papers on new genera and species found in the local fossil beds. The first fossil collecting at Republic began in 1896. During the 1940s, paleobotanist Harry MacGinitie collected at Republic. Until the late 1970s, the fossils found there were given scant attention.

WITHOUT GUY ANDERSON'S financial generosity to me during those crucial years of collecting fossils at

Republic, much of what I've just described might never have happened. During those same years, I continued to take notes and record impressions of Guy: "He spends much of his time with Deryl [Walls] and Ed Kamuda. They may drive into Mount Vernon in the evening to see a movie, usually a foreign film or an art movie, if such a film is showing. Guy doesn't own a television set. If he did, he insists that he would only watch serious programs, such as *Masterpiece Theatre*, or dance performances, operas, or vocal concerts. If he has no company visiting him, he usually reads at night. Lately he's been reading John Fowles's *Aristos*."

Of the book's title, Guy said: "It's an ancient Greek word which can mean several things now, like so many other Greek words. But in this case, it means something like Simone de Beauvoir's 'stain of circumstance,'—but not so political. Fowles is fifty-three years old. He's the most interesting writer I've found in a long time. There are two chapters you should read, those about envy and 'nemo.' He talks about how people draw into themselves."

"Wilhelm von Humboldt wrote in his diary, 'To keep what you already have, you must always be giving it away,'" I responded.

"Exactly! That's the biblical 'leaven.' And I don't mean bread, the way they mean cash and money these days. Leaven means the bread you cast upon the waters, you cast your loaves upon the water," he explained.

On May 4, 1979 I wrote in my diary: "Guy invites me to La Conner for a few days' breather. He says he's painting again, adding, 'I'm only happy when I'm painting, even if it doesn't go well. The rest of the time I'm just acting.' He is hardly ever very specific about his past private life.

He may occasionally allude to a past romance or escapade, but never in a bitter way, nor with any suggestion of regret. If there have been any personal rejections or disappointments in his life, one would never know it. Nothing he says encourages one even to suspect it."

In a similar way, Tobey seldom, if ever, expressed any kind of regret or essential dissatisfaction with his life, even though he did tend to grumble often about ephemeral frustrations and setbacks. During one of our final coffee meetings at Manning's on University Way in 1967, he said to me: "I've had to make many decisions along the way. I'll never know if they were the best decisions I could have made at the time. But having made them, I had to abide by them."

Many years ago, I happened upon a remarkable passage in Montaigne's essay on solitude. Montaigne could well have been describing Guy when he wrote: "People are suspicious of anyone who is silent. They wonder what that person is concealing from them. I have deep within me a great silence that I guard carefully. To protect that silence and myself I have assumed a mask of amiable approachability." This describes Guy very well. Despite his good-natured sociability, he was the most private of people. One could know him for many decades and still not begin to know the many levels of his private thoughts and feelings.

HOW DID GUY GO ABOUT PAINTING? What sort of advice did he offer young painters? I wanted to record such things. So I wrote down parts of our conversations. I saved his letters to me and letters I received from our mutual friends. For instance, while I was in New York in 1956 my roommate, painter Paul Dahlquist, wrote me: "I

went to the [Woodland Park] Zoo a couple of times with Guy to draw. My own drawing style was fast; facility was a characteristic. Guy was carrying a board and large sheets of paper. I think he was using conte crayon. He'd sit down, arrange himself, and start looking. He drew a lioness on one of those trips. What fascinated me was the time he spent looking, compared to the time he spent drawing, like a ratio of ten to one. It took a long time for him to do the drawings. I'd fill six to eight pages of my sketchbook, and he'd still be on the same drawing. But what I was aware of was that his drawings had a real presence. My drawings seemed clever and facile by comparison. I didn't see him destroy anything. We chatted a lot that day but not while he was working."

I read the above account to Guy on the phone. He didn't add anything to it except that he was using French charcoal paper then, and he did many lioness drawings. Tobey had remarked to me while we were looking at one of Guy's Woodland Park Zoo drawings, "That lioness drawing of Guy's is worthy of Delacroix himself!" The Henry Art Gallery on the University campus owned and often displayed a small oil painting by Delacroix of a seated lion, a painting most admired by Tobey and Graves. Guy accompanied Tobey to the zoo to sketch the lions and deer, just as Paul Dahlquist accompanied Guy on sketching trips to the zoo during 1956 and 1957.

Anderson and Tobey drew from the model regularly. In 1955, Tobey and Seattle painters Windsor Utley and Arthur Hall Smith attended evening drawing sessions at the Cornish School on Capitol Hill. Anderson, even when he was in his eighties, continued to draw from the model. Some of his models were his young painter friends Edward

Kamuda and Ron Kellen. I was told that Bill Cumming had modeled for a mural painted by Kenneth Callhan during the 1940s. Except for those times when my painter roommates and I posed for each other, I didn't sketch from the model until Randy James and I attended evening drawing sessions during 2001.

I wrote in my diary: "Guy went on to tell me how he used to sketch at the Central Park Zoo in the 1950s, when he was staying in New York with Phyllis and Robert Massar—'When I was sketching at the zoo, an elderly lady stood at some distance from me, watching me. As she turned to leave, she looked me straight in the face and said, *Concentrate! Concentrate! It is all a matter of memory!* I had no idea just who she might be, but I never forgot that moment.'"

Guy talked so much about the great masters that I was hesitant to show him my own crude works. Susanne Langer had told me my drawings were "frivolous." She characterized my small landscape paintings as too "precious." Nevertheless, I began to take new work along with me to La Conner, especially my "monster" drawings. Guy would study them carefully, without saying anything. Then he would sort them into as many as three piles. He would point to one group and say, "I like these" or "I like these especially." He rarely if ever said anything specific about the individual drawings. But when I showed him some of my figure drawings, that was a different matter. He had advice for me, "You need to work more from the model, and you need to be studying the figure drawings done by the great draftsmen, especially the Italians. [Jacopo da] Pontormo is one of my very favorite draftsmen. You should study his drawings carefully."

Pontormo's study for a lunette decoration at Poggio a Caiano, a study that is now at the Uffizi in Florence, resembles some of the works Anderson began to paint after his 1966 trip to Italy. The large central circle with its limblike figures is reminiscent of Guy's symbolic depictions of the human figure. The extent to which Anderson's paintings have their roots in classical Italian painting is not usually taken into account by many of Anderson's admirers in the Pacific Northwest. Guy's response to his own work could be very defensive at times, especially when it involved his nude paintings and drawings. For an artist who had come through the great classic traditions of nude painting as he had, it was a sad experience to observe how vulnerable he became. He seemed to fear that such painting laid him open to public disapproval or even to some kind of censorship.

When I applied for a Guggenheim Fellowship in 1977, New York painter Loren McIver, Colin Graham, director of the Art Gallery of Greater Victoria, and Guy wrote recommendations for me. Guy's statement was brief and generous: "Wesley Wehr works beyond the two-dimensional activity—his paintings deal with the depth of nature and poetic vision. His drawings are with wit and symbolic penetration. He is one of the few dedicated people in this region. I highly recommend him for a Guggenheim Fellowship." When the judges saw that the dimensions on my paintings were measured in mere inches rather than in feet, I was out of the running.

Guy Anderson felt he had a personal responsibility to "stand up and be counted" when either social or political injustice was at stake. During 1979, the physicians in two far-apart counties in the United States—Skagit County, where Guy lived, and Essex County, Connecticut, where

Susanne Langer lived—banded together to protest the dangers of nuclear radiation. A benefit auction exhibition was held at the Gaches Mansion in La Conner. The proceeds were earmarked for legal fees incurred by the protesting physicians. Guy contributed a painting entitled *Silent Radiation*, and I added a drawing entitled *Madame Meltdown*, a depiction of Washington governor Dixy Lee Ray. Guy's best-known political protest painting, *Ban the Bomb*, is in the collection of the Seattle Art Museum.

Governor Ray had only contempt for anyone who protested the building of nuclear plants. She dismissed the Skagit Valley protestors as being "a bunch of ignorant hippies." While Kirk Johnson and I were staying with Guy in La Conner, Kirk and I drove to Mount Vernon one evening to see the film *China Syndrome*. The nuclear meltdown at Three Mile Island in Pennsylvania took place shortly after the movie appeared.

The other leading painters of the "Northwest School"— Tobey, Graves, and Callahan—gained national and even international reputations while Anderson continued to work in relative obscurity. In 1948, Tobey's and Graves's dealer, Marian Willard, offered Anderson a show at her New York gallery. Anderson declined, saying he didn't have enough work available for such a show. Two years later, dealer Alexander Rabow saw Anderson's work at the Oakland Art Museum and offered him a one-man show at a leading gallery in Paris. Before Anderson could get enough work together for this show, Rabow died. Andrew Ritchie, director of the Museum of Modern Art's department of painting and sculpture, offered Anderson a one-man show in 1951. Anderson again declined, explaining that he was not ready for such an exhibition. Finally, in 1962, Anderson

did accept an invitation to have a one-man show at the Smolin Gallery in New York. There was a newspaper strike at the time, and the exhibition was not reviewed.

One can either say that luck was not with Anderson, or that he had a remarkable instinct for what would be best for his sustained development as an artist. He had already seen at close hand how early fame had complicated Morris Graves's life. Mark Tobey, who had now become world famous, was complaining to friends that he "would not wish fame on his worst enemy." Anderson chose to simplify his life, concentrating on his work, and side-stepping the distractions of the sort of public recognition that eventually plagued Tobey.

I kept notes of my phone conversations with Guy, and I wrote about him in my diaries: "Guy has been very good to me—supporting, encouraging, all of it. He can also be sarcastic & highly caustic. But I never knew him to be vindictive in his actions. And he's honorable. That's a key word with him—honorable. Morris Graves has made a lifestyle out of being unpredictable. Tobey could be such a complex prima donna—deeply intelligent, thoughtful, considerate one moment—obsessively self-centered and disgruntled the next.

"Guy drones on so much about the East Coast art magazine reviews, which he reads very carefully, until they become to him like military field reports brought to an entrenched general. And what does he get out of these art magazine reviews?—more and more news that the 'enemy' is taking over the entire art world—'commercial illustrators' are on the march—'true art' is threatened. The enemy are all in cahoots—standards are sinking—terrible, terrible, terrible—something *must* be done to oppose those

organized barbarians—I guess Guy won't simmer down until everyone paints the same way he does—but not so well. What can one learn here? That's easy: how tiresome defensiveness in artists can be."

Among the leading painters of the Northwest, Guy Anderson occupied a unique position based not only upon the quality of his work but also upon the depth of his dedication to painting. In 1965, painter Bill Cumming said of Anderson: "He is the only one of us who has consistently explored and developed the Northwest idiom in its purest forms. His method (line, color, form, and design) grows directly from the earth, air and water of the La Conner tidal plain: his philosophic stance balances on the polarity between Indian legend and primitive Christian ethic. From this method and this stance grow paintings that are sombre, difficult, and noble: to me they are the finest achievement of the Northwest mythos. The difficulties presented by his tough, diffident surfaces are matched by the diffidence and obliquity of his life. Together, they make him the least accessible and least known of the so-called Big Four."

Painter William Ivey first became aware of Anderson's "strength and breadth" when he saw an exhibition of Anderson's work at the Zoe Dusanne Gallery in 1952. In 1977 Ivey wrote: "Guy Anderson's painting has become an instrument of great flexibility—an extension of his mind and spirit. Sometimes the result is like a casual observation, sometimes a small delight, often strong and personal, but every now and then he creates a work of compelling power and resonance which lives in the mind and memory as only great art can."

New York composer and writer Ned Rorem came

briefly to Seattle in 1990 for a performance of his music at Meany Hall on the University of Washington campus. Guy, who was familiar with Rorem's music and liked it very much, sent a copy of his book to me to deliver to Rorem, who wrote back on October 13th: "Dear Wesley, Please thank Guy Anderson (no address) for his absolutely beautiful book of pictures. It's expert, erotic, personal, and true. I'm so pleased to own it. Always, Ned."

There was a touching gentleness and a trusting vulnerability in Guy's nature. His generosity was boundless. His sense of honor went deep. Those of us who knew Guy as a close friend would likely agree that he was a truly noble human being. The following episode is from a diary entry of mine:

"Guy is very slow to believe the worst of anyone, until the evidence is overwhelming. Only once during the nearly fifty years I knew Guy did he and I ever exchange sharp words. It was about a painter I had regretfully introduced to him. This scoundrel took advantage of Guy's trusting nature in many different ways. While discussing him with Guy, I became increasingly angry. In growing frustration, I finally snapped, 'I hate him as I have seldom hated anyone.'

Guy was much more tolerant than I could be. He took me quickly to task.

'You should not *hate* anyone! That is *not* the Christian way. What about Christian forgiveness? Haven't you ever heard of the milk of human kindness?' he admonished me.

He added, as he often did, 'I would like to think that we are all honorable people.' He was silent for a moment, and then he said, 'I *know* that he lies and steals, but I will defend him, because he works very hard at his painting!'

Wes Wehr, Guy Anderson, and Deryl Walls at the Benham Gallery, First Avenue, Seattle, 1996. Anderson was in town to see his ninetieth-birthday exhibition at the near-by Seattle Art Museum. Photograph by Marita Holdaway.

'In my book, painting pretty pictures does not condone personal corruption!' I replied testily."

I knew very well that in a deeper sense Guy was right about hatred. Nevertheless, I felt very strongly that being an artist does not of itself excuse such behavior. In that respect, a sharp difference existed between us in how he and I judged other people, artists especially. Not knowing what to say next to each other, Guy and I fell silent. My diary contains this passage: "Guy tactfully and skillfully avoids confrontations of any kind. He finds them disturbing and offensive."

There was something about Guy that endeared him to people, even on first meeting. As a human being he was so very much in tune with the sheer magic of life. When he was at an age at which many people are living in the sad ashes of their pasts, feeling that life has passed them by, he seemed to be entirely without regrets of any kind. When his failing health forced him to quit painting, he still retained his sense of humor. Asked if he was still painting, he answered, "No, I'm resting on my laurels now."

IN 1995 GUY WAS AWARDED the Bumbershoot Festival Golden Umbrella Award—a lifetime achievement award on the occasion of his ninetieth birthday. KCTS assigned documentary filmmaker Sheila Mullen to work with Guy and his friends for the filming of this historical tribute. I accompanied Sheila to La Conner on the day she filmed Guy in his backyard on Caledonia Street, and Edward Kamuda at the Valley Museum of Northwest Art. Anderson addresses his impending death in this film: "I think I'm just lucky, because most people don't live this long. So if all of a sudden I don't wake up in the morning,

and I have died in the night, that will be all right. It is part of the process." This film ends with Anderson seated at his piano singing his operatic theme song: *Una Voce Poco Fa (A Voice Not Far Away)*, from Rossini's *The Barber of Seville*. Shortly after Anderson was filmed for his KCTS documentary, his health took a turn for the worse and it was no longer safe for him to live alone. He would now live with Deryl Walls in a large house several blocks away. Anderson's private room at Walls's house contained his grand piano, his library of books, and many of his favorite, long-cherished art objects. This room adjoined a large, sun-lit living room with a door that led to the garden just outside. Deryl saw to it that there were always people present both night and day to keep an eye on Guy—including a trained nurse and a male caregiver. If it had not been for Deryl, Guy would very likely have been put in some local nursing home, away from his familiar surroundings. I had many occasions to observe first hand how pleasant and comfortable a setting Deryl provided for Guy during the final months of his life.

When I arrived for what was to be one of my last visits with him, Guy saw me standing in the doorway: "Is it Wesley Wehr? Do you know how *old* we are?" he asked.

"Yes. I'm 90, and you are 68!" I answered.

"Did you say I'm 90, going on 68? I *do* like that!" he responded.

I offered to assist him as he slowly made his way toward the garden: "No, but thank you anyway. It's slow going now, but I have to keep moving on my own. Because if I stop moving and start staying in bed, I'll never get out of bed, and then it's all over!" he explained. Shortly after this visit, Anderson slipped into a diabetic coma and died on April

25, 1998. So many well-known Northwest painters had recently died. Some of them had been very close friends of mine. But Guy Anderson's passing was an especially deep loss for those of us who knew and loved him as a friend and admired him as an artist.

I RETURNED TO THE SKAGIT VALLEY not long after Guy died. I walked past buildings where he had lived and painted, past fields where I had walked with him in the evening, past taverns where we used to drink together, and past restaurants where he hosted countless dinner parties for his friends. I contemplated the vastness of the valley's sky, the distant snowcapped mountains, the inlets and estuaries, and the drama of the ominously massive dark clouds above the bleak winter fields. I sensed Guy's endearing presence in the Skagit Valley landscape. He had become the very thing to which he had dedicated his long life as an artist.

With Mark Tobey
in New York

I FIRST WENT TO NEW YORK CITY DURING the spring of 1956. It was a city of seemingly limitless opportunities. Things moved quickly and decisively there. It was not a place for procrastinators or for idle dreamers. Everything seemed so much bigger than what I was accustomed to seeing in Seattle: the towering skyscrapers, the many-laned turnpike highways and tall bridges that led into and away from the city, the gigantic airports, and the opulent scale of some of its uptown shops and department stores.

There was so much great art to see in New York, especially at the Metropolitan Museum, the Museum of Modern Art, the Guggenheim, the Whitney Museum, and the Frick Collection. The American Museum of Natural History contained room after room of rare and beautiful minerals, gems, and fossils, and Northwest Coast Indian art. My head reeled when I first got to New York. I wanted to see everything at once.

I wrote Tobey in Seattle: "Dear Mark, Already the Metropolitan Museum is almost too much. I'm going there every chance there is. I can't believe that the Vermeers

were 'painted.' To see so much *really* good painting all at once is a profound experience. I have a piano across the street to use afternoons. I expected to hate this city but there's much about it that is very wonderful and warm. Will write soon. Are you planning to come here?"

Several weeks later Tobey arrived by train in New York for the opening of his show at the Willard Gallery. He refused to set foot on an airplane. This seemed strange to me. So many of his 1950s paintings were abstract images of constellations, galaxies, and the far distant earth as viewed from high above it. Tobey's "space" paintings have such names as *Aerial City* (1950), *Above the Earth* (1953), *Flight* (1955), *Fragments of Time and Space* (1956), *Space Ritual* (1957), *Night Flight* (1958), *Space Rose* (1959), and *Over the Earth* (1960). Tobey's 1950s "space" paintings anticipated the NASA space probe lunar and planetary photographs by nearly a decade. His paintings and the NASA photographs were unforgettable images of the awesome silence of Blaise Pascal's "infinite spaces" that lie beyond the confines of our planet.

Tobey himself remained earthbound. No airplane flights for him. He traveled in his artist's imagination where he would not set foot in his daily life. When he did travel anywhere, it was by train, taxicab, or occasionally on a city bus. He went to Europe by ocean liner. Tobey was a confirmed city dweller, rarely leaving the city. If he spent any time at all outdoors, it was apt to be at a luxurious vacation lodge such as those at Lake Louise and Banff in western Alberta. He usually spent the winters in Seattle, painting. When the spring and summer seasons came, he would get the travel itch. For those months he lived out of a suitcase and did much of his painting in hotel rooms.

During the 1950s, French art critic Colette Roberts con-
cluded that Tobey never lived anywhere. She said he had
at best "only temporary camping arrangements."

After Tobey arrived in New York for his Willard Gallery
show, we met for lunch at the Russian Tea Room. He was
staying at the near-by Manger Windsor Hotel at 100 West
58th Street. He enjoyed taking me to well-known restau-
rants and local landmarks, especially because there was
nothing like them in Seattle. I told him about all the inter-
esting people I had just met in New York. He was amused:
"I know *all* about that sort of thing. You're going through
pretty much the same thing I did when I came to New
York for the first time. I met lots of people, too, many of
them quite famous. Or at least they were then. But I will
tell you something. Now don't get any idea that many, if
any, of these 'important' people are going to be important
to you in years to come. It will be, I can almost promise
you, the most unlikely people who will help you the most
and stand by you."

Lockrem Johnson had invited me to stay with him while
I was in New York. The phone rang at his apartment one
morning: "Wes, it's Mark. What are you doing this evening?
Charmion von Wiegand has invited me over to her apart-
ment for dinner. She was a good friend of Mondrian. I
know how much you like his work. Can you come along?"

Art dealer Sidney Janis had a Mondrian show at his
gallery that month. Compared with the aura that now sur-
rounds Mondrian's work, a dozen or so of his most famous
works were hung on the gallery walls without any fanfare.
While I looked at the paintings, I saw Mr. Janis across
the room, discussing one of the pictures with a visitor. He
was dapper-looking and outgoing. I was surprised when

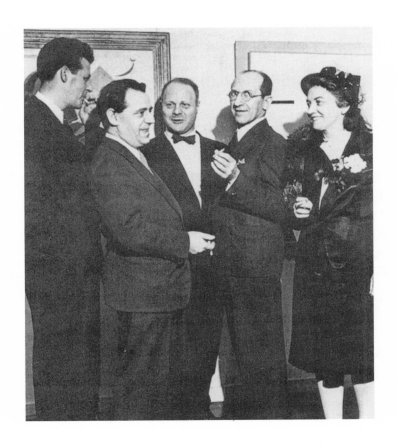

*Tobey's New York painter friends Charmion Von Wiegand
and Carl Holty were also friends of Piet Mondrian. Mondrian
was enthralled by American jazz, especially boogie woogie—
so much so that he often spent his evenings dancing to boogie
woogie with von Wiegand in New York night clubs. Their
painter friends (left to right) Burgoyne Diller, Fritz Glarner,
and Carl Holty are next to Mondrian and von Wiegand
in this 1942 photograph. During the day Mondrian was in
his studio at work on his 1942-43 painting titled* Broadway
Boogie Woogie. *Photographer unknown.*

he later walked across the room and said to me, "If you have any questions, do not hesitate to ask me. That's what I'm here for!"

When Elizabeth Bayley Willis brought Tobey's paintings with her on the train to New York during the early 1940s, she first showed them to Janis, who wrote an introduction for a Tobey exhibition catalogue at the Willard Gallery.

I was also familiar with von Wiegand's paintings. She was a longtime friend of Tobey and of Zoe Dusanne. In addition to her many exhibitions in New York, Switzerland, and Holland, she had a one-person show at the Dusanne Gallery on Seattle's Lakeview Boulevard in 1958. She exhibited regularly in Dusanne's group shows. Von Wiegand's father had been a distinguished journalist. In her own right, she was a respected painter. Her husband, Joseph Freeman, was the co-founder of *New Masses* magazine. She had a relaxed, casual charm about her. She was quick-witted, with a sense of humor quite her own. I especially liked the sound of her voice. It was so down-to-earth. She had known so many interesting people, but in no way did she appear to be living in the past.

Tobey and von Wiegand talked about mutual friends while we had dinner in her small apartment. It was probably just as well that Pehr was not with us that evening. He could be a charming dinner guest, but just as readily he could be the proverbial bull in the China case. There was always the danger that Pehr was going to say something that would mortify Tobey and make him flush with embarrassment.

Facing where I sat was an abstract drawing by Mondrian. It had a lovely spirit about it. From the very first time I saw Mondrian's later work I was taken with it. It

spoke to me in a human way that belied its severely abstract nature. Tobey owned an early landscape drawing by Mondrian, one that he liked very much. He could not, however, share my pleasure in Mondrian's later work, about which he said, "Mondrian performed his own self-purification rite. And he did it so well that there isn't much you can do in that direction any more."

Von Wiegand met Mondrian in 1941, only months after he came to New York. She worked almost daily with him on his essays. I finally initiated an exchange with her:

"Mark tells me you were good friends with Mondrian."

"Yes, I was. I knew him quite well. He was fun to be with," she replied.

She described how Mondrian liked to go dancing, and how much he enjoyed himself at parties. He apparently was not the reclusive figure I thought he might have been.

"I did do something *practical* for him," she added. "He complained to me that it took him so much time to repaint a picture when he moved his stripes one way and then another. It occurred to me that he could put colored tape strips on his canvas while he was deciding where the horizontal, vertical, and diagonal bands should go. I took him to a shop down the street and showed him the different kinds of colored tape—red, black, yellow, and white. This worked out quite well. He could move those strips around until he found what he wanted. His last painting, *Broadway Boogie-Woogie*, is unfinished. It still has the colored tape on it from where he hadn't yet decided to paint in an area."

Von Wiegand invited Mark and me to come with her to the roof of the apartment building where she lived. We took an elevator to the top floor, walked down a dimly lit hallway, and out onto the roof. The low clouds glowed with

the reflected light of the city beneath them. Surrounding us on all sides were Manhattan's skyscrapers with their randomly lit windows. The effect was magical.

"Piet loved sitting here at night, studying these lights," von Wiegand explained. As she said this I began to visualize this nocturnal scene through Mondrian's eyes. Just as his early work, even when it became increasingly abstract, seemed to reflect the formality of the Dutch landscape, his later work caught the jazzlike rhythms of New York and transposed them into a visual metaphor.

Mondrian's *Broadway Boogie-Woogie* (1942–43) has the visual syncopation of both jazz music and the irregularity of the illuminated windows of New York's skyscrapers at night. In an interview in 1943 with James Johnson Sweeny, Mondrian said, "I view boogie-woogie as homogeneous with my intention in painting—a destruction of melody equivalent to the destruction of natural appearances, and construction by means of a continual confrontation of pure means—dynamic rhythms." Mondrian wrote in such abstruse terms as these when he tried to explain why he liked boogie-woogie. I personally preferred Duke Ellington's take on it: "It don't mean a thing if it ain't got that swing!"

Tobey painted his own response to boogie-woogie in his 1942 painting, *Broadway Boogie*. Unlike Mondrian's entirely abstract *Broadway Boogie-Woogie*, Tobey's painting has abstracted Broadway's flashing neon signs, crowded streets, and its tangled crunch of cars and taxi cabs into his own visual response to New York's syncopated rhythms.

Tobey preferred Mondrian's early work, his abstractions of tree forms. I was surprised that he didn't respond more than he did to these later works of Mondrian's. They both

While Mondrian was in New York City dancing to boogie woogie and painting his "Boogie Woogie" masterpieces, Tobey was in Seattle painting his own "white-writing" Broadway Boogie, 1942. Tobey's Broadway paintings capture the high energy and complex interplay of the neon lights, crowds, and heavy traffic of New York's Broadway. One can almost hear the sound of the taxi and car horns and din of voices in the paintings. Collection of Mrs. Max Weinstein, Seattle.

had come to their later abstract works through a similar evolutionary process, starting with their early realistic works. I thought the two of them had something in common.

Tobey and I stood for a while on the roof while von Wiegand pointed out some of the local landmarks: the Empire State Building and Times Square to the south of us, and Central Park nearly below us. We returned to von Wiegand's apartment for coffee and dessert. Her bookshelves contained books on Tibetan Buddhism and theosophy. There were numerous Tibetan bronzes on her cabinet shelves and writing desk.

Out of the clear sky, she announced, "If anyone you know wants to buy a Brancusi bronze and has $1,500 to spend, I know where there's one available just now!" Ironically enough, I did have that much money with me in New York, in the form of one of Aunt Edna's American Telephone & Telegraph (AT&T) stock certificates that I kept in a temporary deposit box at a local bank. (As I have earlier noted, when my Aunt Edna died in Los Angeles in 1953, she left me this telephone stock with the informal proviso that I use part of it for a trip to Europe. I sold off a few more shares of stock whenever my funds ran low. I was never one to put money aside for the future.)

Von Wiegand showed us an original signed etching by Edward Hopper, *Night Shadows*. Tobey bought it from her that evening for $75. When I next saw this print, it was at the Seligman Gallery on University Way, now priced at $200. I bought it for myself. Works changed hands quickly during those years.

I CONTINUED TO STAY at Lockrem's apartment. It was cramped, but it was near the museums and Central

Park. And he was very good about my staying with him. He worked as an editor at C. F. Peters music publishing house in downtown New York. One morning, shortly after he left for work, his phone rang. Mark Tobey was on the phone. "Is that you, Wes? It is such a lovely morning. I thought you and I might visit a few museums today. There are some El Grecos at the Hispanic Museum you should see, and works by [Joaquin] Sorolla [Y Bastida] and [Ignacio] Zuloaga. Not many people seem to know about that museum. Meet me at my hotel at eleven. We can have lunch somewhere later."

I had already spent a good part of my time in New York at the art museums one would usually head for: the Metropolitan Museum, the Museum of Modern Art, the Frick Collection, the Whitney, and the Guggenheim. But it was the little-known, off-the-beaten-track museums that I especially liked. I could spend so much time there without having hordes of art lovers jostling on either side of me for a closer look at the pictures. The popular paintings, such as Wyeth's *Christina's World* and even Van Gogh's *Starry Night,* left me indifferent.

When I visited the Metropolitan Museum, it was the works by Chardin, Watteau, Sasseta, Memling, Bouts, Vermeer, and van der Weyden that enthralled me. I often didn't especially like the works I was supposed to like, those world-famous masterpieces with which one grows up. I liked both the out-of-the-way museums and the hidden treasures in the well-known museums.

The Museum of the American Indian, Heye Foundation, next to Columbia University, had a glass case full of magnificent Aztec inlaid turquoise mosaics. I haunted the gem and mineral collections at the American Museum of

Natural History. Where else could I see the world's largest star sapphire, a gigantic meteorite specimen, or cameos carved of Australian black fire opal?

Of all the objects at the Metropolitan Museum, one in particular never ceased to transfix me: a woman's face, carved in yellow jasper by an Egyptian artist some 3,300 years earlier—a fragment that was all the more beautiful because it was fragmentary. This lovely treasure is in a glass case in the Egyptian wing of the museum.

Tobey and I visited The Cloisters at Fort Tryon Park at the northernmost end of Manhattan Island. He was visibly moved by much of the medieval religious sculpture we saw there. I was captivated by the Unicorn Tapestries and the central courtyard's cloisters which had been reassembled from the original parts of several centuries-old French monasteries. I'd assumed I would have to go to Europe to see anything like this.

Pehr was with us that afternoon. He had just begun to paint. Tobey thought it would be good for him to see some great art, works he couldn't see in Seattle. Unfortunately, the glories of medieval art seemed wasted on Pehr. He was far more interested in when and where we were going to have lunch: "Mark, all this trudging through this museum wears me out. *When* can we have lunch?" Pehr was so insistent that Tobey finally gave up, whispering to me, "You and I will have to come back here another time, when Pehr isn't along with us. It was a mistake for me to invite him to join us today. I should have known better."

We left the museum and sat at an outdoor cafe table having a light lunch. Our view of the Hudson River below was quite lovely. It had never occurred to me that a river with so many cargo ships and freighters could be imbued

with such grandeur. I was accustomed to the solitary Columbia River that flowed through eastern Washington, past the Ginkgo Petrified Forest at Vantage, past miles of sand dunes and desert sage, orchards filled with apple, pear, and peach trees, and far horizons of wheat fields as it made its way to the Pacific Ocean. After our frustrating visit to the Cloisters with Pehr, Tobey and I made a point of visiting galleries and museums without him. He could be such a spoiled brat at times. Our first stop was the Museum of Modern Art's large exhibition of German Expressionist paintings. I was already somewhat familiar with the work of Emil Nolde and Franz Marc. But many of the other painters in this exhibition—Karl Schmidt-Rottluff, Otto Dix, Ernest-Ludvig Kirchner, and Lovis Corinth in particular—were unfamiliar to me, and these were some of their greatest works. But Tobey strode quickly through the exhibition rooms, pausing only now and then to look briefly at some particular work.

The museum's outdoor cafe was almost empty when we got there. It was too early for the lunch crowd. Tobey had gone through this large exhibition at such a clip. I asked him why he hadn't spent more time looking at the various works.

"I'm surprised at how fast you went through that show," I remarked.

"I've known many of these pictures for most of my life. I have a lot of them practically memorized by now. Besides that, I'm more preoccupied with working out my own ideas," he explained.

Another afternoon we had lunch in a French restaurant near Tobey's hotel. In my notes I recorded another brief exchange:

"Mark, I've been feeling a bit old lately."

"And just how old are you now?"

"Twenty-seven!"

"Twenty-seven! And you're feeling *old*! Well, I'm very sorry to hear that. I was just thinking to myself that I'm feeling rather young today."

Tobey reached for the bill, and said, "Come along now. We have museums to visit this afternoon. We have *no* time for feeling *old*. Go buy yourself some vitamins and stop being so convoluted. I like you much better when you're not being so complicated."

I was feeling a bit old that day, and Tobey was feeling rather young! That took me by surprise because of something he had said to me in Seattle seven years earlier. I had gone to visit him at his house in the University District. It was the summer of 1949. I had just met him. He was nearly sixty, and I was nineteen. We sat having our coffee in the sitting room just off the living room, an area where he often painted. I noticed that he was staring at his hands. He held them up before me and said something that startled me, because it was so unexpectedly personal.

"These are the hands of an old man," he said, continuing to contemplate his wrinkled, liver-spotted hands. "But my heart is still that of a young man. You can't at your young age begin to imagine what it is like to have the heart of a young man in the body of an old man."

I didn't know what to say, so I remained silent.

Tobey continued: "I have loved in a Dostoevskian way."

I had no idea what he meant by that.

He continued: "I was young like you once. I fell in love for the first time when I was just about the age you are now. It was with a man somewhat older than I was. But

224

it wasn't mutual between us. It is a terrible thing to be in love and then realize that the person you love doesn't feel the same way you do. I went through a crisis, then something very beautiful happened to me. I can't explain it to myself even now, let alone to you. A little while later he changed his mind. He said he wanted to get back together with me. By then it was too late. Where he was at that moment, I was no longer. I wasn't the same person who had declared my feelings to him so openly."

When Tobey said this to me, I realized that it reflected something Norwegian painter Edward Munch had once said, something that Tobey was often to repeat to me in years to come: "Where you are now, I was once, and am no longer." After Tobey died in Basel in 1976, at the age of eighty-six, I continued to grow older, until a time finally came when I in turn had become the very age Tobey was when I first met him: sixty years old. I began to remember things Tobey had said to me when I was young. His words now had a new depth and poignant meaning for me.

At fleeting moments, Tobey lifted the veil of his past and gave me a glimpse into his capacity for having ardently loved someone when he was young, and into his most private vulnerability. I realized then that there are times in one's life when we will confide our most private secrets to a relative stranger far more freely than we will confide them to someone we have known for a very long time. He was not one to express regret about his past, even though he occasionally might mention that he sometimes found himself wishing that he could have had children of his own.

I came to with a start and saw Tobey staring intently at me from across the restaurant table where we sat. We put on our coats and headed out the door into the street.

Tobey had just reminded me that we had a busy day ahead, and many art museums and galleries to visit before Pehr joined us for dinner.

IT WAS A RICH OPPORTUNITY for me to explore New York with Tobey. He was forty years older than I. His memories of New York and the people he had once known there—composer Edgar Varese, artists Lyonel Feininger, Marcel Duchamp, and Marsden Hartley, writer Janet Flanner, dancer Martha Graham, and the legendary gallery owner Romany Marie, for instance—evoked a time that was long since gone. With Tobey as my guide, there were moments when I had memorable glimpses of those early years in New York City's cultural history.

Tobey, Pehr, and I sat having coffee in the dining room of the Waldorf Astoria hotel. The surroundings were elegant. Even though our coffee was served from an ornate silver urn and our tablecloth was monogrammed linen, Pehr was outraged by the price: "$1.50 for one pot of coffee. Mark, we just can't *afford* that!"

"But Pehr, I want Wes to have at least a taste of what life used to be like here in New York," Tobey explained.

Across the room from us sat two vivacious women of a certain age. They were dressed identically. Their hair was amazingly blond and they wore a great deal of conspicuous jewelry. Their diamonds couldn't possibly be genuine, they were too big to be real, I thought to myself. Seated between them was a tottery but distinguished-looking old gentleman. The two women were hanging on his every word. He was flushed with excitement, enjoying all this flirtatious attention from two flamboyant *femme fatales*.

Tobey stared at them in near disbelief: "Ye Gods, it's

the Dolly sisters! They were pretty famous in their hey-
day. Like the Gabor sisters are now. They never married
any of the men who courted them. But they sure ended
up with a lot of diamonds along the way. And they're *still*
at it! From the looks of it, they seem to have found another
sugar daddy. They're obviously having a good time. All
three of them!" The Gabor sisters, Zsa Zsa and Eva, were
glamorous Hungarian beauties and Holywood movie stars
in the fifties who regularly made the newspaper headlines—
usually because one or another of them was getting mar-
ried again or divorced again. Perhaps every generation pays
court to its Diamond Lils.

Tobey and I went to the Museum of Modern Art to see
exhibitions by sculptor David Smith and Chilean painter
Echaurren Matta. Neither exhibition seemed to interest
Tobey. He walked through the galleries at a brisk clip. I
tried to stop now and then to look at one or another of the
works, but Tobey would look back at me and impatiently
wave me on. David Smith exhibited at the Willard Gallery
from 1940 to 1956. Marion Willard also represented Tobey,
Morris Graves, Lyonel Feininger, Loren MacIver, and
Guemes Island sculptor Philip McCracken. Elizabeth
Bayley Willis introduced Tobey's work to both Marion
Willard and Jackson Pollock.

We left the galleries and stood in the lobby just out-
side the museum's gift shop. Someone said, "Mark!"

Tobey replied, "Mark! I wondered when I'd ever see
you again!"

The stranger approached us, and shook hands with
Tobey.

"Wes, I'd like you to meet Mark Rothko," Tobey said,
introducing me.

"What brings you to New York?" Rothko asked Tobey.

"I'm having a show with Marian [Willard]. Besides that, I needed to get away from Seattle for a while and get my batteries recharged. It's so easy to fall asleep in Seattle."

"How is Pehr? Is he here with you?"

"Oh, he's off somewhere on his own today. Just as well, he doesn't seem to enjoy looking at art."

The two Marks conversed briefly. When Tobey and I were walking down the street later, he said to me, "I've always liked Rothko. He's someone I'd like to see more of, but our paths just don't cross often enough. I think he's the best of the New York painters."

Tobey was usually caustic when he talked about New York Abstract Expressionist painters. He was also capable of changing his mind. For instance, when he first saw de Kooning's *Seated Woman* paintings, he dismissed them nastily. Several years later he announced to young painter Arthur Hall Smith, "I've resisted de Kooning's work for a long time, because of a difference of taste between us. But now I realize that he *is* a great painter!" In a 1962 interview with *Seattle Times* art critic Ann Todd, Tobey commented, "There are fine painters in New York. I admire Rothko, even if he does keep doing the same composition over and over. De Kooning is a fine painter, and there are some others."

How did Tobey feel about Jackson Pollock? An unpublished letter in Tobey's handwriting is revealing. It is addressed to William Rubin, chief curator at the Museum of Modern Art. Rubin was responsible for much of the promotion of Pollock's work at MOMA and for the absence of work by Tobey, MacIver, and other artists on the museum's walls. In this apparently unsent letter, Tobey writes:

Rubin, Rubin, I've been thinking—but not as you think. I have never been a [Paul] Klee-ite—matter of fact I was never near his art except for very short intervals. I used to be condemned on this point years ago. I thought that such critics of the past did it because they didn't know where I hung my hat so [they] decided to take Klee because he too worked small.

Just so Pollock—I never felt I had to imitate him as I had my own ideas and didn't have to live in New York to get something.

What I did [I did] in my rather calm way—I had no desire to kill myself, as I wasn't concerned with intensity as Pollock was. And now he is dead and Time is lifting his head to tell us the truth. This has to be—he [Time] will do the same about me—so let him come. I have nothing against Pollock—I never envied him and in some cases I liked him. But when he made his cathedral over which the NY boys made a huge fuss I felt he had known me better than they did.

I don't think I am dumb about his work. He had to find his gods as I did and any artist has to. They are rather obvious but one must know.

My influences were found in China & Japan—the beginning of all this was in Dartington Hall in England. I was far from what was going on in New York during the 7 years I stayed there.

History shows there are many good artists but alas very few good critics.

WAS POLLOCK'S WORK influenced by Tobey's white-writing paintings? It has been well-documented that Pollock was familiar with Tobey's work during the 1940s, when he visited the Willard Gallery and studied Tobey's

work very carefully. It can also be documented that this "overall" approach to painting had been present in the work of other pioneering artists at that same time. Art critic Clement Greenberg rewrote history to claim that Pollock was unfamiliar with Tobey's work. Conversely, I find Tobey's claim that he was not very familiar with Klee's work hard to believe. For one thing, Tobey was quicker to claim that he had influenced other artists than he was to credit other artists of his time with having influenced his own work.

Tobey enjoyed the stimulation of visiting New York and seeing the great art in the museums there. He maintained, however, a militantly defensive attitude about his relationship to the New York art world. He wanted its unqualified praise, but on his own terms. He was usually caustically dismissive of many of the New York painters, but he felt that he deserved from them more recognition than many of them accorded him. When he returned to Seattle after being in New York, and when I asked him what he had seen there that he liked, it had mostly been works by Marsden Hartley, and an occasional work by Edward Hopper.

Some of the Northwest painters I knew said they preferred one another's early work. Guy Anderson claimed that Kenneth Callahan's early work was his best. Tobey said that the pictures Graves painted when the two of them were seeing each other regularly were Graves's strongest work. I began to notice that these painters rarely applauded one another's most recent work. I soon learned to take their opinions with a grain of salt. There were too many personal factors coloring these artistic pronouncements. Long-held grudges, mutually hurt feelings, and complex rivalries were often at the root of their expressed opinions of each other's later work.

Mark Ritter told me sculptor Alberto Giacometti said he liked Tobey's early work better than his later work. Giacometti's remark ruffled Tobey's feathers. He retorted testily that it was Giacometti's earlier work that was by far his strongest. Tobey was often sharply dismissive of the later work being done by many of the most famous painters of his day. He complained that they were no longer painting "seriously." He accused them of "just playing around." He especially had Picasso's later work in mind.

Tobey conceded that Jean Dubuffet was "very intelligent." Then he added, "But, alas, Dubuffet is all head and no heart." That remark infuriated Andre Malraux, the Minister of Culture for France, when Tobey made it to him at the opening of Tobey's exhibition at the Musee des Arts Decoratifs in Paris in 1963. Malraux was a great champion of Dubuffet. He took Tobey's remark personally and strode angrily away.

Tobey turned to Mark Ritter and said, "Have I just stuck my foot in my mouth with Malraux?"

Ritter replied, "You know very well you have. I think you enjoyed doing it, too. It's that Yankee streak of yours coming out again!"

In a 1962 interview with *Seattle Times* art critic Ann Todd, Tobey said, "Artistically Paris is dead. There's no one there but Dubuffet. He tries to be a brute. He is actually a highly intelligent man, but what he does is make pictures."

Dan Johnson, Marian Willard's husband, sized the situation up very well. He and other friends of Tobey's were discussing the plans John and Anne Gould Hauberg had to build a museum near their tree farm north of Seattle. This museum would be dedicated to Tobey's work and would include works by such other Northwest artists as

Morris Graves, Guy Anderson, Helmi Juvonen, Pehr Hallsten, Clayton James, Margaret Tomkins, William Ivey, Kenneth Callahan, Leo Kenny, and Richard Gilkey. Dan Johnson finally said, "This is all very well, this idea of having a Tobey museum in the Northwest. But we all know that the only thing that will ever pacify Mark will be for him to have his own shrine right next door to the Museum of Modern Art."

Part of the early years of at least five important twentieth-century American painters was spent in either the Pacific Northwest or the Far West. Mark Rothko had his first one-man show in Portland, Oregon, in 1933. Painter Robert Motherwell was born in Aberdeen, Washington, in 1915. Painter Clifford Still taught at Washington State College in Pullman 1935–1945, and Jackson Pollock was born in Cody, Wyoming, in 1912. Painter Chuck Close was an art student at the University of Washington during the 1960s, studying with Alden Mason, while Jay Steensma was studying there with painters Walter Isaacs and Spenser Moseley, and printmaker Glen Alps.

MANY PEOPLE IN THE 1950S Seattle art scene, the painters and writers especially, seemed to nurse a chronic resentment toward the New York art scene. They made a provincial mystique out of their culturally isolated lives. Many of them behaved as if they were Nature's most intimate confidants. They scorned New York in a militantly defensive way, calling it a money-crazed place that had little to do with art and the finer values in life.

Some of the artists I knew in Seattle implied that the only great scenery in the entire world was confined to the Pacific Northwest. I was soon to find out otherwise, espe-

cially when poet Richard Eberhart and his wife, Betty, invited me to their beach house on the Maine Coast near Ellsworth and Deer Island. For three days we had lobster bakes on their beach. In the evening we went in their motor boat to the neighboring islands, many of which had abandoned homesteads and orchards on them. The coast of Maine was wonderful. Some years later I came upon a book by nineteenth-century writer Sarah Orne Jewett entitled *Country of the Pointed Firs*, and Mary Wilkes Freeman's stories set in coastal Maine. The Eberhart family introduced me to the beauty of coastal Maine. Jewett's and Freeman's stories gave me an enhanced appreciation for this marvelous country.

Starting in 1956, I often visited Susanne Langer in Old Lyme, Connecticut. The time I spent with her there and in the rural parts of New York state near Kingston introduced me to even more of the East Coast's scenic beauty. In Connecticut, we collected waterworn quartz crystal pebbles on the beaches where the Connecticut River empties into the ocean. When I stayed with her at her cabin near Kingston, New York, we collected dried pine cones and dried twigs from the forest floor for our campfire and wild mushrooms for our dinner. A forest trail led from Langer's cabin down the hill to a bend in the creek where she had her own swimming hole.

Some of my artist friends in Seattle had also the notion that artists in New York did nothing but socialize and run around town trying to advance their careers. My months in New York City quickly dispelled that notion. In their later years, composer Ben Weber, painter Loren MacIver, and other New York artist friends of mine were among the most reclusive artists I have known. They

seemed to know everyone and, during their later years, to see hardly anyone.

Tobey visited New York regularly. He liked being in Seattle during the winters, when he worked on his painting, leading a fairly humdrum life. But he also needed, from time to time, the stimulating energies of New York. When I was being critical of New York's highly competitive art world, Morris Graves pointed out to me that "many artists can only develop in such an environment."

Tobey continued to introduce me to fascinating aspects of New York City. Several days later, while we were walking down the street together, I heard a voice exclaim, "Mark! Is it *really* you?" The man walking toward us looked familiar. His voice was distinctive, but hard to place. This tall, imposing, almost courtly man was Vincent Price, the actor. On camera he was a scary villain, starring in such popular horror movies as *The Fly, The Pit and the Pendulum*, and *The Fall of the House of Usher*. Price could be elegantly decadent and cynical, as he was in the film *Laura*. When he was off stage and not before a camera he was a cordial, warm-hearted, and outgoing man. Now he was in New York, where he had just won *The $64,000 Question* on national television for answering questions about art. Price was well known as an art collector and expert. Among the works he owned were ones by Tobey and Graves. Price wrote a brief statement for one of my shows at the Humboldt Gallery in San Francisco.

We stood on a sidewalk just off of Columbus Circle. The traffic noise made it hard to converse. Price suggested we go to a nearby coffee shop. We sat at the front counter and ordered coffee. Price and Tobey were very glad to see each other. Just as they began to talk with each other, the

hostess came up to Price, handed him a menu, and said, "Mr. Price, I hope you won't mind, but could you please autograph this menu for me." Price signed the menu and gave it back to the hostess, telling her, "But you should ask the man sitting next to me for *his* autograph. He's far more important than I am!" The hostess ignored this advice and left the counter, clutching her autographed menu.

Tobey invited Price to the Willard Gallery to see his show. Marian Willard had loaned Tobey a guest room at the back of the gallery. It consisted of a narrow bed, a wash basin and shaving mirror, and a small bathroom. There was also a hot plate for heating water for tea. It was quite adequate for Tobey's needs. He ushered us into his temporary living quarters, where he opened one of his traveling bags and took out a large manila envelope.

"Vincent, I want to show you some paintings by my good friend, Pehr. He started painting a few years ago. I think you'll like his work."

Price of course wanted to buy something of Tobey's. He quickly realized, however, that before Tobey would show him any of his own work, he had better buy a Pehr painting or two. Tobey had with him a portfolio of about twenty small paintings by Pehr. Price was charmed by Pehr's pictures and picked out three. Then, and only then, did Mark bring out a portfolio of his own works. Several of them were painted on Manger Windsor Hotel stationary. One small tempera painting was especially lovely. It was almost entirely blue. That was the one Price wanted.

"Mark, would you sell me this one?" Price asked.

"Yes, I'd be glad to, but I'll have to ask you $200 for it," Tobey replied.

Tobey always preferred cash transactions. The less the

tax people knew about his income the better, he'd tell me. He couldn't be bothered with saving receipts or keeping track of money.

Price explained that he didn't carry that much cash on him. He could bring the money to Tobey the next day.

Upon his arrival in New York, Tobey had promptly gone to an art supply shop near his hotel to buy art supplies. He painted the works he showed Price at a writing desk in his hotel room. His *Meditative Series* was painted at a similar writing desk at the Manger Windsor Hotel in 1954. Wherever he was, he either drew or painted. He said artists should never procrastinate: "Don't put things off too much, thinking that you may be in a better position to do something later. If anything, the situation may become even worse with time."

One evening Tobey and I strolled through Greenwich Village and the Bowery. The men sitting in the all-night coffee shops or sleeping in doorways made us imagine we were walking through the Pioneer Square part of downtown Seattle, the original Skid Row. Tobey felt a kinship with these men who had fallen upon hard times. As a young man he had lived here in New York and been befriended by painter Marsden Hartley, who in turn as a young painter had known painter Albert Pinkham Ryder. Ryder's great moonlit seascapes were painted in a small room not far from where Tobey and I were now walking. I remembered what Tobey had said to me over coffee when we were at Manning's on University Way: "Wes, this tradition of our drinking coffee together goes back a long, long way. When I was your age I used to have coffee with Marsden Hartley in New York, just as you and I are doing now. And when Hartley was the age you are now, he used

to see Albert Pinkham Ryder and have coffee with him. So you are now a part of a tradition that goes all the way back to the great Albert Pinkham Ryder. And that is something to be taken very seriously!"

When Hartley first saw a marine seascape painting by Ryder, he wrote, "It was a marine by Albert P. Ryder—just some sea—some clouds—and a sailboat on the tossing waves—I felt as if I had just read a page of the Bible." Hartley remembered Ryder in New York City "in his regular sort of grey clothes—a grey sweater—a grey skull cap knitted—his rich grey full beard hanging down—huge shaggy eyebrows—his hands behind his back—walking up Eighth Avenue usually in the evening."

A single piece of correspondence between Tobey and Hartley survives, a postcard written by Tobey to Hartley in Cuernavaca, Mexico, but apparently never mailed: "Dear Mars, I am laid up with a bad small-pox vaccination and the Doctor says I can not attempt Cuernavaca until Sunday. [Romany] Marie & myself & friends will come and put up at the Savoy. Then we can see you when you want to. I think this is better. Have much to tell you & say to you—and more to listen to you. Keep cheered! Yours mucho, Marco."

Tobey was in the town of Guillermo Prieto, some 120 miles northwest of Durango, when he wrote Hartley, who was staying in a pension in Cuernavaca just outside of Mexico City from late May until November of 1932.

Hartley wrote the catalogue introduction for Tobey's retrospective at the Contemporary Arts Gallery in 1931. Hartley was also friends with Lyonel and Julia Feininger, and with painter Loren MacIver and her husband, literary critic Lloyd Frankenberg. They lived on Perry Street

in Greenwich Village, in an apartment that was a gathering place for such artists and writers as Alexander Calder, Marsden Hartley, Marianne Moore, Elizabeth Bishop, and E. E. Cummings. Frankenberg's husband introduced the poetry of Moore, Bishop, Cummings, Robert Lowell, Randall Jarrell, and Theodore Roethke to a wide reading public when he published his poetry anthology entitled *The Pleasure Dome of Poetry*.

MacIver remembered Hartley's visits to her apartment on Perry Street in Greenwich Village: "We made sure we always had a small box of French candied violets on hand, just in case Mr. Hartley might drop by unexpectedly. He liked them so much that he would sometimes eat an entire box of them during his visit with us. He was a lovely man. He was so modest. Lloyd and I liked him very much. He wrote poetry, too. Some of it was quite good."

TOBEY LIKED TO REPEAT Ryder's advice: "A painter should live to paint, not paint to live." This meant that artists had to know how to live by their wits. Many of them preferred to have part-time jobs that left them more time for painting. Guy Anderson worked at the Seattle Art Museum off and on during the 1930s and 1940s. From 1933 to 1953, Kenneth Callahan worked there as assistant and later as part-time curator. Aberdeen-born painter Clifford Wright also worked at the Seattle Art Museum, installing exhibits, as did painter Neil Meitzler from 1957 until 1977. In her text for *Iridescent Light*, writer Deloris Tarzan Ament explains how Meitzler came to work at the museum: "Meitzler was house-sitting [near Granite Falls] for the [Kenneth] Callahans for a few weeks in 1957." Ament relates how Meitzler invited Graves to the Callahan's

house, where Graves saw some of Meitzler's paintings and praised his work. He asked to borrow several pieces. Taking Meitzler's pictures home with him, Graves displayed them in prominent spots and invited Seattle Art Museum director Dr. Richard Fuller and his wife to dinner. When Dr. Fuller took favorable notice of the borrowed paintings, Graves persuaded him to hire Meitzler for the staff of the Seattle Art Museum, continuing a long tradition of artists who had been hired by Fuller, and whose works Fuller subsequently bought for the museum collection.

Morris Graves was often instrumental in helping the young artists he met to establish themselves in the local art world. Painters Kenneth Callahan, Guy Anderson, and Clifford Wright also worked at the Seattle Art Museum, as did maverick painter Charles Krafft later. I worked at the Henry Art Gallery as a weekend guard for several years, starting in 1950, drawing little critters and creatures during the rainy winter afternoons.

It was also a common practice in Seattle for Tobey, Graves, Anderson and other artists to be on the lookout for art treasures in secondhand shops. These artists knew how to use their keenly honed eyes to spot unrecognized treasures and bargains on the dusty shelves of Seattle's local junk stores and antique shops. They knew how to spot these works and pick them up for next to nothing. If they made a real find, they could hopefully sell it to Dr. Fuller for the Seattle Art Museum's collections.

Tobey and I were ambling along Lexington Avenue, looking at shop windows, observing people walking past us. We came upon a small shop that had a hodge-podge of antiques, curios, and some Asian art in its front win-

dow. We went in. The shop was very narrow. It had a musty smell of old magazines and stale tobacco. The proprietor was reading a newspaper in the corner. Tobey's eyes swept quickly over the contents of the shop. I could sense something was up. He walked slowly back through the shop to the rear wall and stared at a small painting that was hung a little lopsidedly on a nail.

I could tell that Tobey was trying to conceal his excitement from the shopkeeper, especially when he said to me, "Well, Wes, I'm going to have to buy *something* for her birthday present. I don't have all day to shop around." Tobey had said nothing to me about buying a birthday present for anyone that day. It was just a ploy of his to keep the dealer from realizing what Tobey's real interest in this little painting was.

Tobey picked up a nondescript vase from the cluttered counter of a glass case and asked the proprietor, "How much is this vase? It has a chip in it, you realize." The proprietor said Tobey could have it for eight dollars. "And how much is this little painting?" It was six dollars. "I'll take it," said Tobey, paying for it quickly. Waving at me to follow him he darted out the door. We walked several doors down the street. Toeby paused to examine his new purchase. He excitedly exclaimed, "Wes, just look at *this*! It's a Tosa painting. It's Japanese—a very nice little painting. I think I can sell it to Dick Fuller for enough to pay for a week or two in New York!" Several days later Tobey sold this picture for a good profit.

Tobey liked to walk when he was in New York. After dinner in Greenwich Village one evening, we strolled toward the East River. Tobey wanted to see the Brooklyn Bridge again. The side streets were nearly empty. Suddenly,

looming ahead of us at the end of Battery Street was the Brooklyn Bridge. Tobey stood looking up at it: "There it is. I don't think it can be done any better than Stella did it!" he exclaimed. I had seen a reproduction of Joseph Stella's painting of the Brooklyn Bridge. I could easily see why Tobey made such a remark. The bridge glowed with the rivers of car lights crossing it. Their reflections shimmered on the surface of the Hudson River below.

I had never seen the Brooklyn Bridge before, but I had heard Theodore Roethke read Hart Crane's *To the Brooklyn Bridge* to our poetry class. The great English actress Ellen Terry, seeing this bridge for the first time during the 1890s, described it as "hung up high in the air like a vast spider's web." There was a cathedral-like majesty to this bridge, especially at night. It had a religious quality as it rose up above the New York skyline—much like that of the great European cathedrals that towered about the landscape and neighboring cities. It reminded me of such cathedrals as Chartres in the French countryside, Notre Dame in the heart of Paris, and Salisbury Cathedral against the horizon of the Salisbury Plain in England.

I continued to stay with Lockrem Johnson at 134 West 87th Street. It was a short walk from there to Central Park. Just across the park was the American Museum of Natural History. Lockrem's apartment was a third-floor walk up. Danish dancer Eric Bruhn's apartment was on the first floor, near the front door. Lockrem's cramped quarters consisted of a tiny living room, a bathroom with shower, a kitchenette with a table and two chairs, and the smallest bedroom I had ever seen. There were two single beds in it, with barely enough room to edge between them. When Lockrem didn't have any out-of-town guests, the extra bed

was piled high with bundles of sheet music. He had just founded his own music publication house, Dow Music, named for pianist Berthe Poncy Jacobson's first husband, Wallace Dow. Their son, Pierre Dow, would later give many of his mother's Tobey paintings to the collection of the Art Gallery of Greater Victoria, BC.

Lockrem's loud snoring was so awful that I usually slipped into the living room and spent the night on his sofa. The humidity was terrible. I routinely got up in the middle of the night and stood in the shower, trying to cool off. I finally took a room down the street in a rundown but inexpensive hotel called Capitol Hall. Pianist Gordon Grant also had a room there. Gordon studied piano with Berthe Poncy Jacobson in Seattle and with Leonard Shure and Edward Steurman in New York. Steurman had premiered the Schönberg piano concerto a decade earlier and was one of the foremost exponents of Schönberg's piano works. One afternoon, when Gordon and I were in the subway, we encountered Steurman and had a brief exchange with him.

During the day Gordon worked at the Brooklyn Museum. During the evening he practiced the piano and attended concerts. He and I lived several doors apart at Capitol Hall. A young painter from Germany, Willi Ossa, lived with his wife and baby daughter just down the street. They invited us to stay with them in their small apartment. Willi's idol was German painter Max Beckman. Willi's dream was to come to the Pacific Northwest and paint the landscape. When he did arrive in Seattle the following year, he went to Neah Bay and the rain forests of the Olympic Peninsula for several weeks and came back to Seattle to show me his new landscapes. They looked pretty much

the same as the Beckman-like paintings he had done in New York.

When I stayed at Capitol Hall my nights were mostly miserable. The small window in my room looked out at a dingy brick wall about twenty or so feet away. Clean linen was not included in the weekly rent. There was only one bathroom and a single shower on the floor where I stayed. Worst of all was the humidity and the stench of the garbage cans set out on the cement sidewalks. On a hot summer night the smell was terrible. I was too exhausted by the weather to go out in the evening. Even if a breeze did come up, walking in the street at night was dangerous. Walking alone in Central Park at night was out of the question.

After dinner at a Greek restaurant down the street, I struggled with the crossword puzzle from that day's *New York Times*. Looking quickly through the newspaper I noticed a brief item on one of the back pages. It said that a local painter, Jackson Pollock, had been killed in a car accident the night before. The only friend I knew in Seattle who had known Pollock was Elizabeth Bayley Willis. She had worked for the Willard Gallery in New York when Pollock came by the gallery on several occasions specifically to look at Tobey's white-writing paintings.

Several student friends from Seattle days also lived near me in the West 80s: pianist Bob Phillips and poet Kenneth Pitchford, who later married feminist writer Robin Morgan. One night the three of us pooled our money and bought a single head of cabbage. Bob steamed it, added salt and butter, and that was our dinner. Being flat broke in New York was not all that bad, as long as we had money enough

to pay our rent and buy what food we needed. There were so many things one could do that cost nothing. You could visit the countless museums, both large and small, go to free concerts in the evening, attend gallery openings and station yourself at the hors d'oeuvre and liquor table, go to the Bronx Zoo, Central Park, or take a ferry boat excursion to Staten Island. There was no end to the things one could do in New York for next to nothing.

I saw poet Albert Herzing a few times. We had been fellow students in Richard Eberhart's poetry class in Seattle during 1953. Herzing had a composer friend, Ben Weber, a well-known composer who lived with his two dogs in a small apartment on Central Park West. Weber composed atonal music that was richly expressive. Lockrem loathed twelve-tone music, but he liked Ben personally. As he put it, "I love Ben dearly, so much so that I can forgive him for writing that damned twelve-tone music!"

Herzing took me on a tour of the New York bars. At the Whitehorse Tavern in Greenwich Village he had me sit in a certain booth facing him. Just as I took a sip of beer he said, "You are now sitting in the very same place where Dylan Thomas drank himself to death and died that same night in a hospital a few blocks from here." In another bar a man rushed out the door, almost knocking my chair over. "That was Chester Kallman," Herzing explained. Kallman and poet W. S. Auden shared an apartment several blocks away. The two of them collaborated as librettists with Igor Stravinsky on his opera *The Rake's Progress*.

Ken Pitchford had met composer Ned Rorem at a recent party in New York. Rorem had just composed the film score for Tennessee William's *Suddenly Last Summer*, starring Katharine Hepburn, Elizabeth Taylor, and Mont-

gomery Clift. Another Seattle friend of mine, Steve Kelly, had been sitting by himself on a bench in Central Park when baseball player Joe Dimaggio sat down at the other end of the bench. A few minutes later actress Marilyn Monroe appeared, apologizing for being late.

Reclusive actress Greta Garbo was expected at a party given by a friend of pianist John Ringgold. The guests waited and waited for her to arrive. The phone finally rang. It was Garbo apologizing that she couldn't make it after all. She explained that she was shopping at Altman's Department store, and she just couldn't tear herself away. She had disguised herself so well that none of the other shoppers at the store recognized her.

A riddle went the rounds among those of us who came from Seattle but were now in New York: "How do you tell the difference between Seattle and New York?" The answer was, "If a lady comes up to you in Seattle and tells you she's the Queen of Bulgaria, back away from her very slowly. She's probably batty. But if you're introduced to a woman at a party in New York and are told *she's* the Queen of Bulgaria, be very careful how you behave. She just might be!"

Susanne Langer lived at Old Lyme, Connecticut, an easy train or bus ride from New York. I often escaped the New York humidity by spending a week or so with her. We both enjoyed beachcombing and fossil collecting. When I stepped off the train at New London, Connecticut, Susanne was there to meet me. "I have the most exciting news to tell you," she exclaimed. "Several months ago a man was bulldozing land for a new building complex north of here. He uncovered dinosaur tracks under the loose soil! Next week let's drive up to see them!"

The following week we visited the dinosaur track out-

crop and the small visitor center beside it. From there we left for Susanne's forest cabin at Kingston, New York. Once we got settled there, we took off to collect 300-million-year-old Devonian fossilized brachiopod shells in the nearby outcrops. Langer's close friend, physician Nancy Perkins, lived at Westerlo, a short drive north from Langer's cabin at Kingston. The three of us collected fossils in the Devonian outcrops of Windham Quarry near Gilboa and went to see the fossil tree remains at Gilboa, where the oldest known North American land plants had been found. These fossil plant remains dated back to approximately 400 million years ago, at the time of the earliest known land plants.

When I wasn't staying with Langer, I sometimes stayed with Lockrem again. Each evening, when I returned to his apartment, he interrogated me about how I had spent that day. When I told him I had gone back again to one or two of the museums, he was exasperated: "But you've already been to those museums! Why the hell would you want to keep going back to them?" he'd ask. He complained to Tobey that I was wasting my time going to museums all the time, so much so that I obviously would never amount to anything. Where was my ambition, he wanted to know.

Modern dancer Mary Carrigan was living in New York then, studying with Martha Graham. Mary had previously studied with dancer Martha Nishitani in Seattle. Mary was one of Martha Nishitani's first students when Nishitani taught in the Tower Building at 908 East Madison, across from Seattle University. Nishitani moved her modern dance studio to University Way in 1954. Nishitani had been present at the first dance recital given by Merce Cunningham, at the Cornish School in Seattle.

Mary and I had a date to spend the afternoon at Central

WITH MARK TOBEY IN NEW YORK

Park and have lunch there. She suggested I pick her up at Graham's studio after class. The class was just finishing when I arrived. Miss Graham came down the stairs as I was standing with Mary. She was very cordial: "I've just returned from Greece. Have you been there? If you haven't, you really should!"

Miss Graham asked me if I were a dancer. She must have been trying to be polite. I told her I was a composer.

"Why don't you bring some of your music by my studio and play it for me? I'm always interested in hearing new music!" she responded.

When I returned to Lockrem's apartment that evening, he wanted to know how I had "wasted" that particular day. This time I reported to him that I had been at Martha Graham's studio, and that she had invited me to play some of my music for her. Lockrem didn't take this very well. He said petulantly, "I've tried to meet her ever since I got here, and I've gotten nowhere!"

In 1975 Martha Graham came to Seattle with her dance company. They performed at Meany Hall on campus. Even though Graham was now eighty years old, her vitality, theatricality, and charismatic personality were as nearly overwhelming as ever. After the performance, I went backstage to see her. I asked her to autograph my program. Then I realized I didn't have a pen with me. "That's all right, I have one in my purse," Miss Graham said. "I always have a pen with me for signing autographs. It's my vanity!"

Graham and her accompanist, Louis Horst, taught at the Cornish School in Seattle during a spring and summer in the early 1930s. So many of the people I met in New York had unexpected connections with the Pacific Northwest. I told Miss Graham that I was headed for Basel to see

247

Tobey in a few months. Graham exclaimed, "How *is* he? Please give him a message for me. Tell him I'll never forget the night he and I went all around New York in a taxicab. He'll know what I mean. Now please do that for me!"

I WOULD BE SAILING for England in September, and staying with Richard Selig and his new bride, singer Mary O'Hara, in London. After London, I planned to go to Paris. Tobey was very pleased that I was finally going to Europe. Two days before I sailed, while we were at an outdoor cafe at the Central Park Zoo in New York, he mentioned the museums he thought I should visit and the people I should look up: "I'd better make you out a list of things for you to see in Paris—Sainte Chapelle, the Musee de Cluny, the Louvre, of course. And don't forget to see the Rodin Museum. Rodin is a great sculptor. People don't appreciate him nearly enough now. I own two of his watercolor drawings. Did I ever show them to you?"

Tobey tore a page out of his notepad and said as he began to write on it: "You're going to need a letter of introduction. I'll write you one now." He wrote: "This is to introduce my composer friend Wesley Wehr. Any kindness shown to him will be considered a kindness to me. Mark Tobey." This was my note of introduction to many dealers, artists, and critics in Paris. When they read it, the art gallery dealers were especially nice to me. Tobey had become very famous. Many dealers were competing with one another for works of his to sell in their galleries.

The evening before I sailed for South Hampton, England, on the ocean liner *Le Flandre*, Tobey invited me to stay at the Willard Gallery. I slept that night on a pad in the center of the gallery surrounded by Tobey's paint-

ings. Phil McCracken's wooden sculpture *Killer Whale* was next to me. I could detect the faint smell of the red cedar from which Phil carved it. It was a nice reminder of what I would be returning to in a few months—the pungent smell of cedar trees in the rain forests of the Olympic Peninsula.

The next morning, Tobey took me to the boat by taxi-cab and inspected my cabin himself. It was going to be about a six-day crossing. Tobey wanted to be sure that my accommodations would be adequate. As the boat debarked he stood at the landing, waving goodbye.

I traveled light. Before I left Seattle for the East Coast, I bought a cheap suitcase at J. C. Penney's department store on University Way. I took along with me a sport coat and necktie, a few shirts, a spare pair of pants, socks, and briefs. I planned on discarding some of these clothes along the way when I bought new clothes in England: a London Fog raincoat, which I planned to buy once I got to London. And a new pair of Oxford shoes, which I bought one after-noon in Oxford, while I was there with Richard and Mary Selig. Except for a few clothes in a battered suitcase and those on my back, I was unencumbered as I headed for Paris.

Madame Pomier's Pension

WHEN I ARRIVED IN PARIS ON SEP-
tember 12, 1956, I took a room in a pension on
the Boulevard St. Michel, just across from the
Luxembourg Gardens. This building had once been the
residence of French composer Cesar Franck. A bronze
plaque beside the front door gave his dates: 1822–1890. It
also said that he had composed some of his finest music
in this house.

My concierge, Madame Pomier, was most hospitable.
She didn't wince at how badly I pronounced the few
French words I knew. She didn't seem annoyed if I arrived
a little late for meals. All in all, she made me feel that I
was more a member of her family than merely a paying
guest.

Madame Pomier spent her mornings in the neighbor-
hood marketplace shopping for fresh produce. Later in the
day she sat at a table in the dining room peeling onions
and potatoes and shelling peas for our evening meal. At
the end of each day she wanted to know how I liked Paris.
She suggested places I might visit. She provided me with
a free ticket to a performance of *Le Cid* at the Comedie

Francaise. I barely understood a word of it, but the actors' highly stylized gestures were fun to watch.

Breakfast consisted of thickly sliced French bread accompanied by a gob of butter. On the same breakfast tray was a large cup of dark, rich coffee and a small pitcher of warm milk. The tiny cups of coffee I was served in the nearby cafes were another matter. After about three or four sips I had emptied them. In Seattle I was used to large cups of coffee and no end of refills.

The room in which I stayed was spacious, with high ceilings and shuttered windows that looked out on a small courtyard. I slept as near the window as I could because the nights were deliciously warm. The morning sunlight would begin to envelop my bed at about 8:00 A.M. The delicate fragrance of the lilac bushes just outside the window dazzled with its purity, but my room's faded, dingy wallpaper was made up of an obsessive pattern of tiny floral wreaths and fussy flowers.

Taking a bath in the pension was not a simple matter. I had to make an appointment. Madame Pomier put several coins in the hot water tank above the bathtub, turned the switch, and heated the water in the obviously very old metal tank. When my bathtub was filled with warm water and awaiting me, Madame Pomier would rap gently on my door. I began to have a clearer idea why baths and showers were not a common morning practice among the often impoverished students in Paris. In Seattle, we took an unlimited supply of hot water for granted.

Just down the street was the Musee de Cluny, a perfectly preserved medieval manor built on top of Roman ruins. The most famous of its treasures is the medieval tapestry series entitled *The Lady and the Unicorn*. This

Wes Wehr fast asleep in a Boulevard St. Michael pension,
Paris, September 1956. Etching based on a pencil sketch
done by the author's traveling companion, painter Norman
Sasowsky, during their travels through London, Holland,
and France in 1956. Wes Wehr Papers, MSCUA, University
of Washington Libraries, UW22140.

museum is housed in the ancient residence of the Abbots of Cluny. It houses one of the world's finest collections of medieval art. In its basement are the remnants of a Roman bath. In the glass cases upstairs are seventh-century gold votive crowns of the Visigoth Kings. From the street this building looks inconspicuous. But inside it is a breathtaking treasury of some of the most beautiful ancient art and sacred relics to be seen in Paris.

Composer Francis Poulenc lived in an apartment just a few blocks away, one that overlooked the Luxembourg Gardens. While I was in high school, I had written to him for an autograph. Several years passed before I heard back from him. In his note to me he explained that my letter had fallen behind his desk. He had only now discovered it. He apologized for taking so long to respond. With his note, he enclosed a small sheet of music paper on which he had written out for me the opening bars of one of his choral works.

My French didn't improve noticeably during the weeks I was in Paris. Consequently I always ordered the same things in restaurants: *omelette jambon avec pommes frites*— a ham omelet with fried potatoes. It was only when someone else was ordering for me that I escaped having that standard fare day in and day out.

I spent many afternoons at the Louvre. While the tourists thronged around the *Mona Lisa* and the *Venus de Milo*, or stood gawking at the towering *Winged Victory of Samothrace*, I stood transfixed before the archaic Greek Kouros torsos, the Cycladic marble heads, and especially the standing figure of the Kore goddess from the temple of Hera, on the Greek island of Samos. The paintings at the Louvre were marvelous—especially the *Pieta de Avignon*, the full-

length portraits by Goya, Watteau's *Pierrot,* and paintings by Vermeer, Chardin, and Memling.

When Mark Tobey made out a list of what I should see in Paris, the Sainte-Chapelle was nearly at the top of his list. I had already been to Westminster Abbey in London, to Notre Dame in Paris, and to Chartres Cathedral outside Paris. But entering Sainte-Chapelle was a far more intense religious experience for me than seeing those great cathedrals. There was a quality of both grandeur and intimacy about this thirteenth-century chapel that was uniquely its own. It had originally been built to house its most precious possession: Christ's crown of thorns.

One afternoon I went to the venerable establishment of Durand, the music house that first published the works of Satie, Debussy, and Ravel. I wanted to buy some scores by Eric Satie while I was in Paris. I also wanted to buy copies of Ravel's *Sheherazade* and Debussy's cello sonata. An elderly, formidable man came up to me, asking if he could assist me. He peered at me suspiciously. In the best French I could muster up I explained that I wanted to purchase a copy of Debussy's sonata "for cello." I pronounced "cello" as it would be in Italian: "*chell*-o."

This Daumier-like man looked down his beaklike nose at me and said sternly, "You mean to say *sell*-o!" He was using the French pronunciation. I had used the traditional Italian pronunciation for such musical terms.

There was something about him that made me feisty. I answered him with equal firmness, "Mais non, je dit *chell*-o!"

His eyes narrowed menacingly. He spun around and strode across the room. A moment later a different clerk was waiting on me, one who wasn't so militantly concerned with preserving the purity of the language of Racine. I had

been told so often that I'd never understand another society if I were not fluently conversant with its language. I did nevertheless feel that this clerk and I understood each other very well.

I continued to run into still more snobbery, sometimes among the students who met in cafés along the Boulevard St.-Michel. While I sat with several of them sipping cognac, one student asked me offhandedly where I was from. I told him I lived in Seattle. He had vaguely heard of San Francisco, he said with an annoyingly snide tone. But where was this Seattle? Did we have any sort of *culture* at all there?

As luck would have it, our café table was next to an outdoor stand of literary and art journals. I picked up a copy of the latest issue of the Princess Marguerite Caetani's Roman literary journal *Botteghe Oscure* and handed it to him casually. It just so happened that it was a special issue devoted to such Seattle poets as Theodore Roethke, Kenneth O. Hanson, Lloyd Parks, and others. I glanced at some Parisian art journals on a nearby magazine rack. One of them had a Tobey painting on its cover. I showed this magazine to him, telling him that oddly enough we did manage to have something of a "cultural" scene in the far reaches of the Pacific Northwest.

When I apologized to him for not speaking better French, he replied in fluent English, "Well, of course, I shouldn't expect you to speak French very well, should I?" We looked at each other with rapidly increasing dislike. He got up and left. I hated these abrasive little Parisian moments.

I WAS NEVER PARTICULARLY interested in Napoleon. Nevertheless, I got into a Parisian taxicab one after-

noon and asked the driver to take me to his monument. Ten minutes later the driver pulled up in front of a formidable building. I paid my cab fare and walked through the imposing front door to an admission desk where I had to shell out still more French francs. Art museums in Seattle didn't routinely charge admission like the Parisian museums did. By now I had already spent more than my daily budget allowed.

Napoleon's towering, casketlike monument stood in the center of an enormous, high-domed room. I took one look at it, felt an eerie chill and stepped quickly back into the street outside. I was in no mood to appreciate this gloomy memorial. I wanted to escape this depressing place as fast as I could.

I walked back toward the Louvre and the gardens next to it. The Jeu de Paume was there, a small building that housed so many masterpieces of French painting, famous works by Degas, Monet, Manet, Seurat, Van Gogh, Cezanne, and other great artists. Manet's waterlily paintings occupied an entire room of their own.

When I stood before Renoir's *Bal du Moulin de la Galette, Monmartre*, I thought that real sunlight was falling upon the canvas. I turned around, expecting to see the sun streaming through a window just behind me, illuminating the surface of this painting. Through some kind of painterly alchemy, Renoir had achieved the illusion that there was real sunlight on his canvas. The effect was astounding.

The pathways at the Jardin des Tuileries were covered with small shards of opalescent orange and brown chert that glistened in the sunlight. They were like the chert the Indians along the Columbia River in eastern Washington

State used to shape their delicately fluted arrowheads. I picked up several pieces of this chert to bring back to Seattle.

While I was strolling in the gardens I happened upon a most marvelous relic lying on the ground before me: a large, ornate key. It looked centuries old. The door to which it had once gained entrance must have been truly majestic. I imagined myself—like some sort of a Prince Charming— spending the rest of my life going from door to door in Paris, trying to find just which door this key belonged to, if such a door still existed. So many of the beautiful old houses of Paris were being razed to the ground and replaced by modernistic apartment buildings. Perhaps this key had belonged to the regal entrance to some noble family's ancestral home.

I remembered that the concluding poem in Rimbaud's *Illuminations* begins with the line "I alone hold the key to this wild parade." Was this perhaps the metaphorical key to which Rimbaud claimed to have sole possession?

Shortly after I was comfortably settled at the pension I began to contact some of the people Tobey had suggested I meet when I got to Paris. I looked up sculptor Claire Falkenstein. She was a good example of someone who took to heart the advice "follow your dream." She had left behind her in California the kind of life we call "the American dream" in order to move to Paris and become an artist, living like a Spartan in the heart of the art gallery district of Paris.

Claire Falkenstein was born in Coos Bay, Oregon, in 1910, and studied art at the University of California at Berkeley. She was first known for her jewelry, which she exhibited at the Guggenheim Museum and the Museum

of Modern Art in New York. During her Paris years, she did a commissioned fire screen of metal and fused glass for the Baron de Rothchild's chateau, a floor-to-ceiling stair railing for Gallery Sapizio in Milan, and a similar work for the Gallerie Stadler in Paris. Peggy Guggenheim commissioned Falkenstein to make a wrought iron and fused glass gateway door for her palazzo in Venice.

HER SMALL FLAT was a strenuous climb of stairs from the street below. It consisted of a small main room that looked out on the walled courtyard below, and adjoined her bedroom and a kitchen area. When the weather allowed, she worked outdoors in the enclosed courtyard downstairs. She kept her unfinished work and welding tools in a small wooden shed in a corner of the courtyard.

Claire was tall, blond, and appealing in her robust way. She was overflowing with energy. I wasn't used to seeing a woman don a welder's mask. My idea of sculpture was a more conventional one. I associated it with sculptors who worked with marble and bronze. Her work was praised by important critics, owned by well-known art collectors, and handled by leading dealers in Paris, Italy, and New York. She was well connected, but she wasn't an aggressive social climber. She was entirely without any of the cultivated mannerisms that so many American artists acquired once they arrived in Paris.

On her fireplace mantle Claire had placed, even enshrined, a Cambrian Era trilobite, the fossil remains of a creature that thrived on sea floors hundreds of millions of years ago. It was a fossil trilobite similar to the one composer Ernest Bloch kept on his writing desk at Agate Beach on the seacoast of Oregon.

"Every time I start to get discouraged and wonder what I'm doing here, I just look at this little creature and remind myself that we've all been around for a long, long time. This fossil has kept me going at times," she exclaimed to me.

Claire invited me to dinner one evening. The meal was a simple one: two small steaks from the butcher down the street, boiled potatoes, salad, bread, cheese, grapes, wine and coffee. It reminded me of Tobey's cooking in Seattle: simple, nourishing, and tasty. Neither Claire nor Tobey was given to preparing elaborate meals. They had better things to do with their time.

After the dinner dishes were put away, she brought out a welding torch, two visors, a pair of tongs and several pieces of clear plastic Lucite. "Would you please hold this for me while I attach it to this other piece. Hold it very steady. It has to be exactly where I'm placing it now. Don't be afraid. I won't burn you. I know what I'm doing, really," she said.

Claire exhibited her work at the Galerie Stadler, one of the best galleries in Paris. There was to be an opening there in a few days. She was racing to finish a new piece for the show. When it was finished to her satisfaction she asked me to help her carry it to the gallery, which was only a few blocks away from her studio. We lay the sculpture on a narrow board and covered it with a sheet.

Claire had a madcap side. At the end of the plank, sticking out like shod feet, we placed a pair of tennis shoes. We solemnly carried her abstract sculpture through the courtyard and streets to the gallery. With the blanket covering it, it resembled a shrouded corpse. The people we passed along the way quickly got into the spirit of our mock ceremony. As if they were witnessing a funeral cortége they

doffed their hats, crossed themselves, and bowed solemnly as we passed them. But now I'm beginning to exaggerate. It was only one man who did this. The other people in the street entirely ignored us.

Claire conscripted me to be her assistant now and then. On one occasion we walked a few blocks to a local foundry. We arrived just as the workers were finishing their lunch. Claire eyed the heaps of discarded scraps of metal, plastic, and broken glass, spotting odds and ends that she might be able to use in her sculptures. Her elementary French had a charmingly American twang to it.

Claire intrigued these brawny, grease-smeared workers. They didn't know what to make of her. Why did she want these seemingly useless scraps of metal and plastic anyway?

Trying to explain why, Claire said "Je suis une artiste!— une *sculptor!*"

"Une *sculpteur? Vous?*" one of them responded.

"Ahhh, *Rodin!*" said another man, naming the first sculptor that came to his mind.

One of the men—the heftiest of them—perched on a pile of lumber and imitated the familiar pose of Rodin's *The Thinker.* Another well-built man parodied some of the classical Greek and Roman statues one sees in childhood textbooks. One worker puffed up his massive chest like an amorous pigeon and began to make cooing noises. They were having great fun imagining that they were posing for this "liberated" woman's sculptures, and even being (who knows?) someday immortalized by her.

"*Balzac!*—Rodin's *Balzac!*" exclaimed another worker. He started to remove his shirt, as if he were about to dis- robe in front of us. Rodin's nude statue of French writer

Honore Balzac was the most sexually explicit figure sculpture Rodin ever made.

"No, *no!*" protested Claire. "Je suis une—*abstract* sculptor!—like—*Picasso!*" grasping for an example.

"*Aha, Picasso!—Pablo!*" exclaimed one of the men. The other men began to contort their faces with their hands, and to assume grotesque positions. They had a real talent for farce. I wondered if they had been part of some traveling circus before they came to work at this foundry.

I had never seen Claire lose her *savoir faire* before. These men had not at first known what to make of her. Now it was she who didn't know what to make of them. Just then they broke into laughter and started applauding her, exclaiming *"Quelle femme!"*—What a woman!

One of the men came up to Claire and in his deep, resonantly gruff voice said to her, "For you—*anything!* Help yourself to anything on our scrap piles. We like you, American lady. Please come back again."

Even though she made no particular effort to be, Claire was quite attractive. The foundry workers were entertained by her American offhandedness. I think a few of them were even attracted to her. As we left the foundry, carrying armloads of scrap metal and plastic, Claire said, "One tip. If you can't speak French well, butcher it. The French will love it!"

I was standing by the window in Claire's main room when she pointed to an upper storey window across the courtyard.

"Henri Michaux, the poet, lives in that apartment. When Zoe was here a few years ago I threw a party for her and invited him and a few other friends here for dinner. The two of them hit it right off. They were off in the cor-

ner for most of the evening. Zoe charmed Michaux. By the end of the evening it was agreed that Zoe would exhibit his work in Seattle. That is how Michaux's first exhibition in the United States came about."

Several evenings before I left Paris to return to New York, Claire threw a small party for me. There were only five of us present, but in a flat as small as Claire's that was plenty. The all-powerful art critic Michel Tapié was there. I was told that he was directly descended from Henri de Toulouse-Lautrec. Tapié coined the term *Art Autre* in 1952 to designate an art movement that had allegedly broken entirely with the past. Its best-known exponents included French painters Dubuffet and Mathieu, Chilean painter Matta, and German painter Wols.

Tapié was one of the first French critics to recognize Tobey's importance and to throw his entire weight behind promoting him. But, like several other influential European and American art critics, he expected his "kickbacks" now and then. For instance, when he wrote an important article about Tobey in a French art magazine he borrowed a dozen or so small paintings from Tobey for illustration. Tobey told me about how Tapié kept putting off returning these works to him. They eventually showed up for sale at a New York art gallery. This infuriated Pehr, but Tobey told him to quiet down and be "realistic."

The other dinner guests that evening included Claire's New York art dealer Martha Jackson, and California painter John Hultberg. Hultberg was thirty four years old. He was from Berkeley, California, and had studied with American painters Mark Rothko, Clifford Still, and Richard Diebenkorn at the California School of Fine Arts. He had just won a Guggenheim Foundation fellowship that

year. I was glad to be with someone else from the West Coast. We talked about California and a few mutual friends in the San Francisco area. He was pleasant and amiable. Claire and Hultberg were from California, as was young painter John Craig Kauffman, with whom I explored the Paris galleries.

Tapié had brought along with him a tape recording to play for us that evening. It was a parody of a solemn lecture on modern art. It droned on and on in the convoluted jargon of French art criticism, interspersed regularly with the word "dollar." Tapié made a few sarcastic remarks about American "materialism." I was quite used to that by now.

Many of the French art critics were on the defensive that season. The New York Abstract Expressionist painters were starting to overshadow the French artists. The market place was rapidly shifting from Paris to New York. The *art autre* and *art informele* movements in Paris had started to seem tame when compared to such groundbreaking New York artists as painters Jackson Pollock and Willem de Kooning, and sculptor David Smith.

The finely calibrated social behavior of some of these esthete boors baffled me. Nuance was everything. Their sharpest barbs came wrapped in elegant little packages of words. However, all I had to do when I met such people was to remind myself that they represented only a small part of the French populace. A far more endearing side of the French was exemplified by my concierge, Madame Pomier, and her family.

Tapié proposed that the party guests contrive the existence of a soon-to-be famous painter. This painter's works were to be owned by wealthy collectors in South America. His paintings were never exhibited or even reproduced any-

where. Yet, thanks to the complex manipulations of a small group of art world powerbrokers, this painter's name—if not pictures of his work—would appear in all the best art history books of the time. Such is the power of the press, intimated Tapié.

I sat in the corner listening to this stuff, finding Tapié much too cynical for my taste. But this was true of some of the art critics in New York, too. They were on power trips, relishing their abilities, real or imaginary, to be the makers and breakers of reputations in the current art scene.

Martha Jackson seemed at best only faintly amused by Tapié. John Hultberg maintained a cheery sort of neutrality. When he asked if I would like to slip away and go down the street for a drink, Jackson overheard him and shot an infuriated glance at him. She arose from her chair and announced that she had a headache. She asked Hultberg to escort her back to her hotel. They left a few minutes later.

I saw Claire again several days later. I wanted to buy a few graphics from her, things that I could carry home in my luggage. She called her prints *objets gravures*, engraved objects, because she printed them from pieces of copper upon which she had soldered copper wires. I bought two of these graphics from her. One of them is now in the collections of the Boise Art Museum.

Claire wanted to send home with me a present for Tobey. She scratched "For Mark" on one of her *objet gravure* copper plates, and asked me to bring it to him in Seattle. This piece eventually went to the Seattle Art Museum as part of the Tobey bequest. I last saw it for sale in an Asian art shop in Seattle's Pioneer Square area.

Tobey admired Claire's work. On the wall of his Seattle

studio hung a large tumbleweed-like sculpture of hers. She had burnished it to a lovely blue-grey sheen. Tobey felt a kinship with this work as he did with other works of Claire's. But when it came to which artists they did or did not like, they often saw things quite differently.

Claire was part of the *art autre* movement, the "cutting edge" of modern art. She considered French painter Jean Fautrier to be a major figure. Tobey described Fautrier's paintings less enthusiastically, "He makes a big pancake out of paint and slaps it on a canvas. There's a lot more to painting than that!"

Tobey urged me to visit Rodin's former studio in Paris. In his own studio in Seattle, Tobey had tucked away in a portfolio two exquisite Rodin watercolors of women amorously entwined. I had already seen the large collections of Rodin's sculptures and watercolors at the Maryhill Museum on the desert cliffs above the Columbia River in Washington State, and at the Palace of the Legion of Honor in San Francisco's Golden Gate Park. Seeing Rodin's work in the very environment in which he had made it was an entirely different experience, a more direct one.

I loved Rodin's figures sculptures. They were voluptuous and bursting with highly charged sexual energy. Many people claimed that Michelangelo's *David* and the classic Greek statue of the *Venus de Milo* are the last word in idealized beauty. For me, however, it was Rodin's *Adam and Eve, Age of Bronze,* and *The Kiss* that stirred my adolescent gonads. Except for Roman satyr and archaic Greek Kore and Kouros sculptures, most Greek and Roman figures seemed insipid in comparison to Rodin's lusty work.

From 1907 onwards, Rodin's studio was at the Hotel Biron in Paris. It was now the Musée Rodin. His *Burghers*

of Calais and *Gates of Hell* were in the enclosed courtyard outside. Inside the museum were many glass cases filled with hundreds of his clay figure studies. Paintings by Van Gogh, Renoir, Pissarro, and other French artists, works that he had personally owned, hung on the walls. No museum I had visited before gave me such a strong sense of "work in progress" as this museum did.

Claire felt that Rodin was "old hat" and that he had little to do with the concerns of avant-garde sculpture. She could admire Brancusi's work more than she could Rodin's work. It surprised her that I could like both Rodin and Brancusi at the same time. The lines between "The Old" and "The New" had been sharply drawn by the Parisian artists and critics.

Painter George Mathieu represented "The New." He had a Dali-esque capacity for self-promotion. He commuted between Paris, New York, and Tokyo, where he would paint his own brand of "action paintings" while he gave his painting performances in the windows of Tokyo department stores. Mathieu was a good painter. He was also something of a ham. He worked very hard at being an *enfant terrible*. Being "shocking" was a prerequisite part of the role he played as an artist. Zoe Dusanne first handled Mathieu's work in Seattle. Several years later, Otto Seligman decided to handle some of Mathieu's work in his own gallery in Seattle. Mathieu had "arrived" in Seattle as few other Parisian artists had at that time.

While I was with Otto Seligman in Paris, he arranged for Mathieu to take us to his home on the outskirts of Paris. Mathieu had taken up an age-old battle cry, one that had been proclaimed by the Surrealists and the Dada artists: "Down With the Louvre." While Mathieu drove Otto and

In 1961, Tobey became the first American painter since James Whistler to have a retrospective exhibition at the Louvre's Musée des Arts Décoratifs in Paris. Photograph by Arthur Dahl; Mark Tobey Papers, MSCUA, University of Washington Libraries, UW22136.

me to his home in the outskirts of Paris, he announced to us that the Louvre had outlived its usefulness. It had nothing to offer the painters of today, he said. Tobey would have been dismayed, if not downright disgusted, by such nonsense. Even though he was one of the most original artists of his time his roots remained firmly in the past. The Louvre was an essential part of that past for him.

Mathieu lived in an unexpectedly conventional house. It was a modest chateau surrounded by well-cared-for formal gardens. I had assumed that his house would be very chic and modern, like his art. Mathieu combined two lives in one. During the day he worked in the business district of Paris as an executive for the French Steamship Lines. The rest of the time he was an omnipresent rebel in the Parisian art scene. His name appeared regularly in the press as he issued his iconoclastic statements, denouncing the past and praising only that which was "new."

As we were walking up a flight of stairs to the second floor, Mathieu paused on the stair landing and pointed at a small, ornately carved cradle in the corner.

"That was Toulouse de Lautrec's cradle!" he informed us. Mathieu's studio was in an adjoining large room. He spread dozens of his "action" paintings on the floor. They were painted on large sheets of colored paper with boldly calligraphic thrusts and swoops of paint that he squeezed directly from the tube. They were quite effective and elegant. Otto picked out about thirty of them to take back to his gallery in Seattle.

Mathieu and Tobey had a cordial friendship. Mathieu sent incredibly ornate letters to Tobey, ones that he decorated with all kinds of seals and emblems. Tobey's letters to Mathieu were dashed off in Tobey's nearly unreadable hand-

writing. Although Tobey more or less tolerated Mathieu's theatrics, he genuinely liked his work. Mathieu soon became one of Tobey's most effective champions. Claire eventually left Paris and moved to Venice, California, where her house and studio were across from the beach. We stayed in touch by letter and phone calls. She lived to be nearly ninety.

THERE WERE OTHER PEOPLE I wanted to meet in Paris, especially composer Ned Rorem. He was very famous in both New York and Paris. His music was frequently performed and recorded by the leading conductors and soloists of the day. He knew everyone and was invited to parties that were given and attended by all the people who mattered. He had composed the film score for Tennessee Williams's *Suddenly Last Summer*. I was told that he was very handsome, and that his love affairs were many and at times even notorious. I was also told that he was the lover of the most powerful woman in the French cultural scene, the legendary Vicomtesse de Noailles. His friends included French composers Francis Poulenc, Georges Auric, Arthur Honegger, and Darius Milhaud, and writers Jean Cocteau and André Gide.

Rorem was living in Paris when I met him in 1956— at 11 Place des Etats-Unis, the home of Charles and Marie Laure de Noailles. Charles was descended from a scion family of France. His wife, the Viscomtesse de Noailles, came from a wealthy family and was "impeccably descended from the Marquis de Sade." At the head of their grand stairway hung full-length Goya portraits. On formal occasions liveried servants stood in attendance. Paintings by Dali and other Surrealist painters hung in the hallways

and rooms of the house. The salon of this famed residence was considered to be one of the loveliest rooms in all of France. On one wall there hung a very beautiful painting by Cranach. On another wall was a famous painting by Delacroix. A single piece of sheet music lay open on the piano: Chopin's 3rd Ballade for piano, in A flat Major (Opus 47). It was dedicated to Pauline de Noailles, a nineteenth-century ancestor of the Noailles family.

Rorem had spent the summer of 1956 around the Mediterranean—in Cannes, Rapallo, Florence, Venice, and with Marie Laure de Noailles in Hyeres. Shortly after he returned to Paris in September, I contacted him by phone. He invited me to visit him the following day. He had plans to meet a group of his friends at a Moroccan restaurant that evening. It was only a short walk from where we sat having a drink in an outdoor cafe. He invited me to join him and his friends for dinner. The restaurant was in an elegant, intimate space. I sat next to Rorem. Across the table from us, sitting among several gentlemen, was Jeanne Ritcher, an arrestingly stylish woman. She appeared to be in her forties. She was outgoing. Her laughter was enchanting. She wore a ring that was set with a single emerald-cut diamond, a jewel so large that it dumbfounded me. No one I knew in Seattle would have been able to wear such a diamond with comparable nonchalance.

Pianist Jacques Fevrier sat next to Ritcher. He was a member of composer Maurice Ravel's innermost circle, and a foremost performer of Ravel's piano works, especially the two piano concertos.

I noticed a most exotic-looking woman sitting in the far corner of the restaurant. She was dressed all in black. On either side of her sat several young men. They were

as attentive to her as suitors would be. She seemed distant and remote as she sat with them, listening to them but rarely responding.

I noticed that even though she wore an impassive expression on her face her eyes were watching everything that was taking place. She saw me staring at her from across the room. She neither acknowledged me nor seemed annoyed at my looking at her as intently as I did.

Ned noticed me staring at her. He half-whispered in my ear, "Don't hesitate to look at her, even to stare at her. She likes to be recognized when she's in public."

"Who *is* she?" I asked him.

"That is Leonor Fini, the painter," he answered.

Leonor Fini was a famous Italian painter, stage designer, and illustrator. She never married, but her lovers were said to be legion. Their names eventually read like a roll call of the literary and artistic talents of her time. She would have been about forty-eight years old when I saw her across the room that evening. Her severe beauty was arresting. When she died in 1996 the *New York Times* described her as having been "perhaps the last link with the Surrealist era."

Several days later my concierge came up to me as I returned from a day of visiting museums and galleries. She looked distressed. She told me that the German Embassy in Paris was trying to contact me. When I phoned the number she had given me, a man on the other end of the line asked me to come to the embassy at my earliest convenience. Without explaining why, he asked me to be sure that I brought my London Fog raincoat along with me.

I arrived at the embassy the following day and was immediately escorted into the large, luxurious office of the German ambassador himself. He was a tall, impres-

sive-looking man, about forty or so, I guessed. He got up from his desk and walked across the room, extending his hand in greeting. In his other hand he held a London Fog raincoat.

"We appear to have each other's coat. I noticed this when I tried to put it on. It was much too small for me," he said.

I had noticed when I left the restaurant that my raincoat seemed much too large for me. The ambassador and I had somehow ended up with each other's raincoats.

"Was that Ned Rorem, the composer, you were sitting with?" he asked.

"Yes, it was," I answered.

"I like his music very much. I have never met him personally, but I would very much like to. Please do tell him that I am a great admirer of his music."

I was puzzled by how the embassy staff had been able to trace me to Madame Pomier's pension so quickly. I also realized that an embassy such as this would have highly efficient ways of tracking down just about anyone.

Another evening Rorem told me that he planned to attend a special viewing of a new film with avant-garde filmmaker Kenneth Anger. He asked if I would like to join them. We walked together to the cinema district. Anger was waiting for us in front of the theatre when we arrived. We bought our tickets and walked down a flight of stairs to a large room.

The room was crowded to overfilling with some of the most intent and interesting-looking young French men and women that I had yet seen in Paris. The film they were eagerly awaiting to see was an American one called *Kiss Me Deadly*. It was based upon a pulp fiction novel writ-

ten by American mystery writer Mickey Spillane. The anticipation in the room ran high. Some of the people in the audience were preparing to take notes.

This 1955 film by director Robert Aldrich was far more exciting than Spillane's book ever managed to be. A contemporary review described the film as "an exuberant and harsh thriller set in an unlovely world and shot with brutal close-ups and unusual camera angles that create a disquieting effect. It is as unremittingly tough as its thuggish hero." The film's hero, detective Mike Hammer, was involved in preventing crooks from stealing a case of radioactive material. Actor Ralph Meeker, a former classmate of Ned Rorem at Northwestern University, starred as Hammer.

I could readily understand why an avant-garde filmmaker such as Kenneth Anger would have been so interested in seeing this film. Even though Spillane's book was pulp fiction, Aldrich had visually translated it into a brilliant *tour de force* of cinematic pioneering.

Rorem continued to introduce me to Paris. At Le Flore on Boulevard Sainte-Germain he pointed out sculptor Alberto Giacometti, who sat across the room, engaged in animated discussion with another man. Unlike Leonor Fini, Giacometti did not appear to like being recognized in public. When he noticed me looking at him, he glared fiercely back at me. Later that evening, Ned pointed out actor Charlie Chaplin walking just ahead of us in the street, and said, "It's rare to see him up close this way."

I continued to stay at the pension because it was so pleasant there. Two rooms down from mine lived an elderly woman, Madame Zytowski, who, I was told by my concierge, was Polish and had been in Paris during the

German occupation. She dressed austerely and seemed like a relic of long ago. Even though she appeared frail, she conveyed a quality of great inner strength.

I took several lessons in conversational French from her. The formal French she attempted to teach me was of little help on the streets of Paris. She taught me to say properly *pardonnez moi* and *je suis d'accord*—"excuse me" and "I agree with you." In casual speech these formal phrases became quickly mumbled *"pard"*s and *"dac"*s.

Madame Zytowski and I occasionally went to a small cafe just down the street and had tea and pastry, and sometimes lunch, together. I would attempt to order something in my stilted, textbook French while she watched me trying to negotiate the complexities of everyday conversation. An elderly ladyfriend of hers joined us one afternoon. Wearing an antique cameo brooch and dressed in a style that was decades out of fashion, she too seemed to belong to an earlier era. They conversed with each other in French and with me in English.

After several weeks of taking my meals at the same table with her, I noticed that Madame Zytowski would often look at me in an intently probing way. What puzzled her, I wondered. Over dinner one evening I finally said to her, "You seem to be curious about something. What is it?"

At first she seemed startled that I would be so direct with her. Then she responded, "You are in Paris. I know that you are enjoying yourself here. But I can tell from your eyes that you are not in love. To understand Paris, you should be in love here. I can tell that you have not had that experience while you are here. What a pity!"

My five weeks in Paris passed quickly. The time had come when I needed to think about returning to Seattle.

I phoned Ned to tell him that I would soon be flying home. We met in a Boulevard Sainte-Germain cafe for a parting drink together.

During the time I had spent with him I had come to know a Ned Rorem who was unexpectedly endearing, one who was quiet, reflective, and serious. For all his fame and the complex social life he lived, there was something very private about him. I soon found that I liked him in a way that touched something very personal in me.

We sat at an outside table. Ned finally said to me, "You're headed back to Seattle now. I don't know when we'll see each other again. I'm sorry you're leaving. I'm afraid that you'll disappear into your life in Seattle and neither I nor the rest of the world will ever hear of you again."

Ned was curious about my life in Seattle.

"What kind of life are you going back to in Seattle? Do you have a lover waiting for you there?" he asked.

"Yes, I do," I answered.

"Would you care to tell me about whoever it is?"

"No, I'd rather not."

"I don't understand. When I'm in love I want to shout it from the roof tops of all Paris."

"But, Ned, I found out long ago that when one is in love that is so often the *last* thing one's friends want to hear about. It either bores or annoys them to hear about it," I explained.

For the rest of the evening and well into the early hours of the morning we walked through Paris, saying almost nothing to each other. We walked for miles along the great boulevards, past the illuminated fountains, and the sidewalk cafes that never closed. I was finally seeing Paris through the eyes and sensibility of someone with whom I

could feel entirely open to the intoxicating beauty of this matchless city.

Madame Zytowski was coming down the pension hall-way as I came in the front door several hours after dawn. I was exhausted. I was happier than I had been in a long, long time. As she was about to walk past me, Madame Zytowski hesitated, stood facing me, and stared intently at me.

"*Welcome* to Paris!" she exclaimed. She embraced me impulsively, then continued to walk down the hall toward the dining room where breakfast was about to be served.

Mark Tobey
in Basel

IN 1956, TOBEY TOLD ME THAT IT WOULD be the most unlikely people who would play an important role in my life. His remark was prophetic; it was a fellow music student from college days, Andrew Apostle, who changed the course of my life some twenty years later.

On a Spring morning in 1975, I was sitting in a booth at Manning's coffee shop on University Way when Andrew appeared unexpectedly and sat down across from me. He handed me a printed form, saying, "I have a contract for you to sign. I think you'll like what's in it!" I glanced at it and exclaimed, "But Andy, it's in German! I don't know what it *says*!" "It's your contract with the Rosenau Gallery in Bern. I showed them some of your paintings. They would like to show your work. This is the contract," he answered.

"But what exactly does it say?"

"They tell you that they will handle all the costs of the exhibition, the publicity and mailing costs, the preview catering—all of that. I've looked it over carefully. It's a very generous contract. If you have a show and can go to Bern for the opening, the gallery owners have invited

you to stay with them. I know you'll like them. This way I can finally show you around some parts of Switzerland. I can even introduce you to Paul Klee's son, Felix, and his wife."

Needless to say, this sort of thing didn't happen to me every time I went to Manning's for a cup of coffee.

When I first met him, Andrew Apostle studied violin at the University of Washington. He now lived in Bern with his wife, Charlotte. As conductor of the Bern Chamber Orchestra his professional name was Andreas Apostolou. His mother and many of his closest friends lived in Seattle, so he had occasion to come back to Seattle now and then.

Andrew and Charlotte owned several small landscapes of mine. Their friend, Bernese painter Lotti Pulver, exhibited with the Gallery Rosenau at Zollikofen on the outskirts of Bern. She suggested to Andrew that he show some of my work to the gallery owners. Now, thanks to him, I would have my first exhibition in Europe, and I would be going to Switzerland, where I could also visit Mark Tobey and Mark Ritter in nearby Basel.

I plunged into painting new works and mailing them a few at a time to the Gallery Rosenau. I also sent them Paul Klee-like drawings of fanciful creatures. Andrew was meanwhile back in Bern, where he oversaw the arrangements for my show and trip to Bern the following year.

On April 2, 1976, I flew from Vancouver, BC, to London. When I arrived at London's Gatwick airport, I transferred to a local bus for the Heathrow airport, where I would catch an evening flight to Basel. I mailed a hastily scrawled note to Susanne Langer from the airport: "Dear Susanne, I'm flying to Basel at 10 P.M. tonight—I wasn't able to sleep

during the flight, an 11 1/2 hr. one. But I saw one of the awe-
some glories of our planet—at 3 am we flew through the
Northern Lights above Labrador!—the Scotch Hebrides
were clear this morning—a two-hour bus ride through won-
derful villages in Surrey—the currency exchanges have me
quite mixed up—excuse the stupor."

Upon my arrival in Basel I checked into the Greub
Hotel, directly across the street from the Bahnhoff train
station. This was a very convenient place for me to stay. I
would be regularly commuting by train between Basel and
Bern. Besides, one of Basel's best chocolate shops was
located next to the Greub Hotel's entrance. They sold deli-
cious chocolates, ones that were filled with kirsch liqueur.
Whenever I had insomnia I found that four or five of those
alcohol-laden chocolates sent me right off to sleep.

After my first day in Basel I wrote Susanne again: "I'm
bewitched by Basel—the tomb of Erasmus is in the
Munster—the ethnographic collections are a jolt—large
and superb—the *Kunstmuseum* has works by Holbein,
K. Witz—superb Paul Klees—they must be seen in the
original!—I'm somewhat bored by the early Picassos but
thrilled by the late ones—they too must be seen in the
original—my hotel in the heart of town is only 28SF
($11.50). I'm still trying to reach Tobey. He lives on the most
beautiful little street—where Erasmus, Holbein, Klee, and
Einstein lived—I slept for 12 hours."

I was anxious to see Mark Tobey and Mark Ritter. I had
last seen them in Seattle in 1967, when they came there
following Pehr's death in Basel in 1965 and Otto Seligman's
death in Seattle the following year. Tobey had come to
Seattle partly to arrange for the shipment to Basel of more

of his possessions from his studio on University Way. It was clear by then that he would be settling permanently in Basel.

When I arrived in Basel it was early April. Flowers were starting to bloom in the city parks. Even though the air was still cool, the sun was usually out. But the long, damp winter had taken its toll on Tobey. His house, which was only a few blocks from the Rhine River, was large and difficult to heat, and chillingly damp during the long Basel winters. His health suffered accordingly. Acutely weakened by a prolonged bout of bronchitis, he entered Basel's St. Clara–Spital hospital in January 1976.

I met Mark Ritter for lunch at a restaurant in the Basel marketplatz, a few blocks from Tobey's house on St. Alban Vorstadt. I was already aware that Tobey had written and signed two entirely different wills. The first will left everything to the Seattle Art Museum. It unfortunately was not notarized. The second will, which left everything to Mark Ritter, was elaborately witnessed and notarized.

Mark Ritter immediately began to discuss these two wills: "I can well imagine how the tongues are wagging in Seattle. I had better explain to you why Mark made a second will. He felt the first will was too restrictive. He said to me, 'Circumstances can change. You know which people I like. You know what my financial obligations are. I'll make out a new will and leave everything to you. That way you can parcel my estate out later to the people who should share in it. And you're of course to honor my commitments to John Hauberg and the Seattle Art Museum.'"

After Ritter and I had lunch together he took me to visit Tobey in his hospital room. I was stunned by how frail he looked. Ritter led me across the room to where Tobey sat by the window looking silently out at the hospital gar-

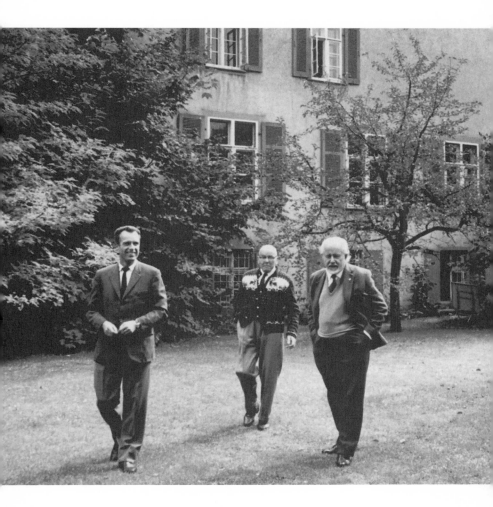

Ernst Beyeler (Tobey's dealer), Pehr Hallsten; and Tobey in the garden at 69 Saint Alban Vorstadt. Tobey was careful with his money but often casual with his own paintings, knowing he could always paint more of them. When Beyeler arranged for Tobey to live in this seventeenth-century house rent-free in exchange for his paintings, Tobey couldn't resist such an offer. Mark Tobey Papers, MSCUA, University of Washington Libraries, UW22203.

dens and said to him, "Mark, look who has come all the way from Seattle to see you! It's Wesley!" As I sat next to Tobey I quickly realized how very difficult it was for him to respond in any way.

Tobey's hospital room looked out at a garden court below where patients sat in the sun. Hanging on the wall above his hospital bed was a framed photograph of the founder of the Bahai religion. Facing his bed was one of the loveliest white-writing paintings by Tobey that I had ever seen. Ritter saw to it that there were fresh flowers in the hospital room. He had made every effort to make the surroundings as pleasant as possible. Next to Tobey's bed was a small cot with a blanket and pillow on it. Ritter later explained to me, "If Tobey is having a bad time of it I sleep on that cot during the night. That way he knows I'm here if he needs anything. Sometimes I don't get much sleep during the night, so I go back to the house and take a nap during the afternoon."

Ritter had brought with him several serigraphs that were based upon a Tobey ink drawing. These prints would eventually become part of portfolio entitled *Meanders*. Tobey studied them intently. When he approved the final state of each print he initialed it, authorizing it for publication. It was obvious that he was much too weak to sign his full name. After a brief stay, Ritter and I left the room and walked down the hospital corridor. Ritter said, "Tobey's art, as you well know, *is* his life. His friends mean a great deal to him, of course. But you know what I mean when I say that. It's been very important that I find a way to keep him actively connected with his work, even when he's much too ill and weak to do any more work. These prints are a collaborative work between Tobey and Mr. Lanz, the

printer, who is a very fine artist in his own right. He under-
stands Tobey's work very well. As long as I can find some
way to keep Tobey involved in something of his own, he
still has a foothold in life. Without that, a part of him has
already died. When I bring him these trial proofs, he perks
up and takes an interest in his work again."

I wrote to Susanne Langer the following day: "Tobey
is in precarious health now so I visited with him only briefly.
At first I didn't know if he even recognized me. When I
talked to him he could only nod. He is so frail and barely
hanging on. But as I started to leave he slowly extended
his hand to me. His penetratingly blue eyes came to life
for an instant. He grasped my hand firmly and stared
intently at me. Then his eyes withdrew and he sank back
into himself again. For a fleeting moment he had sum-
moned up enough strength to convey his farewell to me.
It was a shattering moment.

"After Ritter and I left hospital room Ritter said to me,
'Now you have seen for yourself how serious things are.'

"I left the hospital and walked to the Munster cathe-
dral to sit on a ledge looking at the Rhine—I started to
fall apart—here I am in Basel—such a beautiful, ancient
city—I've just seen Tobey for the last time—both of us so
far from Seattle—I don't know what to say—except that
it seems like some dream I'm stumbling through.

"One of the last things Tobey did was to have Mark
Ritter bring me a thousand franc note. I'm to pick out a
painting for Tobey and a drawing for Mark R. from the show
& let it be known discreetly that Mr. Tobey purchased two
works from my show in Bern. My travel funds have been
dwindling faster than I expected, and now I'm fine again.
I leave for Bern tomorrow & then return to Basel for the

rest of my stay in Switzerland—leaving for London April 18th or so."

IN 1975 TOBEY MET HANZ LANZ, the Basel print-maker. Tobey was very impressed by Lanz' graphic editions and they discussed collaborating on a Tobey portfolio. The nine serigraphs that comprise the *Meanders* suite were executed in Basel during 1975–76 and are the last works to be completed by Tobey. Ritter explained to me how they came about: "Tobey and I were having lunch last year in that restaurant where you and I ate the other day. He started drawing on his placemat. Usually, he'll make just a few quick sketches of people around the restaurant or in the street, but this time it began very abstractly, until he had nearly covered the page with what finally became a very good Tobey drawing—very abstract, very dense, lovely!

"When I looked at his drawing, I had a brainstorm. I held it up in front of him and said, 'This could become a fine graphic! Why don't we show it to Lanz and see what he thinks about it?'

"He studied the drawing for a while. Then he said, 'I think you may be right. It might make a good print, prob-ably a better one than if I had tried to do a drawing with graphics too much in mind.'"

The following week, Mark Ritter introduced me to Hans Lanz at the Lanz Edition Studio, a few steps down the street from Tobey's house. Lanz showed me the trial proofs for the *Meanders* art portfolio. Tobey had initialed each one in pencil to authorize its inclusion in the edi-tion. When the portfolio was completed posthumously, each print was stamped with Tobey's signet ring as an

estate authorization of authenticity, and countersigned in pencil on the back by Ritter.

Saint Alban Vorstadt, the street on which Tobey lived, has a long and distinguished history. Painters Hans Holbein the Younger and Paul Klee, Dutch humanist Erasmus, theologian John Calvin, cultural and art historian Jakob Burckhardt, philosopher Friedrich Nietzsche, psychologist Carl Jung, and physicist Albert Einstein lived on this same street at one time or another. Several families of vast wealth now lived here. Ritter told me about one elderly couple down the street who often invited Tobey and him to their house for dinner. In the dining room hung paintings by Cezanne, Gauguin, and Degas, and in the study hung a fifteenth-century portrait by Hans Memling. Tobey liked to sit alone looking at it after dinner. He once told me, "Memling is the most quiet painter in the world!"

Tobey's house was built around 1600. The front door was only a few steps from the street. On one side of the house was an enclosed garden that adjoined the house of a pastor who was a close friend of theologian Hans Barth, Martin Heidegger, Karl Jaspers, and other eminent European intellectuals. Although Tobey spoke and understood very little German, his Basel friends were invariably fluent in many languages, including English.

In every room of Tobey's house was a richly eclectic accumulation of art objects. A fearsome African sculpture stood in the corner of one room. A New Guinea mask hung on the wall in another room. When you walked up the stairs to the landing where the sitting room was the first thing you saw were two of Tobey's sculptural heads that had been cast in Murano glass. They were on a window ledge where the morning light shone through them.

Adjoining the sitting room were two rooms, one of which contained his grand piano. A smaller room next to it was where he painted. A large, ornately decorated porcelain stove stood in the corner. It was several centuries old. The bedrooms upstairs were damp and drafty. For warmth, especially during the winter, the best place was the sitting room next to Tobey's adjoining piano room and painting studio. It had a large fireplace above which hung a small painting by Pehr. Three comfortable armchairs encircled a small table. Tobey, Pehr, and Mark Ritter had their evening coffee and pastry here.

A lavishly inscribed photograph from Italian actress Anna Magnani hung on the wall behind Tobey's favorite chair. Eleven years earlier, in 1955, Tobey, Arthur Hall Smith, and I had seen Magnani's incandescent, earthy film performance in *The Rose Tattoo* at the Varsity Theatre. For several weeks after that, Tobey urged friends to see this movie, calling Magnani one of the greatest actresses of our time. In the intervening years, they had become friends.

On the fireplace mantlepiece sat two small sculptures by Tobey's friends, James Washington Jr. from Seattle and Portland sculptor Hilda Morris. On the mantlepiece was also a photograph of Colin Graham, Ernst Beyeler, and Tobey. The large oak table in the corner contained a surprise for me: a polished round of golden orange and brown Chinese walnut wood from eastern Washington's Yakima Canyon. I recognized this specimen because I owned a nearly identical piece of this fifteen-million-year-old opalized tree. There were branches of deep red coral and brain corals, Brazilian rock crystals, chunks of snowflake obsidian and polished slabs of rare types of jasper from Oregon and Italy on the bookcase shelves about the house. I rec-

ognized some of these pieces from when they had been in Tobey's University District studio in Seattle.

Some of these specimens are now in the collections of the Burke Museum of Natural History and Culture in Seattle. They originally were part of the Tobey bequest to the Seattle Art Museum and were later transferred to the Burke Museum's historical collections. They are sometimes included in exhibitions of Tobey's work as examples of how often his "abstract" paintings derived from the geological and botanical worlds. The Burke's collections also contain the superb collection of polished Brazilian "eye" agates owned originally by nineteenth-century art writer John Ruskin. After she died, Susanne Langer's son, Leonard, and her daughter-in-law, Nancy, sent me a good part of Langer's natural history collection. It is now in the Burke Museum's historical collections, and it contains exotic insects and beach shells that Langer collected during her 1960's trip to India, Ceylon, Bali, and other parts of the world.

DURING THOSE FINAL FEW WEEKS of Tobey's life, many of his closest friends came to visit him. His long-time dealer Marian Willard came from New York. Vera Russell, former wife of *New York Times* art critic John Russell, came from London. Gotthard de Beauclair, with whom Tobey had done many of his finest graphics, came from France. Mark Ritter's brother, Gottfried, came from Paris. Visits with Tobey were necessarily brief during his final weeks in the St. Clara–Spital hospital in Basel. He had grown much too weak to communicate in words. At best, he could manage a nod of his head.

While I was in Basel I saw Ritter almost every day. There were numerous questions I wanted to ask him. I

wondered why Tobey had decided to settle in Basel. I was curious about this because there were several speculations going around Seattle about why he had left town. One story claimed he was upset by the public uproar surrounding his new mural at the Olympia State Capitol library. His initial studies for this mural depicted the sort of people one saw at the Seattle Public Market on a weekend afternoon: the vendors with their stalls of fruit and vegetables, and the steady flow of shoppers and tourists through the market. This seemed like a very appropriate subject matter for such a mural. Many people were already familiar with Tobey's Public Market drawings. The University of Washington Press published a very popular book illustrated with Tobey's ink and watercolor sketches of the people and life of Seattle's Public Market during the 1940s.

Tobey's final mural turned out, however, to be an entirely abstract work, consisting of just a few geometric shapes, painted in primary colors. With its highly simplified forms and colors it was reminiscent of French sculptor Jean Arp's work. It was effective enough in its way, I suppose. But it just invited public controversy. The local press smelled a good story and suggested Tobey had left Seattle in a huff because people didn't like his "modernistic" mural.

Another story going the rounds claimed that Tobey's moving to Switzerland had something to do with the Swiss having a more advantageous income tax system. I finally asked Mark Ritter why Tobey did move to Basel. His explanation follows: "The way this came about is a charming story. Tobey was in Basel to see his dealer Ernst Beyeler. Beyeler had a Paul Klee exhibition at his gallery. Of course Tobey was very interested to see that show. We

started walking around the old part of town. We came to St. Alban Vorstadt, a narrow street that dated back to the fourteenth century. It was near the marketplatz, near the art supply store, near the pastry shops and restaurants, and near Beyeler's gallery. It was all within such easy walking distance for Tobey.

"When we got back to the Beyeler's gallery Tobey told him how much he liked this ancient street. It turned out that Beyeler knew the man who owned a very beautiful house on that street, a house that was built around 1600. Part of it was even older than that. John Calvin had lived in it for a year and written some of his religious tracts there.

"Beyeler took us to the house and showed us through it. There was a long hallway that led to the kitchen and up a short flight of stairs to the sitting room and four adjoining rooms. On the second floor were three more large rooms and the bathroom. There was even a third floor. The house had many windows and the rooms were filled with the kind of indirect light that Tobey likes to have when he paints.

"The owners of this house, Mr. and Mrs. LaRoche, were members of the Hoffmann & LaRoche Pharmaceutical Company. Now and then I run into Mrs. LaRoche at the laundromat at the end of the block. One afternoon she was painting her front door. These Swiss people have more money than you could ever dream of. But they prefer to live simply. Tobey likes that about the Swiss.

"Tobey was very taken with the house," Ritter continued to tell me. "And he liked the neighborhood very much. Beyeler told him that if he were interested he could arrange for Tobey to live there rent-free. He could pay his rent with paintings rather than cash. You know how Tobey is about money. Paintings don't seem like real money to him because

he knows he can always paint more pictures. Of course an offer like that would very much appeal to him!

"But Tobey had to make up his mind then and there. He stood in the doorway trying to decide if he should live there or not. It was a serious decision for him to make. Just then a lovely little girl with golden hair waved at us from a window across the street. 'That's a good omen! That settles it. We'll live here!' he said to me.

"It was that window over there," said Ritter, pointing to a second-storey window just across the street from Tobey's soon-to-be front door. "We never did see that little girl again. She was like one of those very lovely little angels in early paintings."

Tobey felt at home in Basel. It was a short stroll from his house to the Marketplatz where he bought his fresh vegetables and spring flowers. Surrounding the market place were coffee and pastry shops, and a bakery where he liked to buy his bread. The Munster cathedral was nearby, overlooking the Rhine River. Sacred music performances were held there frequently. Beneath this ancient cathedral was a Roman cemetery. Rebetez's art supply store was a few blocks away, as was Beyeler's gallery. It was all very convenient for Tobey.

During my first day in Basel I walked from Tobey's house on St. Alban Vorstadt to the places I knew he would visit regularly. The distances were almost the same as those from his house on University Way to the Wilsonian Hotel, where Tobey exhibited his paintings at the Otto Seligman Gallery. This gallery later became the Francine Seders Gallery and continued to represent Tobey's work on the West Coast. The market and bakery where Tobey shopped, the University Bookstore, and John Uitti's frame shop were

all on University Way. The Varsity Theatre, Manning's coffee shop and Loman and Hanford's art supply store were also there.

When I arrived at Tobey's house one morning I found several letters from Helmi awaiting me. It took about five days by airmail for them to arrive in Basel from Elma. While I was there I wrote regularly to both her and my painter friends Paul Dahlquist and Glenn Brumett in Seattle. I had brought with me from Seattle small works by Helmi, Guy Anderson, and Glenn Brumett to show to the various artists, museum curators, and art dealers I met. It occurred to me that I might just as well at least attempt to arrange for them to have exhibitions in Switzerland.

Brumett's landscapes of the eastern Washington desert near Vantage looked especially beautiful in the early spring light of Switzerland. Then I realized that Switzerland and Washington state are on the same latitude. Ritter liked Glenn's paintings so much that he thought they should be exhibited in Switzerland. Brummet and Ritter had met in Seattle in 1977, when all the Tobey estate heirs and lawyers gathered to discuss and divide the works, memorabilia, and assets in the estate. The estate was divided between the Seattle Art Museum, Mark Ritter, and Tobey's two nieces.

The museums in Basel were amazing. There was the Kunstmuseum with its great collections of Witz, Cranach, Durer, Grunewald, Rembrandt, Baldung, and Holbein, and superb collections of work by Klee, Picasso, Matisse, Giacometti, and Leger. Of all the great paintings in that museum, one in particular moved me. It stirred me more deeply than any painting I had ever seen before. It was Konrad Witz's *Saint Christopher Carrying the Christ Child*. Tobey once told Guy Anderson, "You come to the great

German painters last of all—Dürer, Holbein, Cranach—just as you finally come to Bach." It was during my visits to the Kunstmuseum in Basel that I first realized why Tobey would have said something like that.

Tobey's monumental painting *Sagittarius Red* hung on a wall by itself in the contemporary wing. This painting was originally intended to be a mural for the Seattle Opera House. It is a much stronger work than what was finally installed in Seattle, an enormous collage painting entitled *Journey of the Opera Star.* This title struck me as being something of an afterthought, a way of linking Tobey's painting with the concerts held at the Opera House.

The central part of downtown Basel was very much like that of any modern city with its large office buildings and department stores. But if I walked a block or two away from that crowded business area and turned a corner, everything abruptly changed. I was plunged back in time to seventeenth-century Basel, with its sunless narrow streets where the houses are so ancient-looking that I was amazed they could still be standing, let alone occupied. The cobbled streets are a maze of twists and turns.

EACH APRIL, the *Fastnacht* festival is held in Basel and nearby cities. This festival dates back to pre-Roman times. It celebrates the coming of the spring and the driving out of the winter spirits. It begins in the Marketplatz at the stroke of 4:00 A.M., when the assembled crowds and adjoining oldest parts of town are plunged into darkness. For the next three days and nights the streets are filled with grotesquely costumed and masked cliques playing fifes and drums. The shops are closed. The city nearly shuts down.

I was in Basel for the Fastnacht. For hours I lost myself in the crowds. I would go back to the Grueb Hotel and sleep for a few hours, and then return to the Fastnacht. For three entire days and nights, people in Basel set aside their identities and various social masks and wore other kinds of masks, ones that were fanciful, comical, and at times frightening.

I was making my way through the crowd when I saw a tall figure striding toward me. It was Death himself, making his way majestically and silently through the throngs of revelers. Then I realized that it was my young photographer friend, Yvo Kohl, whose father, Walter, was manager of the Hug Music Store in downtown Basel.

I walked up to him and exclaimed, "Yvo, it's you!"

"Not now!" he whispered to me. "I'll be Yvo again later!"

THE MUSEUMS IN BASEL were filled with some of the greatest art and antiquities I had ever seen. The Museum of Antiquities contained Greek works dating back to 2500 B.C., including original Greek sculptures, not the later Roman copies. The Etruscan bronzes were breathtaking. These tiny, corroded metal figures have a power that, for me at any rate, surpassed even that of Giacometti's elongate bronze figures. The Basel Museum of Cultures contained more tribal art from the Sepik River and other parts of New Guinea than I had ever seen before. There were several rooms entirely filled with towering wood figures and great masks. During the 1990s a group of these works was brought to Seattle's Burke Museum from the Basel museum for a special exhibition. During the coming weeks I would be alternating between staying at the Greub Hotel in Basel and commuting to Bern for the Gallerie Rosenau exhibi-

tion. These two cities are 91 kilometers apart, about the distance between Seattle and Olympia. It was an easy commute. I boarded the train just across the street from my hotel room, and I got off the train next to the University of Bern, a few blocks from the heart of the city.

The owners of the gallery, Fritz Lehmann and Bernhard Oplinger, had invited me to use their guest room. They lived in what is locally called a "Landhaus" (a country house) in the nearby village of Zollikofen, a ten minute train ride from the Basel train station. Their gallery rooms were in the downstairs rooms of their house. The preview receptions were held in their living room upstairs, where musicians performed chamber music during the social hour.

The preview and reception were a pleasant experience for me. Most of the people who attended it spoke English fluently. Art critic Agnes Hirschi came to the gallery the following morning to interview me for a story in the *Berner Zeitung*. She wrote that my small, pocket-size landscapes "capture the timeless grandeur of endless oceans and desert landscapes." Art critic Peter Bohm wrote, "True poetry speaks to us from these modest pictures. It is the extreme concentration of only the essential content." I soon found that the Swiss were among the most hospitable people I was to meet in Europe. They could seem a bit formal and stiff at first, but once you had cracked the proverbial ice with them, they had a sense of humor that I found enchanting.

The Historical Museum of Bern was just across the Aare River from the famed Casino. It contained late medieval tapestries, a large room filled with glass cases that contain Burgundian gold trophies won at the Battle of Grandson in 1476, and Islamic art. I often walked there

from downtown Bern after lunch. I introduced myself to one of the curators and mentioned that I was from the Pacific Northwest. To my great surprise she showed me a small but remarkably fine collection of wooden and argillite Haida Indian pipes from the Queen Charlotte Islands, just off the coast of British Columbia. These magnificent pipes date back to the 1830s and 1840s. Glenn Brummet and I had been in the Queen Charlotte Islands in 1973, collecting Cretaceous ammonites on the beach at Queen Charlotte City and traveling the length of the northern island to see the totem poles of Haida Gwaii. The ethnographic museum in Basel had eight of these Haida argillite pipes. I soon discovered that the Swiss museums were a veritable treasure trove of eighteenth- and nineteenth-century Northwest Coast Indian artifacts.

The Kunstmuseum in Bern had over 2,500 of Paul Klee's paintings and drawings in its collection—many of them a gift of his son, Felix Klee. I was already familiar with some of these works from my college days when my roommate, painter Bob West, and I hung reproductions of them in our apartment. But I was unprepared for the overwhelming beauty and mystery of Klee's very last works. They had a simplicity and intensity that moved me deeply. I had not until that moment experienced the real depth of Klee's final works.

The botanical gardens were a short walk from the Kunstmuseum. It was usually the case that, as a paleobotanist, I was familiar with the fossil forms of many plants long before I knew their living counterparts. I had worked with fifteen-million-year-old opalized *Osmunda* ferns from Saddle Mountain near Vantage for several years and yet never seen a living *Osmunda* fern. I was startled to see how

much the living *Osmunda* ferns looked like the fossil ones I had back at the Burke Museum. The *Osmunda* ferns in the botanical garden grew close to the ground in a grove of pine trees, just as they did in the fifteen-million-year-old Miocene forests of what is now eastern Washington. In 1983 the opalized *Osmunda* stems from Saddle Mountain were formally described as a new species of now-extinct fern by paleobotanist Charles N. Miller Jr.: *Osmunda wehrii.*

Peter Mani, whom I had known in Seattle as a visiting Swiss mathematician, taught at the University of Bern. He showed me the stone façade building where Albert Einstein had worked in the patent office just before he published his six epoch-making papers on his Theory of Relativity in 1905. Peter took me to a small coffeehouse at the foot of the hill, just below the University of Bern. When we sat together in a corner of the cafe, Peter explained, "You are now sitting just where Einstein sat while he did his math."

As a teenage student at Queen Anne High School in Seattle in 1945, I sent a copy of a book about him to Einstein at Princeton, New Jersey, asking if he would autograph it for me. He not only did that; he also addressed the return package himself. I saved that bit of his handwriting for many years and finally deposited it in my papers at the University of Washington. When I visited Richard and Betty Eberhart at Princeton in 1956, they drove me past Einstein's former house on Mercer Street. Now, twenty years later, I was in Bern, drinking coffee in the same cafe corner where he had once sat, formulating his revolutionary theories. All of these experiences humanized such giants as Einstein for me. It made me realize that they, too, had once been flesh and blood.

Andrew and Charlotte Apostolou introduced me to many of their friends, including painters Lotti Pulver and Daniel de Quervain. Lotti's paintings captivated me, and we soon became close friends. Within a few days I had began to feel that I could have settled in Bern for the rest of my life. I liked the people there and I liked the city. But as I thought more about it, I realized how far away from the sea Switzerland was, and that there was something in me that would always need to be near both the sea and the desert, as I am in Seattle.

I went to the Museum of Natural History and introduced myself to the curator, Dr. Hans Stalder. The mineral and crystal displays were remarkable, among the finest in all of Europe. Dr. Stalder was a geologist and he had assembled a remarkably comprehensive collection of spectacular examples of the world's rarest gems and minerals. I brought some rare fossil specimens with me from Seattle, ones that I intended to donate to the museum: a polished round of opalized fossil Ginkgo wood from the Ginkgo Petrified Forest on the Columbia River at Vantage in eastern Washington, and a polished slice of a very rare Dinosaur Age fossil plant called *Rhexoxylon* from Cycad Canyon in Utah. The Ginkgo wood was fifteen million years old, a new species that was named for my paleobotanical mentor, George F. Beck, who had pioneered the study of fossil wood in the Pacific Northwest, starting in the late 1920s. Dr. Stalder in turn gave me a small group of rare Swiss fossils and minerals for the Burke Museum's collections.

ON APRIL 23RD I FLEW BACK to Seattle by way of Vancouver. Glenn Brumett and Guy Anderson's painter

friend Edward Kamuda were at the Vancouver airport to meet me when I arrived. As I wrote of it in a letter: "It was a good thing they were there. By then I was down to less than twenty dollars! When we arrived at La Conner, Guy had set the table with candles, and he had prepared his specialty, salmon teriyaki. After that steady diet of veal and potatoes in Switzerland, the salmon tasted even better to me than before. I knew I was home again. I had just returned to Seattle when art critic Richard Campbell announced Tobey's death in the *Seattle Post-Intelligencer*. It had been very important to me that I be able to see Tobey in Basel. Mark Ritter would tell Tobey how the exhibition was being received. Tobey did something last year which I understand & had anticipated. But it will come as a jolt to people in Seattle when it becomes known. In his former will everything went to the Seattle Art Museum. But Tobey changed this & has pretty much entrusted to Mark Ritter the authority to attend to all of his wishes & intentions."

WHILE I WAS IN SEATTLE during 1977, the Gallerie Rosenau showed a group of my things at the Basel Expo 77 Art Fair. That same year the heirs for Tobey's estate—Mark Ritter, Tobey's two nieces, and the representatives for the Seattle Art Museum—met in Seattle to review the works and assets in the estate and to divide them among these acknowledged heirs. American and Swiss estate taxes and the lawyers' legal fees nearly wiped out the estate. In fact, several of Tobey's heirs were forced to sell many of the works they were supposed to inherit in order to raise enough money to pay the inheritance taxes on those works.

I returned with John and Anne Gould Hauberg to Basel

in 1978 in the role of consultant to the Tobey estate and the Seattle Art Museum. It was my job to sort out the works and papers in Tobey's house and arrange for them to be shipped to Seattle. Colin Graham, director of the Art Gallery of Greater Victoria, had already gone to Basel during the early 1970s to sort out Tobey's correspondence for shipment to the Seattle Art Museum archives. Graham had arranged several boxes for shipment when Tobey abruptly changed his mind and announced: "Nothing more leaves this house until I'm dead!"

So much of the selling off of Tobey's estate and the ruinously high estate taxes and legal fees could easily have been avoided if Tobey had both transferred his works to the Seattle Art Museum and given the remaining works to his friends while he was still alive. I learned a great deal about artists' estates watching the legal complexities surrounding Tobey's death and the distribution of his paintings and other assets.

Shortly after I arrived in Basel with the Haubergs, I wrote to Gary Lundell: "The Haubergs left for Cairo today. John [Hauberg] put me in charge, with my own Basel inventory secretary, and with Mark Ritter's blessing, of a massive shipment to the Seattle Art Museum: Tobey's piano, easels, furniture, music, books, letters, manuscripts, art supplies, minerals, fossils, dicta, objets d'art, unfinished oils on canvas, graphics, drawings, monoprints, early oils (1912, 1925, etc.), paintings by others—a pile of Pehr's work—a steel cabinet (6 drawers) full of work, etc. One of Europe's best shippers is handling it. Everything has gone beautifully. Snow here today. We went to Tobey's grave yesterday. Pehr and Hans Barth, the theologian, are buried near by. Of course, I'll have many stories to tell you in Seattle."

In 1976 Mark Ritter introduced me to the publisher of *Edition de Beauclair*, Gotthard de Beauclair. Many of Tobey's finest graphics resulted from this collaboration and friendship with Mr. Beauclair. It was Beauclair who in 1970 introduced Tobey to Francois Lafranca, a master printmaker from Locarno, Italy. For one week, Lafranca worked with Tobey at his house on St. Alban Vorstadt, a week of intensive collaboration. From it emerged twenty new graphics, among them such luminous aquatints as *After Harvest, Evocation, Movement in White,* and *Summer Breeze.*

I was surprised that Tobey had become so involved in graphics. When he lived in Seattle he was reluctant to do any graphics, even when printmaker Glen Alps offered to assist him. He was convinced that people would start to buy only his graphics and fewer of his paintings. Once he settled in Basel he changed his mind. During the late 1960s and early 1970s much of his attention went into printmaking. Some of the works sold as Tobey "graphics" were, however, merely photo-offset lithograph images of his paintings. In other instances he worked with several fine printmakers on the printing of original etchings and aquatints. Tobey's *Urban Renewal* lithograph, which he drew for the limited edition of his University of Washington Press book of his market drawings, is one of the few original graphics he did during his years in Seattle. Printmaker Harold Keeler produced the edition for Tobey. While Tobey was in New York during the 1930s, he did a few lithographs of the burlesque hall dancers and musicians.

Ritter took me into a small room adjoining Tobey's sitting room. Pointing at a small, badly stained sink, he said: "That is where some of Mark's most beautiful prints came into being! When Lafranca came here to work with Mark,

they had a wild time of it, what with all the acids and chemicals. You've given Tobey music lessons. You know what he's like. He always has to do things his own way, to experiment. Sometimes I was afraid that he was going to blow up the house and all of us along with it. He knew as much about printing chemicals as I do. Lafranca tried to show him what to do, but with someone like Mark you can be sure that he'd have to try something entirely different each time. Those were wonderful days, even though Pehr kept complaining that all the chemical smells were driving him crazy. Lafranca inspired Mark. You can see that by the results!"

ANTHROPOLOGIST EDMUND CARPENTER and art collector Adelaide de Menil leased a house down the street from Tobey in Basel. De Menil's Texas-based family amassed one of the world's greatest collections of surrealist art. Her mother, Dominique de Menil, commissioned Mark Rothko to design a chapel for her art museum complex in Houston. Ritter suggested I phone them: "They're a charming young couple. Mark liked them very much. I think you'll enjoy meeting them."

They had just returned from a visit with painter Max Ernst on the Normandy coast when I phoned them. Carpenter said, "We're preparing dinner now. If you don't have other plans why don't you join us." Within fifteen minutes I had walked down the street to their house on St. Alban Vorstadt and was ringing the bell on their front door.

As I sat in the living room conversing with Carpenter, Adelaide de Menil came into the room and announced that dinner was ready. She had prepared a chicken dish that we had with French bread, salad, cheese, wine and coffee. It

was a very simple meal, but a delicious one. After all the heavy food—the wiener schnitzels, the Berner Rosti (a dish of browned potatoes) and the Spatzl pastas—I had been eating in Bern, this meal was refreshingly light. As Mark Ritter thought I would, I enjoyed this couple immensely.

Carpenter pointed at a wall across the room from where we sat, and said, "We recently had that wall redone. When we took off the paneling we found work painted by Holbein on the original wall. It is now in the Kunstmuseum here." Holbein the Younger lived and painted in Basel between 1515 and 1538. The paintings on that wall were painted some four hundred years ago! I had trouble adjusting to this entirely different sense of antiquity. After all, I was from the Pacific Northwest where a Skagit Valley barn that was built around 1910 was considered a venerable relic.

An aged street vendor sold newspapers and fresh fruit on the corner just down from Tobey's house. Tobey noticed that the vendor's cart was nearly falling apart. He bought a new cart for him. He even gave him a small painting, telling him, "If you grow tired of this little picture, or need some money later, take it to one of the art dealers around town. I'm sure at least one of them will want to buy it from you." Although Tobey could be slow to part with money, he could be casually generous with his paintings, giving them to visitors, to hotel employees, or to people he thought could sell them and use the money. He thought highly of Claire Falkenstein, and gave her works of his to sell so that she could make ends meet while she attempted to re-establish herself in Paris.

Ritter suggested I visit an elderly art dealer who lived several blocks away; "You should meet her. She was the

first dealer to handle Paul Klee's paintings. Mark and I used to have dinner with her now and then."

She lived only a few blocks away from the Greub Hotel where I was staying. I rang her doorbell the next day and told her that Mark Ritter had suggested I visit her. Her apartment was filled with paintings and drawings by many of the best-known artists: Picasso, Klee, Braque, and Leger among them. I spotted a lovely little painting by a relatively unknown but very fine painter named Ubac.

"You have an Ubac! He's a fine painter!" I exclaimed.

"How do you know of Ubac's work?" she asked.

"Because I bought a signed lithograph of his at the Seligman Gallery in Seattle. Francois Mathay was there from Paris the day I bought it. He encouraged me to buy it. That's why!" I explained. Mathay came to Seattle from Paris during the early 1960s looking for Tobey works to include in his exhibition at the Musée des Arts Décoratifs in Paris.

She took me next into her private apartment to see some of her own collection. Like Zoe Dusanne in Seattle, this woman had her gallery in the front room of her apartment, and adjoining her gallery were her living quarters.

She owned some very fine works by Klee, Giacometti, Kandinsky, Tobey, and Pehr, some of which were personally inscribed to her. She was delighted that I had known Pehr. "When they would come to dinner here, Tobey often brought a little painting for me as a gift. He was ever so generous. Some of his loveliest works are these small paintings."

The casualness with which Tobey gave his paintings to friends and sometimes to relative strangers upset Pehr.

"Mark, we just can't *afford* to be invited out for dinner at these people's places. You *give* them such valuable paintings. It would be so much cheaper for us to go to restaurants by ourselves," he howled.

I remembered how Pehr used to protest back in Seattle about this casualness with which Tobey sometimes gave his works away:

"Mark, if you hadn't given all those works away you'd have so many more pictures to sell now!" Pehr complained.

"But Pehr," Tobey explained. "If I hadn't given those works away to people nobody would ever have heard of me now. You know, sometimes it's more important to give your work to the right people than to sell it to the wrong people."

Even when he was successful and his works were selling very well, Tobey had a deeply rooted anxiety about suddenly finding himself penniless. He stashed large amounts of money around his house. If art dealers and collectors came to his house hoping to buy something privately from him, he wanted to transact in cash.

During my several weeks in Basel and Bern during 1978, I saw Ritter almost daily. He had a flair for telling stories. He could mimic Pehr's voice and antic behavior in an uncanny way. He could evoke a sense of Tobey's long-suffering but affectionate patience with Pehr. In fact, Ritter was a born actor. He could tell stories in which he took each part in turn. Some of his best stories were about Pehr. German painter Julius Bissier and Tobey, admiring each other's work, became good friends, according to Ritter's account. When Bissier died, his funeral was held in the small village of Ascona, some distance from Basel. Ernest Beyeler planned to drive there and invited Tobey and Mark

Ritter to accompany him. Tobey had assumed that Pehr would attend the funeral and memorial gathering at the Bissier home.

Tobey came into their living room to find Pehr stretched out on the sofa, reading a Swedish newspaper.

"But I took it for granted that you would be coming with us today! You really should, you know. Bissier liked you very much," Tobey told Pehr.

"Oh, Mark, I'm so *comfortable* here. Do I really *have* to come along?"

Tobey was dismayed. "Well, all right then. I can't force you. But sometimes I just don't understand you at all. The Bissiers have been very nice to you! Is *this* how you show your gratitude!"

The front door bell rang. It was Beyeler. He had parked his car in the street outside. As Tobey and Ritter started to walk down the stairs to join Beyeler, Tobey heard Pehr calling to him from the sofa:

"Mark, I just happened to think of it. Will you be stopping at that nice little restaurant that's on the way to the Bissier's house? The one we've stopped at before."

"Well, yes. We did plan to stop there," Tobey answered.

"In that case, I *will* come along with you!" said Pehr, getting up from the sofa and hurriedly putting on his coat and beret.

They arrived at the Bissier's home to find a large group of people already assembled there. Pehr walked quickly up to Bissier's widow, Lisbeth Bissier, and said: "We have just had the *nicest* lunch in that charming little restaurant I like so much!"

The other guests were dismayed by Pehr's graceless priorities. He had not told Mrs. Bissier how sorry he was about

her husband's death. All he could talk about was the lunch he'd just had.

Mrs. Bissier understood Pehr very well, so much so that she was not at all offended by his behavior. She exclaimed to him, "Yes, life does go on, doesn't it! And that's the way it should be! Thank you for being here with us today, Pehr. I am always glad to see you!"

Tobey's favorite composers included the standard old masters, such composers as Beethoven, Bach, Brahms, Scarlatti, Chopin, Schumann, and Debussy. After he had put away the dinner dishes, he would often spend the evening at his piano in the University District, playing works by these composers. He himself was an amateur pianist and a composer of many miniature works for both piano and flute. Wherever he was, he had a piano close at hand. His closest friendships always included musicians, painters who were amateur musicians, and painters for whom music played an important role in their creative work.

Before moving to Basel, Tobey lived in Seattle's University District. When he invited friends to his house for an evening of coffee, pastry, and discussion during the early 1950s, he sometimes played his latest piano piece for us. Painter Guy Anderson would play something from the piano classics for us. And I would play a little piece of my own. When Tobey moved to a large house on University Way during the late 1950s, he bought a grand piano, which he played before going to the studio in the morning, and in the evening after the dinner dishes were put away.

Tobey was a painfully slow learner. He often claimed that he learned by "gradual osmosis." In Basel, he called the street where clothing was sold "Bond Street" (after the equivalent street in London). He had other English nick-

Mark Tobey at his piano in Basel, September 1971. During his last years, museum curators, art critics, gallery dealers, and collectors appeared at his doorstep constantly. The demands put upon him by his worldwide fame made him long for his days in Seattle, when his life was simpler. When he played his piano and wrote his own piano pieces, he could lose himself in music and not always have to be "Mark Tobey." Photograph by Karl-Heinz Bast.

names for the German-named streets of Basel because he
was impatient with his inability to remember their German
names. Despite his ability to be highly analytical in criti-
cizing a painting, the mechanical aspects of music and lan-
guage usually escaped him.

As I have earlier noted, it was Tobey's interest in music
that led to my meeting him. In 1949 I was a music com-
position student at the University of Washington. Tobey
and I both studied privately with Lockrem Johnson. Tobey
would be without a music composition teacher that sum-
mer because Johnson was attending the Tanglewood
Music Festival sessions to study with French composer
Olivier Messiaen. Berthe Poncy Jacobson suggested to
Tobey that I might tutor him in music while Johnson was
away. Tobey was nearly sixty years old then, and I was nine-
teen. I was taken by Mrs. Jacobson to Tobey's house in
the University District and introduced to him. His first les-
son with me was to be the following week.

During his first lesson with me I gave him a very sim-
ple technical assignment. When I arrived at his house the
next week, he had quite forgotten the task I had set for
him. It was a simple enough assignment. He was to write
a short piece for piano that would modulate from a major
key to a minor key, and then back to a major key. He had
written a little piece entitled *Blues Lullaby* instead. He was
anxious to play it for me. It was unexpectedly abstract, even
though it had the recognizable quality of blues music. His
manuscript sketch was an indecipherably dense page of
musical notes and cross-outs. It looked very much like one
of his abstract paintings.

When I returned to his house each week, my ele-
mentary harmony and counterpoint assignments for him

were invariably long-since forgotten. He had spent the week composing a new piece for piano. I soon realized that Tobey would not be willing to do regular textbook-like music assignments. He would compose music as the mood struck him. I don't think he wanted me to assign him technical problems. He needed an audience, not an overly technical teacher.

Tobey never really learned how to count musical beats. I came into his living room one evening while he was playing the piano. The piece I heard was both somehow familiar and quite unrecognizable. Then it dawned on me. Tobey was playing a well-known piano piece by Schumann in 6/8 time instead of 3/4 time. The accentuation was not what the composer had intended but the result was wonderful. Each measure now had two accents in it, instead of three. This didn't bother Tobey one bit. He was giving Schumann's piece a syncopated twist, jazzing it up.

It is difficult to describe how Tobey played his own piano music. The manuscript in front of him was a bewildering page of quickly written musical notes, cross-outs, and tempo and dynamic indications. Little groups of notes were scattered here and there across the page. He wrote music down on the page with the same quick, restless movements with which he painted his densely constructed works.

I could never follow his piano playing or what it had to do with the page of his own music in front of him. These scattered notes were more like musical reminders and cues for him. An isolated cluster of five or six notes on a page was enough for him to almost improvise several bars of music. He played his own music in the same way he painted, with intense concentration and a highly charged

energy. Notes flew in all directions. The music had a strong sense of movement forward. Where it was headed was something only Tobey knew.

One evening during the late 1950s, Tobey phoned me and invited me to come to his house on University Way for a game of *Scrabble*. As I came up the stairs to his front door, I could hear him playing his piano, which was next to his living room's front window. I stood on his front porch, listening to him, watching him engrossed in the music. As a human being Tobey could be pretty much like everyone else. He could be kind and generous. He could also be competitive and petty. He could be serenely relaxed or angrily frustrated. It was said of Balzac that he was like everyone else, but no one was like him. The same could be said of Tobey.

The Mark Tobey I witnessed playing a piano piece by Schumann that winter evening in Seattle had the enraptured expression of a centuries-old saint in a European religious carving. It was an intensely private moment I was witnessing. I had known him in so many of his infinitely complex and at times seemingly contradictory moods. But it was in that fleeting moment as I watched him playing the piano that I felt I had glimpsed the essential Mark Tobey.

He once said to me "I would not wish fame upon my worst enemy!" As he became increasingly famous, there were constant demands made upon him for more paintings, more exhibitions, and more interviews. All this public attention made it difficult for him to forget for even a moment that he was "Mark Tobey." Then music became even more important than ever for him. For it was when he was listening to music, or playing the piano alone, or during those rare, mysteriously inspired moments while

he was painting that he could experience pure self-forgetfulness.

MARK RITTER AND TOBEY attended a Bahai program in Basel. Ritter described Tobey's reaction to it: "Tobey was very upset. The Bahai's were 'jazzing up' the traditional Bahai music. Tobey hated that. He felt it had nothing to do with the spirit of Bahai. He felt it was just an attempt to popularize Bahai. The Basel Bahai group held some of its meetings here at his house. It upset him that these meetings were usually too concerned with business and not enough with matters of the spirit. They conducted their meetings in German and Persian. Tobey could only speak English and the barest smattering of French."

Ritter described to me another account of Tobey and Pehr's life together in Basel: "During one of their meetings Pehr was sprawled out on his sofa in the far corner of the sitting room, seemingly asleep, with his Stockholm newspaper partly covering his face. I was in the kitchen downstairs preparing a tray of coffee and pastries for the group upstairs. Tobey came into the kitchen utterly frustrated and exclaimed, 'They're all talking at once. I've no idea what they're talking about!'"

As Ritter came up the stairs bearing the refreshments, they heard the leader of the group exclaiming in his booming voice, "You are all *asleep*! You must awaken now into spiritual awareness." Pehr, who had been sprawled out on the sofa in the corner, pretending to be asleep, let out a grunting noise, and opened his eyes. Seeing the tray of pastry that Mark Ritter had just brought into the room, he jumped up from the sofa and headed for it, exclaiming: "Aha, coffee and pastry! Now I for one am fully awake!"

Pehr piled his plate high with pastries. This was typical behavior for him. He often told me that he felt it was his role in life to play the clown, especially when the people around him were being pompous and stuffy.

Pehr's death in 1965 was a profound loss for Tobey. They had been close companions for over twenty-five years. Pehr had been in Stockholm and had just returned to Basel when he became seriously ill and soon after died in a Basel hospital. While Pehr was dying, Tobey continued working on a large painting which he later entitled *Unknown Journey*, explaining, "This painting turned out to be my farewell to Pehr. I gave it that title because death is the greatest journey of all."

WHEN TOBEY VISITED Pehr's grave in Klein Basel, just across the Rhine River from the central part of Basel, with Mark Ritter in 1965, he stood contemplating the groves of birches and tall poplars surrounding him. He liked the cloisterlike intimacy of this small cemetery. He turned to Ritter and said, "It is very lovely here. When my time comes, I wouldn't mind being here." Tobey was buried there eleven years after Pehr was. Mark Ritter is also buried there now.

Several days before I left Seattle in 1978 to return to Basel, I went to the Seattle Public Market. I went to the upper level of Manning's coffee shop and sat at a window table watching the sea gulls swooping through the sky, the ferry boats coming and going from the terminal below, and the distant Olympic Mountains to the west. This had been a favorite place in the market for Tobey.

In a tourist shop in the lower arcade of the market I saw some local seashells for sale. I bought several of them,

planning to bring them with me to Basel. Tobey was so very far away from the Pacific Northwest. I wanted to bring him a few of these shells and beach agates from the Washington and Oregon beaches.

When I visited the cemetery with Mark Ritter I found that Tobey was buried next to theologian Hans Barth. I also noticed some beach agates on his grave.

"Are those agates from the beaches around Seattle?" I asked Mark Ritter.

"Yes. Tobey brought them with him when he moved to Basel," he responded. "He kept them in a little jar on the window ledge, where he would hold them to the light and be reminded of Seattle. I thought he would like to have them here with him now."

INDEX OF NAMES

WESLEY WEHR is affiliate curator of paleobotany at the Burke Museum of Natural History and Culture, University of Washington. He has served as curator of numerous art exhibitions and is a leading authority on Mark Tobey. His other publications include *The Eighth Lively Art: Conversations with Painters, Poets, Musicians, and the Wicked Witch of the West. Photo by Randy L. James, 2003.*